SHORE to SHORE

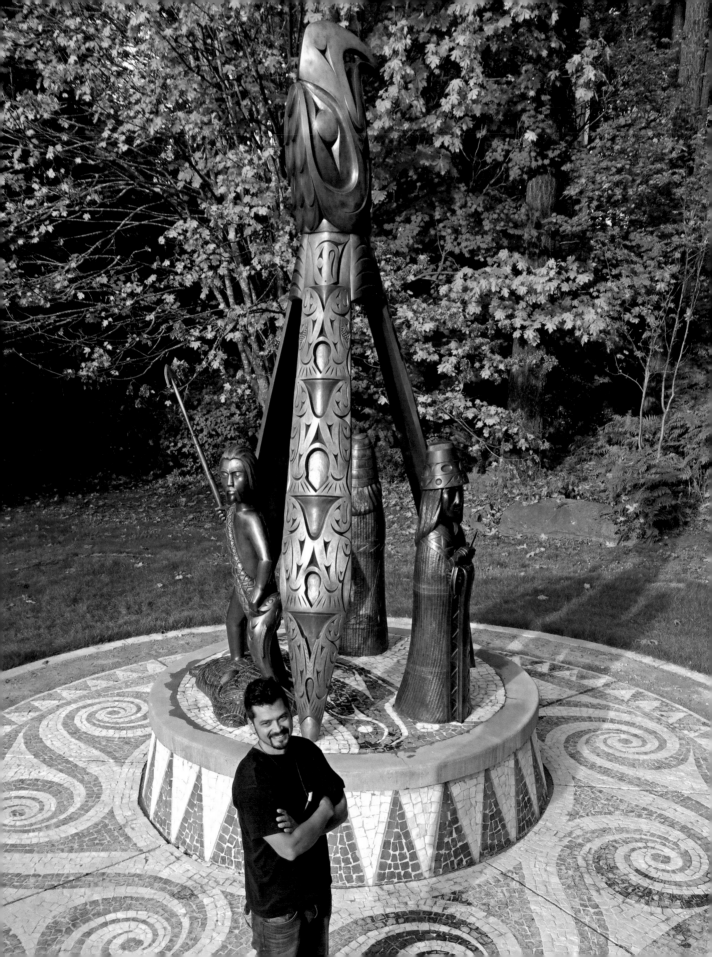

SHORE to SHORE

THE ART OF TS'UTS'UMUTL LUKE MARSTON

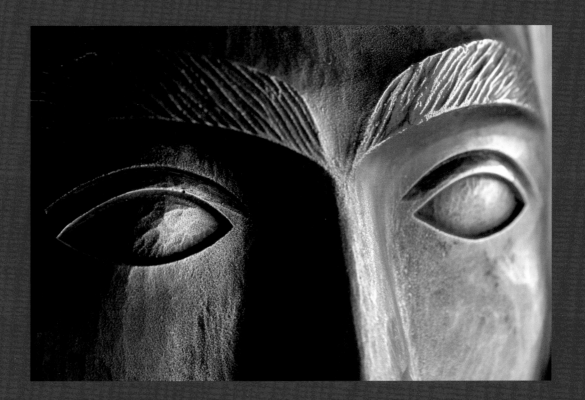

SUZANNE FOURNIER

HARBOUR PUBLISHING

To my husband Art Moses,
Our daughter Naomi Nattrass Moses and her wife Elan Nattrass Moses,
And our son Zev Moses

And to Jane Kwatleematt Marston

Harbour Publishing Co. Ltd.
PO Box 219, Madeira Park, BC V0N 2H0
www.harbourpublishing.com

Front cover photograph by Jeff Stokoe
Author photograph by Zev Moses
Artist photograph by Ashley Marston
Back cover maquette photograph by Jeremiah Armstrong
Cover design by Shed Simas
Edited by Pam Robertson
Indexed by Brianna Cerkiewicz
Text design by Roger Handling
All artwork copyright Luke Marston
All photographs copyright the photographer
Printed and bound in Canada

 Canada Council **Conseil des Arts**
for the Arts du Canada

 BRITISH COLUMBIA
ARTS COUNCIL
An agency of the Province of British Columbia

Harbour Publishing acknowledges financial support from the Government of Canada through the Canada Book Fund and the Canada Council for the Arts, and from the Province of British Columbia through the BC Arts Council and the Book Publishing Tax Credit.

Cataloguing in Publication Data available from Library and Archives Canada.

ISBN 978-1-55017-670-4 (paper)
ISBN 978-1-55017-671-1 (ebook)

CONTENTS

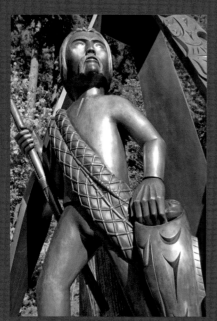 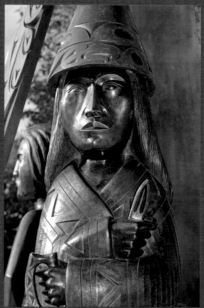 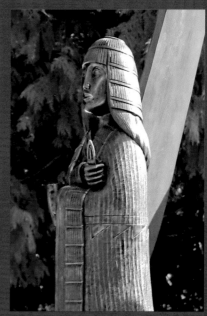

Previous spread, left: Artist Luke Marston stands proudly beside the bronze *Shore to Shore* sculpture. It was completed and assembled among a cedar grove in Stanley Park in the autumn of 2014. *Photo courtesy of Wawmeesh G. Hamilton*

Previous spread, right: The proud and striking face of Portuguese Joe Silvey was one of the first pieces to emerge from the bronze casting process. *Photo courtesy of Jeff Stokoe*

Above: Details from the *Shore to Shore* sculpture in bronze. From left to right: Portuguese Joe Silvey, Kwatleematt and Khaltinaht.
Photos courtesy of Wawmeesh G. Hamilton

FOREWORD

THIS BOOK IS ABOUT A COAST SALISH ARTIST named Luke Marston, who as a child had the opportunity to study art in the form of nature. He grew up influenced by and immersed in art. He observed and studied the intricate knife cuts that combine to make up Coast Salish art. His mother was a Coast Salish artist and his father was a carver of fine art. It was only natural for Luke to take up the knife and become a master carver himself, beginning at a very young age.

As Luke matured he designed beautiful contemporary art relying on nature, his culture, our stories and legends, and traditional Coast Salish art forms. Coast Salish art was not recognized as widely as Northwest Coast, Kwakwaka'wakw or Haida art. The Salish art style became accepted when people like the late Cowichan elder Simon Charlie persisted in studying and carving in this style. As Simon, in his studio near Duncan on Vancouver Island, struggled to redefine Coast Salish art, across the Salish Sea on the mainland artists such as Debra Sparrow, Susan Point and Stan Greene were doing the same. Members of the younger generations, like Luke Marston and his brother John, Dylan Thomas, LessLIE (Leslie Sam), Joe Wilson and Maynard Johnny Jr., have all benefited from the redefining of the distinctive art formlines that flow together to create Coast Salish art.

As you study the artworks in this book, you will become aware that each piece of art tells of a historical struggle for life, identity and peace. When you read this extraordinary book, I hope that you too will embark on a journey of self-identification. That journey may cause you to question your former identity and pose questions that will have you searching for different answers. It will be a journey of your own self-identity, just as it was for Luke.

Because of Luke Marston's expertise in carving he was chosen to do the project honouring our ancestry in Stanley Park. Luke believes in looking at people's strengths and bringing cultures and people together. He has become a world-renowned artist,

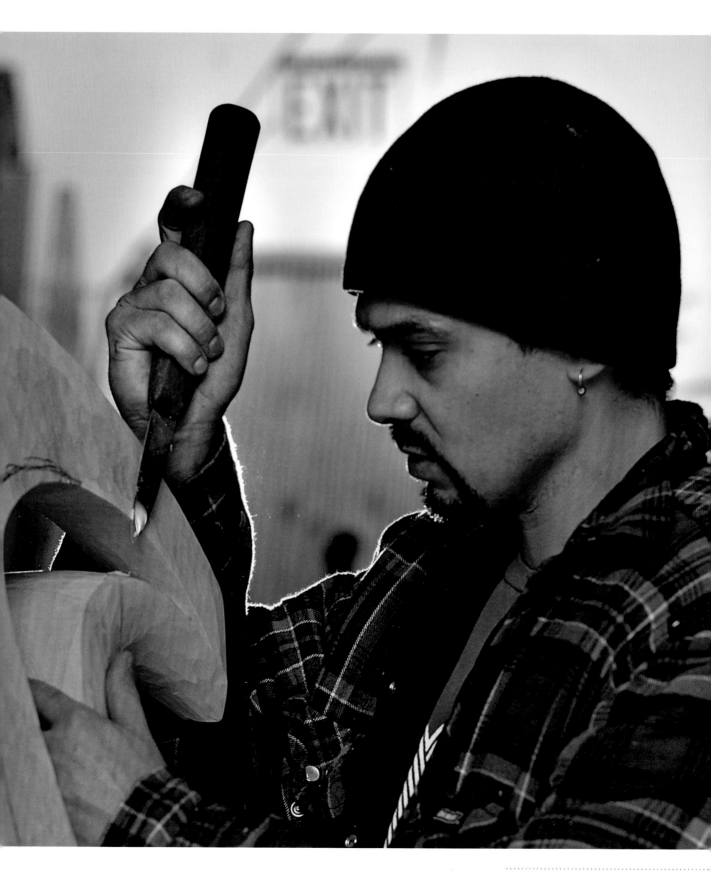

who displays an exacting perfectionism in his work. He knows and respects the Coast Salish design conventions but is able to use them to appeal to a broad majority of people. He designs so the meaning and strength of the art leaves the viewer with a sense of awe and peace.

At the outset of this project, almost five years ago, I saw the historical impact it would have on the Salish people, the Portuguese in Canada and Portugal, all British Columbians and the Canadian people. It is a part of our history that has not been told and was waiting for its rebirth. The time was right. The Ancestors were guiding the project, and we had a strong team in place to complete it. Unfortunately, before we had completed the project our fundraiser, Miles Phillips, my son-in-law, died in a car accident. This blow to our group and family was felt with profound grief and loss. However, at one of our previous meetings we had all agreed: if anything happened to one of us the others would see the project completed.

This book is about Canadian history, self-identity, artistic diversity and the search for peace in a challenging and changing world. It is also a book about an artist who works hard and believed in what was at its heart a project about family. The book captures the life of Luke and it also shows the unseen steps an artist must take to research an inclusive sculpture involving mixed cultures, and to design a sculpture that depicts the diversity of cultures that made up the young province of British Columbia and the new city of Vancouver. It takes you on a journey from Luke carving in yellow cedar to all the steps he had to take to get the cedar pieces poured in bronze. You also get glimpses of the bureaucratic nightmare he faced as he applied for permission to place the sculpture where his great-great-grandparents lived. This book is not only a book about the history of Canada; it is also a book about an adventure in discovering a family identity that was Salish, Portuguese and Canadian.

I raise my hands up in respect to all those who have contributed to this project and I humbly thank them for their support. I am the great-granddaughter of Kwatleematt and Joe. I carry her name into the future.

Jane Kwatleematt Marston
Stz'uminus First Nation

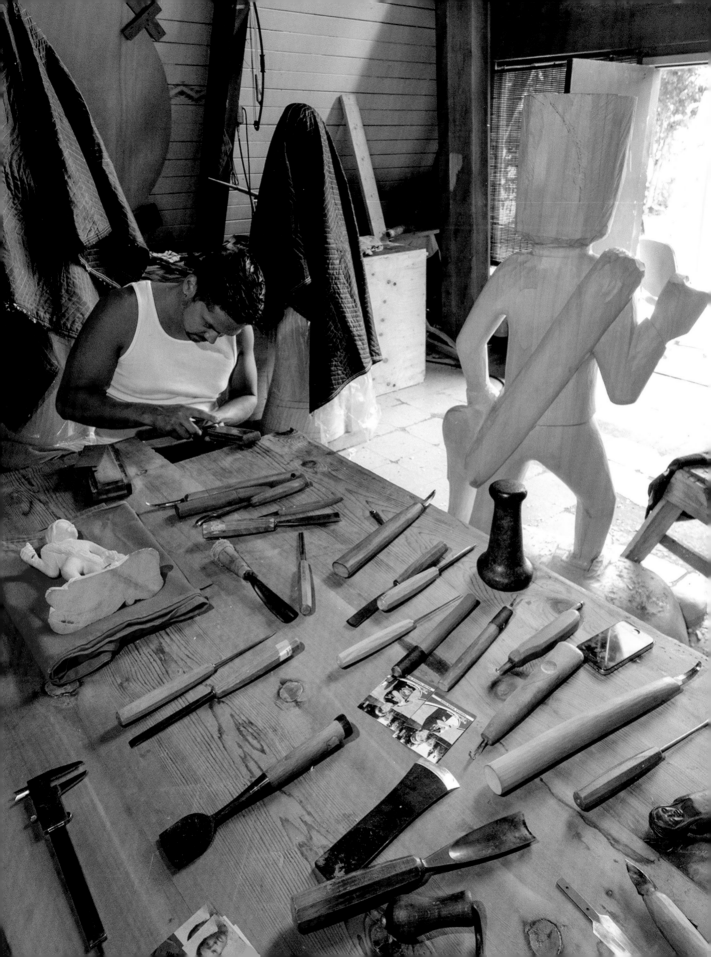

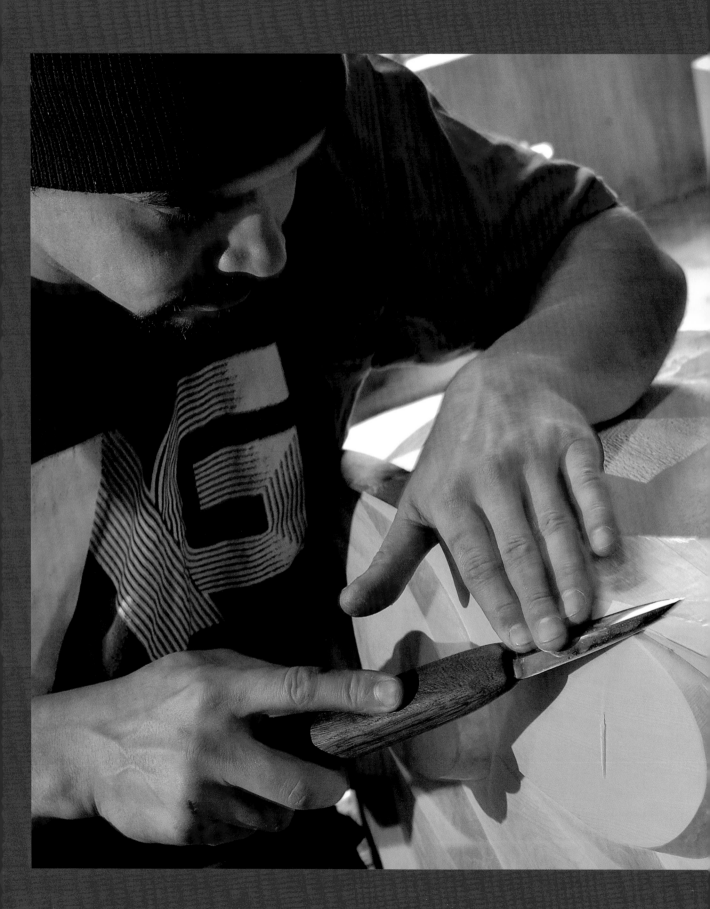

Guided by Ancestors: An Artist's Early Start

A ROARING WOOD FIRE WARMS THE CARVING SHED of Ts'uts'umutl Luke Marston, on Stz'uminus First Nation land on southern Vancouver Island, bordered by the sparkling waters of sheltered Kulleet Bay. Once a church, the tall A-frame shed still features a large wooden crucifix hanging on the wall. Beneath it, Luke labours with handmade carving tools on what will be one of Vancouver's most significant public monuments. It will be a life-sized bronze sculpture of his great-great-grandparents, Kwahama Kwatleematt and Portuguese Joe Silvey. Silvey, born on the Azores island of Pico, was whaling by the age of 12 and it appears he left for good on a whaling ship in 1846 at 18, following the gold rush to Canada by 1860. As a whaler, a logger, a Gastown saloon owner and British Columbia's first licensed seine fisherman, Silvey forged strong bonds with the First Nations people who made up the vast majority of the population when he arrived on the West Coast. He first married Khaltinaht, a Squamish/Musqueam noblewoman, in a traditional marriage with the permission of her people, which was signified by canoes full of precious woven wool blankets. They had two daughters together, and lived happily at what is now Brockton Point in Stanley Park, but Khaltinaht died at a young age from tuberculosis. Left alone with two small daughters to raise, Silvey remarried on September 20, 1872. His new wife was a young woman from the Sechelt First Nation, Kwahama Kwatleematt—Luke's great-great-grandmother.

All three of the figures—Portuguese Joe, Khaltinaht and Kwatleematt—appear on the monumental bronze sculpture that is now prominent at Brockton Point in Vancouver's Stanley Park, close to where his forebears lived, in what is one of North America's largest urban green spaces. The park, long the traditional territory of three coastal First Nations, receives an average of eight million visitors a year. Many tourists stop to photograph the Brockton Point totem poles, a collection that originated in the 1920s and was sourced from First Nations of the north and central coast. The area's Coast Salish people were not represented until the 2008 installation of magnificent house frontal

Opposite: Luke, using one of the carving tools he makes himself out of sharp steel, wood and leather, pays close attention to precisely outlining a detail of a traditional Salish formline.
Photo courtesy Jeremiah Armstrong

gates by Musqueam artist Susan Point, and the addition of the Yelton pole, erected in 2009 by one of the last aboriginal families to live in Stanley Park.

The Silvey family lived intermittently at Brockton Point in the 1860s and 70s, joining First Nations who lived in the area, but in a newer mixed-race village that sprung up on the western shore, made up of Hawaiian, Portuguese and First Nations families. Then, to escape mounting racism toward mixed-race marriages, sometime around 1878–79 Joe Silvey moved his family from Vancouver to Reid Island in the Gulf Islands, just off the north coast of Galiano Island. There Joe and Kwatleematt raised ten children to adulthood, surviving off the land and sea and founding a legacy of hundreds of descendants, many of whom worked in resource-based industry and helped to create the province of British Columbia.

Luke Marston's workshop lies just across Trincomali and Stuart Channels from Reid Island, in the heart of Vancouver Island's traditional Coast Salish territory and close to the site of a significant ancient village. Kulleet Bay was called K'elits' in the Hul'qumi'num language, so named for the sheltered bay in which rich marine resources thrived, yielding a vast harvest of herring in season and abundant shellfish. Above the bay, massive stands of Douglas fir, alder, big leaf maple and cedar furnished wood and bark for indigenous people's homes, canoes, everyday dress and implements, as well as ceremonial dress and carvings. The ancient habitation was called Shts'emines, and today its name is lent both to the nearby pretty Vancouver Island town of Chemainus, and to the First Nation to which Luke, his mother Jane Kwatleematt Marston and most of his six siblings now belong.

Luke and his younger brother John Marston, although not yet forty years old, are riding the crest of a new wave of appreciation and collector interest in contemporary Coast Salish art. The two brothers, who worked together closely in their early years as artists, have achieved comparable acclaim and recognition, but their styles have recently begun to diverge somewhat. John still shares a contemporary, elegant and culturally based style with his brother, however, and has enjoyed his own considerable artistic achievements, including installations at the University of British Columbia's Museum of Anthropology, the Vancouver International Airport and the Vancouver Convention Centre.

Before Luke started work on the *Shore to Shore* project, he had already established a strong profile as an artist, becoming known particularly for his refinement and delicacy of technique—from finely chased repoussé gold and silver bracelets to carved and boldly painted paddles, rattles and masks. He works in a wide range of media, including gold, silver, precious shells, glass, stone and West Coast woods. Each piece respects Coast Salish artistic conventions yet reflects in unique ways the indigenous legends and stories Luke has absorbed since he was a child. Powerful Salish spirit animals are given life in his art with a contemporary flair.

The massive cedar *Shore to Shore* sculpture, depicting Khaltinaht, Kwatleematt and Portuguese Joe Silvey, represents in many ways the pinnacle of Luke's two decades of achievements as an artist. "I would regard Luke Marston as a highly successful mid-career artist, interpreting Coast Salish art forms in an exciting and contemporary way," says Melanie Zavediuk, director of the Inuit Gallery of Vancouver, who has staged

Opposite: Luke proudly holds his magnificent *Eagle Talking Stick,* carved for *Honouring the Ancient Ones,* the Inuit Gallery's 2009 exhibition of the work of John and Luke Marston. This seminal show highlighted the Marston brothers' unique, modern-yet-traditional Coast Salish aesthetic.
Photo courtesy of Inuit Gallery of Vancouver Ltd.

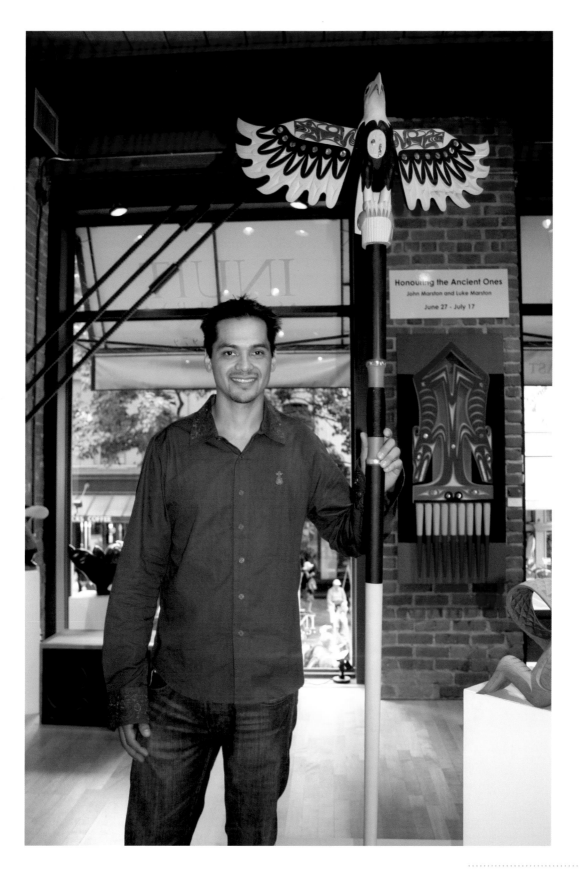

important openings for both Luke and John Marston, including the key exhibition *Honouring the Ancient Ones*. A long line of local and international collectors formed outside the Inuit Gallery at the June 2009 opening. Potential buyers, in person and online, were each restricted to one ticket, entitling them to purchase one Marston piece. As soon as the doors of the Gastown gallery opened, collectors rushed in and red dots swiftly appeared beside beautifully carved masks, bowls, paddles, bracelets, panels and an eagle talking stick. Almost every work sold, either in the gallery or over telephone and computer lines, on the first night of the show, even with some priced well into five figures.

Douglas Reynolds, owner of the eponymous gallery in the prestigious South Granville gallery district, who has been involved with indigenous art for twenty-five years, says that he considers Luke to be "among the top 10 percent of West Coast artists… and his prices reflect that. Luke does get a premium for his art because he's established both locally and internationally. Good work will always sell, and Luke Marston is very good.

"He's been working from a very young age and he has developed a distinctive style—it is Coast Salish, but like all the best artists, he hasn't stood still, he has developed and refined his work within that style, as do all artists of that calibre," says Reynolds, who sells Northwest Coast art both locally and internationally.

Luke has had difficulty keeping top galleries stocked with his pieces, as his primary focus for much of the four years leading up to the 2014 installation was on the *Shore to Shore* monument. From his relatively solitary life as an artist, Luke moved into the complex realm of public art donation in a major metropolitan park, requiring ongoing consultations with elected city and park officials, federal granting agencies, the Portuguese consular and business communities, the three First Nations who traditionally occupied the park, engineers, surveyors and landscape architects, as well as his own extended family. That includes the Silvey descendants in southwestern BC, who have held frequent fundraising gatherings for *Shore to Shore*.

A key event that sparked Luke's interest researching his Silvey ancestry was the publication of historian Jean Barman's 2004 book, *The Remarkable Adventures of Portuguese Joe Silvey*. And Silvey descendants including Rocky Sampson of Duncan, BC, have created online genealogical research sites and conduct enquiries that some claim are accurate enough to generate a tentative mitochondrial DNA match. Many searches for "Joe Silvey" relatives come from all over the world, with no apparent link to Luke's ancestor. That could reflect the tendency of English-speaking employers and immigration officials to dub many newcomers Portuguese Joe, or Portuguese Pete, and Silva, Silba and Silveira being common surnames. "Portuguese Joe Silvey" is a name that appears in records, logs, registers, government files and stories, in both Canada and the United States, in numbers far too substantial for one person to generate.

Although the surname "de Silveira" does appear in Joe Silvey's lineage on his mother's side, he was baptized as José de Simas, and most of his Azorean relatives appear to still use that surname. The identity is further confirmed by comparing the names Joe Silvey gave his children in Canada with those of his siblings back in his home island of Pico; they are virtually identical. Portuguese names typically use more than one surname, reflecting maternal and paternal lineage, and the complexity of naming tradi-

tions cannot have been helped by the fact that Portuguese Joe Silvey was not proficient at reading or writing. Nor does the fact that Joe Silvey gave his name at various times as Silva, Silveira or Simas—which may have been heard as Siemens or Simmons— necessarily reflect a deliberate bid by him to conceal his identity because he may have jumped ship. It is unlikely American whaling companies possessed the resources to track down ship-jumpers, who quickly melted into the growing settler communities in New England, San Francisco and British Columbia. Most American whaling ships did not even record the names of Azorean crew members, although almost every American whaler of that era can be tracked.

Mark Procknik of the New Bedford Whaling Museum confirms it is unlikely Joe Silvey's name ever appeared on a ship's log. According to Procknik, there are "crew lists for all New Bedford vessels that left port during the years 1841–1927, but unfortunately these crew lists only include men who shipped from port—not those picked up during the voyage," leaving few records of men recruited in the Azores. Some reports, as Jean Barman has noted, suggest that "Joe's father, or perhaps it was his uncle, told him about sailing all the way to North America in the *Morning Star*, a ship that regularly hired young men from Pico and the other islands of the Azores." But Procknik has said that in fact the *Morning Star* "was built in 1853 and sailed on her first whaling voyage in November of that year. Unfortunately, given the vessel history of the *Morning Star*, Joe Silvey could not have left the Azores in 1839 on board the *Morning Star*."

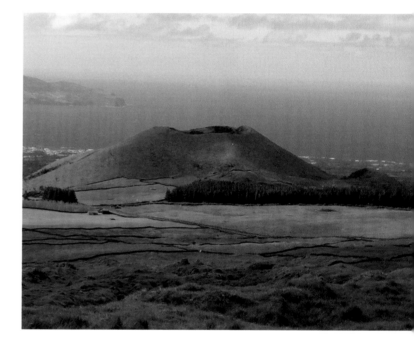

A ship with that name did however make four complete trips from New Bedford around Cape Horn into the Pacific Ocean, with two of those trips falling between the years 1853 and 1862. Since Joe Silvey replied in the 1901 census that he arrived in British Columbia in 1860, and stories suggest he was chasing the 1858 Fraser Canyon gold rush, he may well once have been a crew member on the *Morning Star*, as it rounded Cape Horn toward the San Francisco Bay area on the Pacific coast. Certainly that name was what he christened his beloved boat that he built himself, many years later, and in which he sailed many a voyage in West Coast waters, both as a solitary fisherman and with his growing family.

By travelling to Portuguese Joe Silvey's home village in 2014, Luke Marston forged new links with people from the Azores who were excited about his project and plan to travel to Vancouver to view the *Shore to Shore* monument—his tribute to an Azorean son.

The once-stark black lava landscape of the Azores has altered over the eons to green, as rock eroded to create a verdant landscape dotted with dormant volcanoes. This was one of Luke's first views of his great-great-grandfather Joe Silvey's homeland on the island of Pico, very different from the desolate place Joe left at the age of twelve.
Photo by Suzanne Fournier

The massive Portuguese stone base of the sculpture was assembled in Avante Concrete's contracting yard in Surrey, BC. Made of 27 tons of concrete, stone and rebar, the base was cut into pieces like a pie and shipped by crane and flatbed trucks to Stanley Park.

Photo courtesy of Terry Bottomley

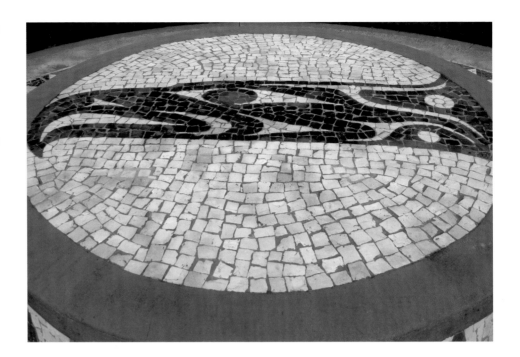

Luke named the sculpture *Shore to Shore* to honour the connection forged between people of the Atlantic Azorean shores and the people of the Pacific shores surrounding Stanley Park. The sculpture's name also reflects Luke's intent to portray the two Coast Salish women Silvey marrried, Khaltinaht and Kwahama Kwatleematt, as equally significant to Portuguese Joe, and to reflect their high-born status, heritage, skills and legacy. The base of the monumental installation is a black-and-white mosaic design that is both Coast Salish in character and quintessentially Portuguese. It is a swirling ring of waves, forming a circular path on which visitors walk to view the sculpture in the round. The base was created from authentic Portuguese stone that was flown by the Azorean government to Canada. It was then painstakingly cut, shaped and installed on a giant concrete base at a warehouse in Surrey, BC, by Azorean stonemason Carlos Menezes.

To Luke, there was no more fitting location for *Shore to Shore* than in the iconic park, right across from downtown Vancouver, in a prominent setting still preserved much as it was many hundreds of years ago. A peninsula surrounded on all sides by the Pacific Ocean, Stanley Park is ringed with busy public beaches and criss-crossed with paths and trails, yet at its heart evokes a sense of wilderness, with its mammoth cedars and Douglas fir. It is a beloved, well-used space that provokes a proprietorial interest among people all over the Lower Mainland. Classed as federally owned land, Stanley Park is leased to the city of Vancouver. The Musqueam (xʷməθkʷəy̓əm), Tsleil-Waututh and Squamish (Skwxwú7mesh) First Nations, however, who occupied for millennia the land now known as Stanley Park, regard it as their unceded traditional territory. Since fee-simple and homeowner lands are not on the negotiating table in BC for any future treaty or land settlement, the First Nations keep a very close eye on the park, as

they would any lands still held by the Crown. They did not disguise their anger when Ottawa in 2008 quietly renewed a ninety-nine-year lease given the city of Vancouver to continue to run the peninsula as Stanley Park. And in 2010, former Conservative Member of Parliament Stockwell Day rejected outright a proposal by Squamish hereditary chief and councillor Ian Campbell to acknowledge the park's history by having it revert to the traditional name Xwayxway, a village once located near the park's Lumbermen's Arch. Since it is held by the federal Crown, the park will certainly be part of any future treaty or land settlement discussions involving the three First Nations whose history is closely tied to it.

At every step of the way, Luke has done his best to follow traditional First Nations protocol, consulting with his own elders, First Nations representatives and archaeological consultants, and with Chief Campbell.

Luke's Early Immersion in Art

Born in 1976, Luke Marston spent his early years in a small home, without electricity or running water, in the remote woodlands of central Vancouver Island. His older siblings have memories of their mother Jane—whose mother Edith was the daughter of Joe Silvey's son Antonio—working ceaselessly in the home to raise her children, with few resources, while their father often was away logging, welding or finding other paid work. Luke's memories of his young life at the homestead are of an intense and happy time. He remembers both his parents as being immersed in their artwork, and always carving. His father David was seldom without a piece of wood—one that might be plain in the morning when Luke went to school and a near-finished piece of art when he returned. David Marston was of English heritage but also Canadian Algonquin, a nation with which he had no direct experience, although he researched and diligently practised some of its art styles.

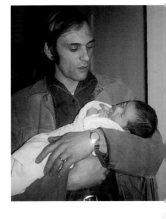

Luke is lovingly held by his father David Marston, a carver of English and Algonquin heritage who had to find work logging or welding. Marston says his father's refined, precise style was an early influence on his own work.

Photo courtesy of Denise Augustine

"My very first memory of carving was when I was about four, picking up wood and a knife and being encouraged by both my parents, and that was at the property we left when I was only six," Luke recalls, adding that he could immediately see an animal image in the soft and crumbling piece of cedar. "My dad used to help me make bows and arrows there but his were always so much better than mine. My father had a very refined, precise style and although I definitely see my own artwork as being within the Coast Salish tradition, and I learned a lot from my mother's designs and cultural knowledge, my dad's style also has been a strong influence on me."

Luke points to a piece he carved in 2009 as a tribute to his father, his *Blue Heron Ladle* of maple wood and abalone, with swooping, curving lines forming the bowl of the ladle as the heron's strong beak and head create the handle. The eye, beak and body of the heron feature abalone inlays. The colours of the ladle are clear and few. White-grained western maple sets off the heron's grey head and chest feathers, a colour echoed in the swooping bowl of the spoon. The carving and painting of the eye observes the Coast Salish design traditions of a prominent eye, painted in brown and offset by deeply carved Vs. Coast Salish trigons run along the edge of the ladle and the bottom of the bowl is clear green, as is the base that holds the ceremonial spoon. The underside of the bowl is a design painted in brown, grey and green.

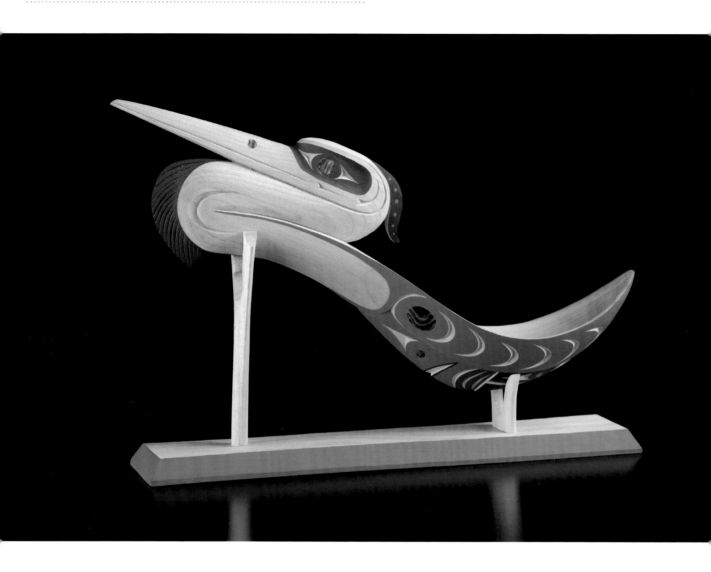

Luke's *Blue Heron Ladle*, made of white-grained western maple and abalone, is a tribute to his father's clean style, although it closely follows Coast Salish design conventions with trigons along the edge of the ladle, curving formlines and a prominent eye.

Photo courtesy of Jeremiah Armstrong

"Whenever I carve a blue heron, I think of my father and how he would carve a spoon, sitting at the kitchen table," says Luke. "His style is kind of engrained in me, even though I consciously use the Coast Salish design tradition. I recall him carving in long, swooping lines without a lot of excess ornamentation, and I aspired like him to bring out the spirit of the bird or animal in my carving." Luke notes that even the stand on which his *Blue Heron Ladle* is placed harkens back to his father's techniques for carving violins.

By the time Luke was about ten years old, both of his parents had become full-time artists. His mother Jane, a strong, talented woman with a gifted ability to carve and paint, actively researched her Coast Salish tradition and studied artifacts, taking note of the styles and stories associated with each piece of art. Jane had been shown how to live in a "proper" indigenous way, to fish, knit and pray to the four directions, to give thanks for sun and water and earth, by her mother, Edith Silvey. Yet Edith was a residential school survivor who feared for the rest of her life to be seen practising aboriginal ways.

Edith's teachings were never termed "native," but were presented as a natural, good way of life to her children, says Jane. When Jane later sought out the mentorship of a nearby Cowichan elder and artist, Hwunumetse' Simon Charlie, she already had the benefit of her mother's teachings. The challenges of Edith's life intensified when her husband, Ernest George Baines, drowned in a tragic accident, leaving her with six small children to raise. As a young woman on her own, Edith was especially careful not to appear "Indian."

Ironically, Edith still spoke Hul'qumi'num fluently and knew many Salish legends and practices, but her facility with the language did not survive even one generation. "My mother was afraid to identify as being native, because then she wouldn't have been allowed to own an oyster lease as an Indian woman, or to own the seine boat that she needed to support her kids," recalls Jane Marston. Jane's mother almost never took her to the Bighouse, the ceremonial centre of Salish culture, and she didn't teach her children her language. It is a skill that Luke has had to painstakingly acquire by listening to elders and Hul'qumi'num language audiotapes, and by taking instruction in the Hul'qumi'num language on-reserve.

Edith's Portuguese heritage did not save her as a child from being forced to attend the Kuper Island residential school. "She rarely talked about it, what happened there," says Jane. It would not be until after Edith's death that Luke learned his grandmother's crippled and bent hands were caused by a nun who had deliberately pushed her down the stairs, breaking her fingers, then neglected to obtain medical help for the child. In her later years, arthritis set in to her badly crippled fingers, causing her even more pain.

In 2009 Luke was asked to create a work of art for the Truth and Reconciliation Commission that would represent all the survivors of the residential school system across Canada, something that would travel with the TRC on its visits to many

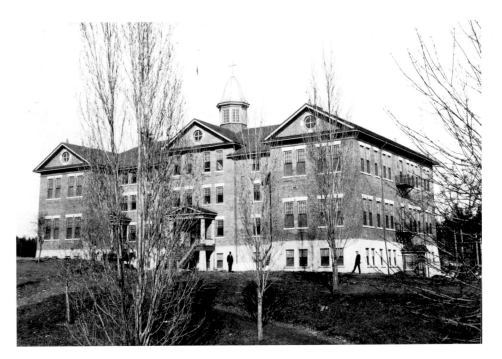

The Kuper Island residential school was located on what is now Penelakut Island, named after the people whose children suffered for generations at the school. Recent documentation has revealed that children were subjected to medical experimentation, including denying adequate nutrition. Many children died of starvation or tuberculosis—the school had a staggering 40 percent mortality rate—while others drowned trying to escape. Both Luke's great-grandmother Alice Aleck and his grandmother Edith Silvey attended the school as children.
Photo H-07256 courtesy of Royal BC Museum, BC Archives

Below: The bentwood box carved by Luke for the Truth and Reconciliation Commission became a striking symbol of the brutality of residential schools. The side of the box featuring the stylized image of Luke's grandmother crying black tears with her crippled fingers held up to her face was kept facing the audience.

Opposite: One end of the box depicts a Woodlands aboriginal boy with a red hand painted over his mouth to represent the fact that children were forbidden to speak their own languages. A Metis infinity symbol appears above the boy and his face is surrounded by a medicine circle.

Photos courtesy of Ashley Marston

communities. From a large steamed and bent piece of cedar, Luke produced a remarkable carved and painted bentwood box. Through this work, Luke expressed his outrage at the injuries done to his grandmother and other aboriginal children.

One side of the box shows a stylized image of Luke's grandmother, crying silent black tears, with her crippled fingers. Another side shows a Woodlands aboriginal boy with the typically imposed "bowl" haircut. A red hand painted over his mouth, explains Luke, "represents the fact we were forbidden to speak our language, which is why so many native languages are in danger today, with only a few elders still fluent in our language." A Metis infinity symbol appears above the boy, and his face is surrounded by a medicine circle. The third side depicts an Inuit man looking at the Northern Lights, which are said to represent the ancestors dancing in the sky. "The Thunderbird on the back is a symbol common to all First Nations of North America, and it represents the mighty voice of all the people who survived the residential schools," says Luke.

The box became "an eloquent, powerful reminder of the abuses that took place in the schools and their lasting effects," wrote Ronald Niezen in his 2013 book *Truth & Indignation: Canada's Truth and Reconciliation Commission on Indian Residential Schools*. Niezen describes how the side of the box with Luke's grandmother's image was "prominently turned to the audience" at TRC meetings across Canada. At every meeting, the box was filled with pieces of paper representing memories of hurt or

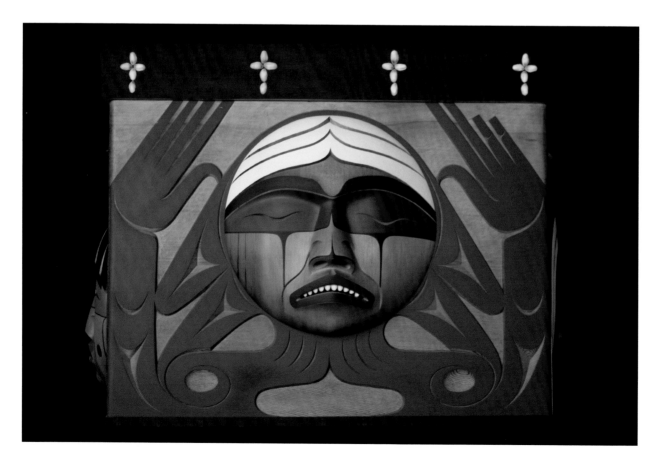

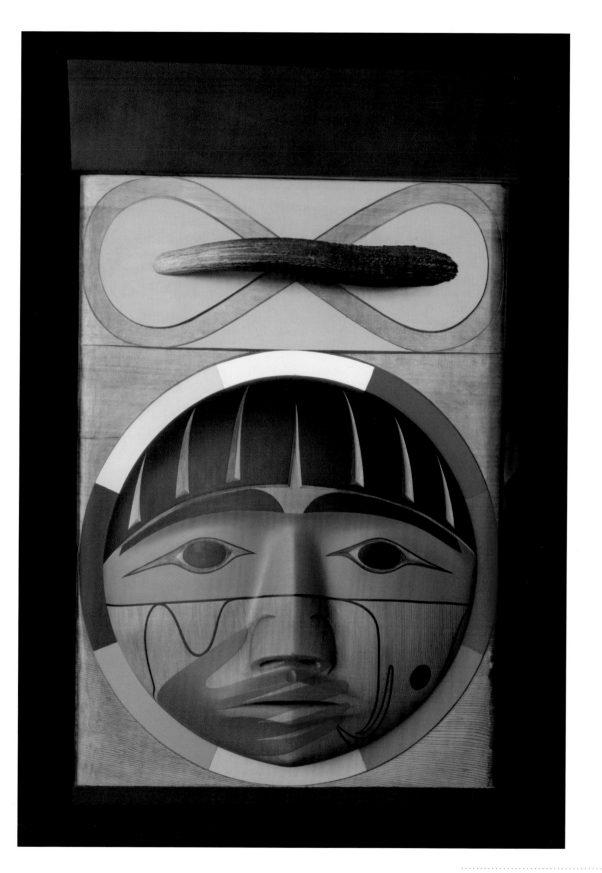

Right: The third side of Marston's Truth and Reconciliation Commission box depicts an Inuit man looking at the Northern Lights, which are said to represent the ancestors dancing in the sky.

Bottom: On the back of the box a carved cedar thunderbird stands as a symbol common to all First Nations, and to Luke "it represents the mighty voice of all the people who survived residential schools."

Photos courtesy of Ashley Marston

At every Truth and Reconciliation Commission meeting this image of Luke's weeping grandmother was turned to the audience. The box was filled with pieces of paper representing memories of hurt or sadness that people wanted to release, becoming a cleansing receptacle for memories and prayers.

Photo courtesy of Ashley Marston

sadness that people wanted to let go. The box would be emptied of tears and pain after each meeting and would fill up at the next. It became one of the most powerful symbols of the TRC, Niezen writes: "In later meetings there was a notable change in the ritual aspect of the box. The material representation of suffering, resilience and cultural recovery were given the additional qualities of sacred power." Luke's box became a cleansing receptacle for prayers, offerings and items of remembrance.

In retrospect, Luke was shocked that he only found out about the cause of his grandmother's crippled hands after he was asked to carve the TRC box. It prompted him to reflect on the impact such cruelty had on successive generations, and on his own. "My grandma was a strong person, but she could be so harsh and so cold to us as kids, and then my mother explained what happened to her in residential school and it all made sense—I could see that's how the schools go on to affect other generations," says Luke. Another elder Luke talked with didn't want to say much about what happened to him in residential school, until almost a year later, when Luke accompanied him to a TRC meeting. "He always used to say the smell of wood shavings when he came to my carving shed bothered him. At the residential school, there was a priest who had a woodworking shop who would select him out and make him and his friend perform sexual acts and bring in other kids to watch and laugh at them," Luke recalled quietly. "This priest was always making wooden chests for the kids to take home but this elder, he took his box and burned it."

Luke says that his grandmother was "a strong and beautiful woman" and had six children with his grandfather, Ernest George Baines. "After he drowned, she supported her family by becoming an oyster farmer, a knitter and a fisher. She showed us that life has many obstacles but we can persevere and become strong, compassionate people." Luke's great-grandmother, Alice Aleck, who married Portuguese Joe Silvey's son Antonio, also went to the Kuper Island Indian Residential School as a child, after her parents drowned. Her Stz'uminus name was Swealt, or small one, and Alice was tiny all her life. Documentation has recently emerged showing that the Kuper Island school conducted experiments on children's diets, feeding some children adequately and deliberately keeping others malnourished.

With the grounding of her mother Edith's indigenous teachings spurring her on, Jane Marston sought out elder Simon Charlie in his nearby Duncan workshop. "Charlie's artistry issued from his deep knowledge of the language, history, oral traditions and ceremonial practices of his Cowichan (Quw'utsun') people rather than from copying older examples of the art forms," writes Barbara Brotherton, the curator of Native American art at the Seattle Art Museum and the author of a seminal 2008 book, *S'abadeb The Gifts: Pacific Coast Salish Art and Artists*. Charlie first emulated Haida and other Northwest Coast art teachers, "but in the 1960s he developed a distinctive, energetic narrative style," Brotherton comments. Charlie, driven by his imagination and need to pass on his knowledge, carved eight hours a day well into his eighties. As Brotherton summarizes, "This beloved artist and elder, who died in 2005, instructed Jane Marston, Joe Wilson, Cicero August and Doug LaFortune and inspired many other Salish artists. He was one of the first Salish artists to achieve wide recognition; his totem poles stand in Victoria, Ottawa, New York, Chicago and Australia and he received the

Order of Canada in 2003." Rebecca Blanchard and Nancy Davenport, directors of the Seattle-based Stonington Gallery, organized an important 2005 show called *Awakenings: A Gathering of Coast Salish Artists,* that recognized the active mentorship in Salish revival by Simon Charlie and Jane Marston, as well the "re-kindling spirit" role played by up-and-coming artists Luke and John Marston. Along with Coast Salish artists residing in the US, Blanchard and Davenport particularly highlighted BC-based Salish artists such as Stan Greene, Musqueam's Susan Point, Penelakut artist Maynard Johnny, Jr. as well as the Marstons in the book *Contemporary Coast Salish Art,* which accompanied the show. In an interview, Becky Blanchard recalled seeking out the young Canadian Salish Marston brothers, about whom she had heard "such exciting reports." Blanchard met Luke and John Marston at the BC Ferries terminal in Tsawwassen, and she was struck by how the brothers could not wait to look at the portfolio of work she was considering for the exhibition. "They were so excited and so enthusiastic about their art, and eager to see the art of other Coast Salish artists, it was absolutely remarkable," Brotherton recalled. "I really had a sense that we were onto a powerful revival and renaissance in an art form. The Marston brothers really had such a deep commitment to the Coast Salish designs and legends, and to their work."

When Jane Marston increasingly studied and drew on her Coast Salish culture in her artwork, her sons—and daughters—became the beneficiaries of her renewed interest and knowledge. Luke and John also began to hang around Simon Charlie's workshop, where they learned by listening and watching the elder work on his often ambitious carving projects. "We talked about artwork all the time, my mum would be sketching out designs on a napkin or at the table and I'd just take it and refine the design and consult with her," says Luke, who often saw a design of Jane's take form in Simon's workshop. As Luke and his brother progressed in their abilities, they were able to help their parents on carving projects and much later, Luke and Jane both helped

Simon Charlie work on a commission of four house posts for a public school in Seattle. While still actively producing her own artwork, Jane also decided to return to university to obtain a master's degree in aboriginal art and history, then became a teacher of art and indigenous culture. Jane also forged links with major galleries, challenging the relatively low prices often paid for Coast Salish art, and began to ship her art all over North America and to Europe.

With his early immersion in Coast Salish culture and art, Luke did not seriously consider another career. He sold carvings to his teachers in high school. After graduation, he moved to Victoria and began carving at a small gallery called Ravensong, where he met and was instructed by the legendary Haida/Nisga'a artist Wayne Young. "Wayne encouraged me at a young age to be more refined and precise in my work," Luke recalls. Young, the nephew of Nisga'a artist Norman Tait, was known for his exquisite, finely detailed designs, which even in those days drew prices that astounded Luke but helped to show him the challenges and rewards of producing "fine art" as opposed to "craft." "He used to call me a 'diamond in the rough,' and he helped me a great deal while working alongside him—I remember him carving just an amazing three-foot bear totem pole, going to the [Royal BC] museum shop with him and seeing it sell right away for a price I couldn't believe. I hadn't sold anything at that point for more than a thousand dollars."

Luke's "undergraduate career," as he calls it, consisted of the five years he spent among a collective of aboriginal artists who carved daily in Thunderbird Park, in a longhouse facility outside the Royal BC Museum in Victoria. The much-respected artist Mungo Martin had presided over a new generation of Kwakwaka'wakw artists in earlier years at that site. Luke found himself among skillful practitioners of Northwest Coast art, although very few of them were familiar with Coast Salish style. He learned refined carving methods in an intense hands-on atmosphere that no art school in Canada could have provided. Working with artists such as Shawn Karpes, Johnathon Henderson and Sean Whonnock, all of whom were at least a decade older than him, Luke swiftly learned strong technique and skills. "Right off the bat I could tell the difference between what was 'craft' and what was 'fine art,'" recalls Luke, noting he had no interest in producing the assembly line designs that clog tourist shops. "They were hard on me, they'd ask, 'Are you really listening? Are you really watching?' but it was the best instruction I could have had."

During that time, Luke played a small part in helping Whonnock and Henderson carve and raise a 7.5-metre (25-foot) pole outside the museum. "Working at the museum was an incredible learning opportunity, because not only did we have mentors, we also were given full access to the museum collection," recalls Luke. His brother John joined him at the museum carving shed in his second year there. "We had security tags and after a while, the museum people got to know us and after they'd let us into the collections where we'd just lose track of time, poring over the Salish and other art, trying to identify pieces and recognizing the styles I'd learned from my mum and Simon Charlie."

Luke and John were also fortunate to have some intense learning time with another highly regarded artist, Art Thompson, who was of both Coast Salish and Nuu-chah-

nulth heritage. Thompson was born in the remote village Whyac, in the territory of the whaling First Nations of western Vancouver Island. Art Thompson's father and grandfather both were celebrated artists who created ceremonial regalia including masks, totem poles and canoes. Thompson learned his culture from his family and was inducted at an early age, along with his brothers and sisters, into the sacred and private Tlu-Kwalla Wolf Society. He also suffered greatly as a child, confined in hospital with tuberculosis from age two to five, and later was sent to Alberni Indian Residential School. Thompson told a courtroom in 1999 that he was "physically, sexually and culturally assaulted," by as many as six former school employees, one of whom he faced directly in court while dressed in his ceremonial regalia. Art Thompson's evidence was uncontested and helped lead to a negotiated settlement for several former students.

Later in life, Thompson took a commercial art program at Camosun College, then began to seriously explore and produce traditional Nuu-chah-nulth design at a time when it had been virtually ignored, much like Coast Salish art. The Marston brothers loved to accompany Thompson to the archives of the Royal BC Museum, looking at ancient Salish and Nuu-chah-nulth pieces. Luke says he "totally respected" critiques of his work from Art Thompson. "Art told me once that I was going to be one of the best artists out there, but I would have to work really, really hard," he recalls. Sadly Art Thompson did not live to see the Marston brothers' work emerge into the top echelons of indigenous art; he died in 2003 at the age of fifty-five.

As Luke directed his work more toward the fine art market, he began to develop

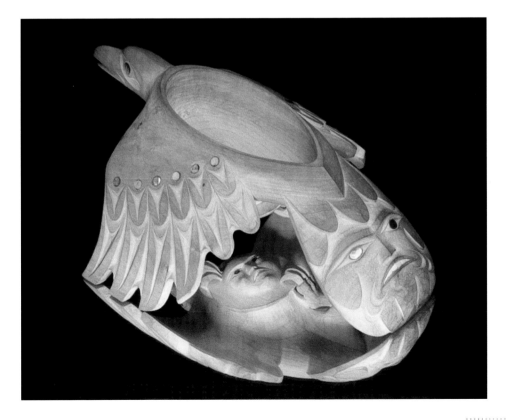

Luke's 2001 sculpture *Raven Stealing the Light*, a carved bowl in alder and abalone, is a depiction of his mentor Simon Charlie's telling of a traditional Coast Salish story. In the story, Raven reclaims the Sun's and the Moon's light from Seagull, thus bringing light to the world.
Photo courtesy of Alcheringa Gallery

relationships with gallery owners and curators. Elaine Monds, an early mentor for Luke, was the director of the Alcheringa Gallery in downtown Victoria, which specialized in contemporary indigenous art of the Northwest Coast, Papua New Guinea and Australia. She appreciated the work of both Luke and John Marston almost immediately. "I remember bringing a mask into Alcheringa in the early days and it was kind of thick still and pretty rough," Luke recalls. "Elaine Monds asked me, 'Can't you hollow it out a bit more?' and then she showed me Tony Hunt Junior's mask. I'd never seen a mask hollowed out that nicely in my life. I was just blown away by how refined Tony's work was. I took mine back to work on it."

Luke knew the world of fine art, especially top-level indigenous art, had high standards, but it suited his own perfectionist drive. "I was always interested in improving my work, learning how to make a line clean and perfect," he says. "Unlike some artists, I never resented the galleries. They need to take a percentage, which can seem like a lot but they also have high costs and overhead. They're buying your work outright and giving you constant feedback. I've always tried to use that relationship with gallery directors who I respect to make my art better." Elaine Monds also curated several shows of miniatures at Alcheringa, inspiring Luke and other artists to work as hard on tiny, perfect figures or canoes as they did on large masks or panels.

Luke had a strong interest in carving in precious metals, even spending time while he was still at school at a Ladysmith jewellery shop near his home. He was especially keen to reproduce complex yet fluidly curving Salish designs in silver and gold. While still at Thunderbird Park, Luke met the Haida artist Robert Davidson, a skillful artist in every medium—including silver, gold, paper, wood and bronze—and one who was considered to be at the peak of his profession and at the leading edge of prices that indigenous art could command worldwide. Davidson refused the first time Luke asked him to take him on as a student. "I was surrounded by so many artists, and I didn't realize that everyone wanted to work with Robert Davidson," recalls Luke. The second time Luke saw Davidson, they were both in an art show, along with Art Thompson. "I asked Robert to teach me repoussé and he said, 'Here's my card, call me and we'll set something up,'" says Luke. "Then I started going to Robert's studio out in White Rock and I'd spend about a week at a time, working with him." Luke's studies with Davidson continued off and on from 2006 to 2008, with Luke learning jewellery and carving techniques and Robert critiquing him. Davidson also mentored both Luke and John, as he has many promising artists, about the realities of the business side of the life of a First Nations artist.

Eager to keep learning, Luke discovered repoussé jewellery instructor Valentin Yotkov, a Bulgarian-born master craftsman who lived in New York. Reached by telephone in New York, Yotkov announced he couldn't help because he was about to leave for Italy to give a week-long workshop. Luke and another young artist, the hereditary Kwakwaka'wakw chief Rande Cook (K'alapa) of Alert Bay, both applied for and got in remarkably short order a BC Arts Council grant of $7,000, which enabled them to jump on a plane and spend two weeks with Yotkov, honing their skills. The two indigenous artists also took time to roam through art museums and galleries in Italy, their visits culminating in the Vatican Museum, standing in intense appreciation of paintings by Car-

avaggio, Leonardo da Vinci, Giotto and Raphael, as well as masterpieces of Roman sculpture. Luke marvelled at the perfection of Michelangelo's famous *Pietà* sculpture, in St. Peter's Basilica in Vatican City, of a youthful Virgin Mary grieving over her dead son, who lies in her arms after the Crucifixion.

Both artists were in awe of the Vatican's spectacular art. Struck by the beauty that surrounded him, Luke threw out his arms to embrace the sun streaming down from a high window in the basilica. Security guards immediately ordered him to stop, and to move away from the light, although Luke had no idea what had been his transgression.

Raised by two Roman Catholic parents, Luke says he could appreciate the peaceful setting, where a choir sang softly. But amid the lavishness of the art, he also started to reflect on the "incredible damage done by the Catholic Church, by some of their priests and people, to every indigenous culture across the world." He urged Rande to take from his bag a mask that Rande had carved and to put it on, inside the basilica. "I wanted to make a political statement to say here we are in the church of all churches, and yes the art is beautiful, but they tried to destroy us, to take away our culture," says Luke. "We know from the residential schools and everything the Church did to us over the years that they didn't value our art, or us as people.

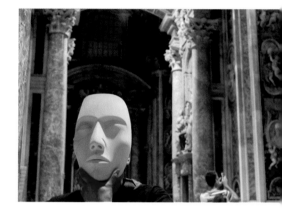

"It wasn't meant to be disrespectful," Luke emphasized, "it was just to make a statement that we survived, and that we're still creating our own beautiful art in our First Nations tradition." Rande Cook put on his mask, and Luke filmed him and took photos. Then Luke went back to the security desk, where he had checked one of the portrait masks he had been working on in Italy, took it back, and also put his on. "Rande was worried they would take our masks away, but I said, 'Ha! That'd be even better, the Church would still be taking away our masks!'" said Luke. In the background of some of the photos of the indigenous artists proudly wearing their masks in the Vatican, security guards can be seen passing by without even noticing what was going on. "It was our statement to the head of the Roman Catholic Church—you tried to wipe out our culture, but here we are," said Luke. "You didn't win."

His appreciation for the zenith of Catholic art was definitely impacted by the fact that he had just finished carving the memory box for the TRC. "The residential schools hurt so many of our people, took away the children, turned the adults toward alcoholism, for generations and generations; and we are still paying the price today for the Church trying to exterminate our culture," Luke says. "Religion was behind the Potlatch Ban, and the ban on making our own masks, practising our culture and speaking our language—it's why we've had to go back and relearn things that our ancestors knew, because our parents and grandparents were afraid to practise their cultural traditions."

CTV's *First Story* program produced a documentary about the two artists' experience in the Vatican and Rande Cook, for his part, wove it into an art show at the Art Gallery of Greater Victoria, which included him wearing his Kwakwaka'wakw mask and regalia not only in the Vatican but in other locations, such as Times Square in New York City.

Visiting the Vatican with Kwakwaka'wakw carver Rande Cook, Luke was awed by the beautiful art but also struck by the "incredible damage" done by the Catholic Church to indigenous peoples' own art and culture. He and Rande donned masks they had carved to say that the Church did not succeed, and that First Nations art is very much alive and thriving.
Photo courtesy of Rande Cook

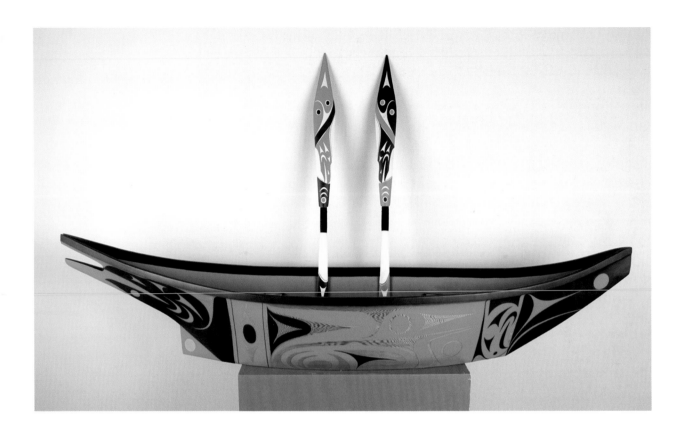

This striking red and black carving of a traditional Coast Salish canoe, complete with standing paddles, was displayed at the Douglas Reynolds Gallery on Vancouver's Gallery Row. Reynolds, who has represented indigenous art for twenty-five years, considers Luke to be among the best West Coast artists. Luke's work commands a premium price and is sold both locally and internationally.

Photo courtesy Douglas Reynolds Gallery

By his early thirties, Luke had begun to sell both jewellery and carvings to top galleries in Vancouver. Melanie Zavediuk, director of the Inuit Gallery in Vancouver, first purchased work from the Marston brothers in 2003. "The level of their technical ability was really impressive, from the beginning, and I was able to buy more and more work from them, leading up to the Marstons' *Honouring the Ancient Ones* show in 2009, which was very successful," said Zavediuk. "They're not only technically astounding, they are also strongly connected to their Coast Salish culture, they've studied the elements of design very diligently." Other Vancouver galleries, including two others in Gastown—the Spirit Wrestler Gallery and Coastal Peoples' Fine Arts Gallery—were already keeping a watch on Luke Marston and buying his work. Soon other galleries began vying for his work, including the Stonington Gallery in Seattle, one of the first to base an exhibition solely on Coast Salish art, and the Douglas Reynolds Gallery.

The career of Luke Marston was on a solid foundation before he agreed to take on carving the monument to his ancestors that would occupy much of the next few years of his life. And it was a journey that would take Luke from his great-great-grandfather's birthplace on the island of Pico, in the Azores archipelago, back to Reid Island where Joe Silvey lived and is now buried alongside Luke's great-great-grandmother, Kwahama Kwatleematt. Woven into the *Shore to Shore* sculpture is a tapestry of symbolism of that journey.

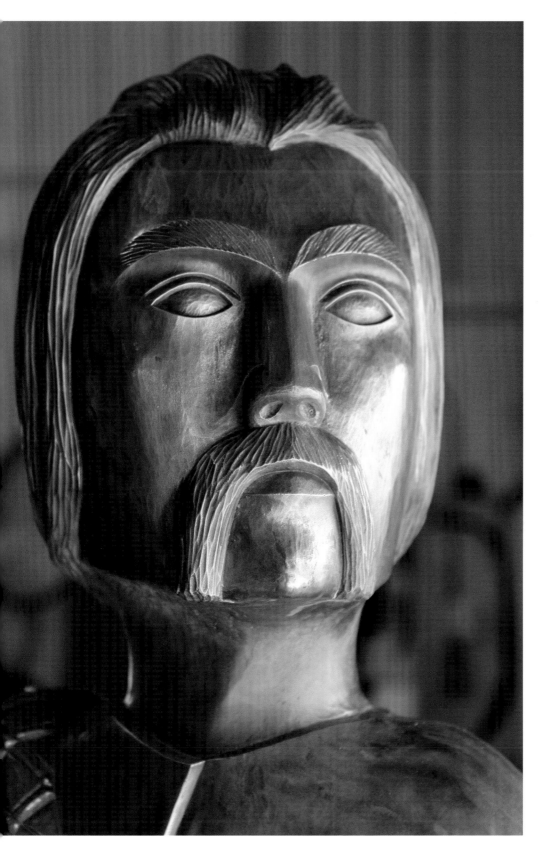

The proud face of Luke's great-great-grandfather Joe Silvey emerges from the bronze-casting process, an exact replica of the original carved by Luke in yellow cedar. The bronzework by the Harman Sculpture Foundry in Red Deer used a complex lost-wax adaptation of the ancient gold techniques of the Maya and Inca civilizations.

Photo courtesy of Jeff Stokoe

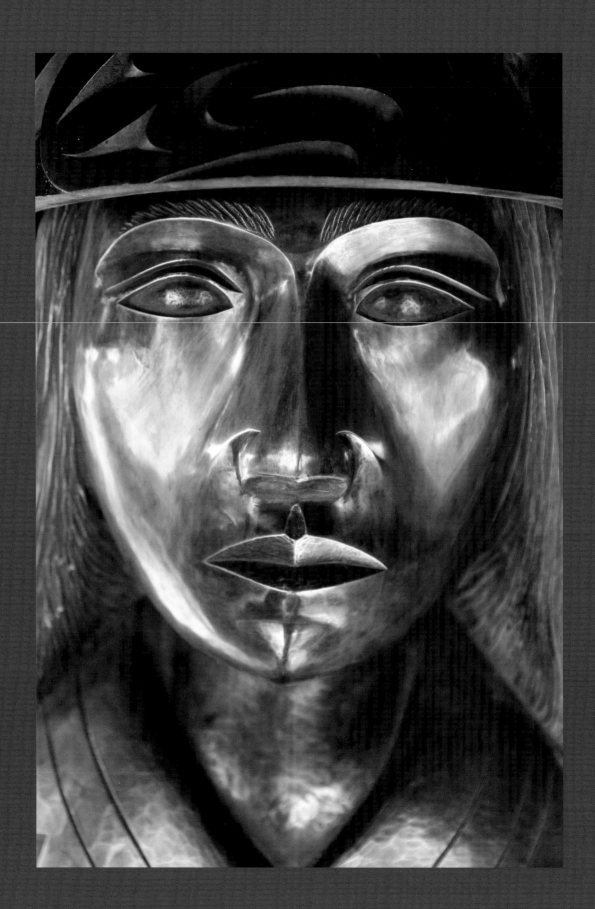

SHORE TO SHORE TAKES SHAPE: CREATING A MONUMENTAL TRIBUTE

2

L UKE'S MOTHER, JANE KWATLEEMATT MARSTON, became increasingly drawn to stories of her cultural and personal history. As she researched oral history and legends to weave them into her artwork, she also began to delve more closely into her family history. Jane was fascinated by tales of her Coast Salish mother, grandmother and great-grandmother, and also of the Portuguese great-grandfather known to her as Portuguese Joe Silvey. The keen interest of the Marston family and the extended Silvey family clan, together with BC's large Portuguese and Azorean expatriate community, came together to make the monumental *Shore to Shore* tribute a reality.

The earliest wave of Portuguese immigration to Canada, in the mid-1800s, was made up of Azorean whalers seeking their fortunes, or even mere survival, abroad. Many young men with few options left in the Azores chose to remain in Canada, and some did go on to become prosperous, playing active roles in BC's resource-extraction industries. Vancouver lawyer Manuel Azevedo, who goes back and forth frequently between Vancouver and his homeland in Portugal, says there were many men like Portuguese Joe. Numerous families in BC can trace their heritage back to Portuguese newcomers who married First Nations women and never left the New World: the Silva family on Gabriola Island, the Bittancourt brothers on Salt Spring Island, and in the Lower Mainland, families were established with names like Cunha, Jorge and Dacosta. Indigenous people had enjoyed a long and prosperous history on the West Coast, but at the time of European influx were greatly diminished in number, their population decimated by waves of smallpox and influenza. Marriage to a European may have been seen as a reasonable option at the time, even for high-born First Nations women who were never before permitted to marry outside their status or tribe. Perhaps their families wanted them to survive and to secure their place in what was clearly going to be a different society.

In addition to well-documented examples of strife, there were also considerable degrees of mutual respect between the two cultural traditions in the early days.

Opposite: Kwatleematt's strong spirit will live on at Brockton Point, 136 years after she and her husband Joe Silvey moved from Stanley Park to Reid Island. Luke's great-great-grandmother used her Coast Salish traditional knowledge and considerable skills as a fisher, food-gatherer, gardener, weaver and net-mender to raise a family of ten children, leaving behind a legacy of thousands of Silvey descendants.
Photo courtesy of Jeff Stokoe

Khaltinaht's Squamish and Musqueam family welcomed her marriage to Portuguese Joe with lavish gifts. His second wife, Kwahama Kwatleematt, who was from the Sechelt First Nation at the head of Jervis Inlet, was married to Joe in both a traditional and legal manner, although she spent the rest of her life away from her own First Nation. As discussions about the *Shore to Shore* monument began to take shape, it was important to what was called the "Portuguese Joe Memorial Society" that the project be as inclusive as possible, of all the Portuguese, First Nations and mixed heritage descendants. This proved to be a significant challenge.

Ramifications of a disputed inheritance of Joe's land persist up to the present day. As in almost any large extended family, not all branches of the Silveys were on amicable terms. When Joe Silvey died in 1902, his ten children might have been well set up for life, had Joe found a way to secure his most precious asset, the land on Reid Island. If Joe had been able to convert what was termed "Lot 35" into a Crown grant, it might have been left to his widow, who was only in her mid-forties when he died. It could not be passed on to Joe's family until about $400 in costs and taxes were paid, and that did not occur. Joe's eldest son Domingo "managed to get Crown grants for the smaller Lots 34 and 36 he had pre-empted, but not for Lot 35, which was sold for unpaid taxes at the end of 1919," wrote Jean Barman. "Domingo used the opportunity to purchase it outright and on that basis secure a mortgage to cover the cost, thereby saving his father's legacy of Reid Island, but to the advantage of his (Domingo's) own family." Domingo lived out most of his life on Reid.

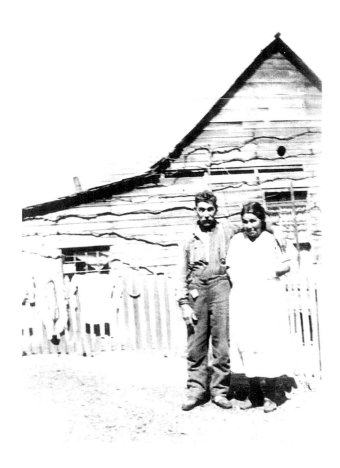

Joe and Kwatleematt's eldest son Domingo and his wife Josephine, standing in front of the house Joe built on Reid Island. Other Silvey family members resented the fact that Domingo managed to secure two Reid Island lots for his own use.
Photo courtesy of Chris Thompson

Antonio, Luke Marston's great-grandfather and a renowned fisherman, also stayed on Reid Island, in large part to care for and comfort his mother, despite his unhappiness at being disinherited. It was Joe's second son, Joseph, born in 1879, who in about 1904 began an exodus to Egmont, on the Sechelt Peninsula, where his father was said to have spent a few years living and fishing in Jervis Inlet. Later, Portuguese Joe's son Henry followed Joseph to Egmont, where the family acquired a saltery—similar to the Japanese-owned salteries the family had known on both Reid and Galiano Islands—and built a "family compound" where various family members came and went. In the end, a substantial branch of Portuguese Joe's extended family moved to the Sechelt Peninsula, closer to the home where Kwatleematt had been born. Joe Silvey was known to have ranged up and down the West Coast, logging, fishing and working at other resource industry jobs, and many of his descendants followed the same life path. Almost all of his children and grandchildren would have become familiar with the Gulf Islands, Vancouver Island and the

Lower Mainland. It is no surprise that most of Joe Silvey's descendants eventually settled in the towns and cities of southwestern BC. For the most part, however, that family contingent did not remain in close touch with the Sechelt Silveys.

To Luke, who grew up two generations after the family's dispute over Reid Island, "it's absolutely crucial and very important to me that there is representation of all the Silvey descendants at the unveiling of the sculpture, because it is a tribute to their lives as well. I don't want to minimize what may have been the source of the resentment long ago, but in this new generation, and in my daughters' generation, I would really like to see us go forward together, to honour Khaltinaht and Kwatleematt, and Joe." Luke also felt strongly motivated to recognize and honour the foremother whose ceremonial name had been given to Jane Marston in 1994.

Reaching out to the Portuguese and Azorean communities in BC, Luke discovered some generous and energetic individuals who were able to play a significant role in funding the sculpture and its proper installation. The first spark of interest in creating a monument to Joe and the Coast Salish women he married came from several members of the Silvey family, including some who settled in Sechelt. However, plans proceeded more quickly with descendants of Domingo and Antonio, partly because their families remained in closer geographic proximity to each other on and around Vancouver Island and the Gulf Islands. Luke's great-aunt Eunice Weatherell (Domingo's granddaughter) was a key force in getting the commemorative project started. Eunice, who spent the first twenty years of her life on Reid Island and now lives on Saturna Island, was a contributor to Jean Barman's book, providing photographs and stories from her childhood. Eunice went on to travel to Pico Island in 2011 and self-published her own book in 2013, called *Walking in the Footprints of Portuguese Joe Silvey: Reid Island Connections.*

An original grave marker for Joe Silvey, made on Pico, had been given to Eunice for safekeeping, but Eunice wanted a more public tribute to the contributions of her great-grandfather. Eunice and her cousins Chris Thompson and Marie Bell Gabara decided to present the grave marker to the Ladysmith Museum. On May 15, 2010, the Ladysmith and District Historical Society hosted a celebration to honour Joe Silvey, with speakers that included Eunice, Professor Barman, Carlos de Sousa Amaro, who was Portugal's consul-general in BC, and Ladysmith mayor Rob Hutchins. The Ladysmith Historical Society has since established a place of honour in its museum for artifacts from the lives of Joe Silvey and his extended family. It was a first step toward what Eunice hoped to achieve: a major stand-alone tribute.

In August 2010, Eunice, her cousin Chris Thompson and other family members held a fundraising seafood dinner in Ladysmith. Eunice held the proceeds in trust until a project could get off the ground. In 2011, the Portuguese Joe Memorial Society was organized as a non-profit society to pursue a commemorative project. The board members of the society included Jane and Luke Marston, as well as Jane's daughters Karen Marston and Angela Marston, Angela's husband and community fundraiser Miles Phillips, and Melanie Martin from Vancouver Island University. Angela is a gifted artist herself, creating exquisite rattles and paddles with Salish motifs that have been shown in top galleries. Melanie had been a teacher of Jane's at VIU, and the two remained in

touch after Jane obtained her master's degree from the University of Victoria and then became a VIU teacher herself. A working committee was also set up for the day-to-day work on the project, and that included Jane and Luke, Portuguese consul-general Carlos de Sousa Amaro and Jean Barman, along with Victor Marquez and Fil Jorge from the Portuguese-Canadian community. Eunice turned over the proceeds from the seafood dinner to the new non-profit society and the extended Silvey family officially gave its blessings to the Marston project.

The Marston family debated at length how exactly to honour the legacy of the Coast Salish family of Joe Silvey. As a family with considerable artistic talent, their thoughts immediately turned to sculpture; not a painting or a plaque but perhaps a likeness of Joe and his Coast Salish families. "We are all carvers, this is what we do, so the thought always was to carve a sculpture of the people involved, and illustrate the important elements in their lives," recalls Luke. He began sketching designs, a task not easily done by committee, and eventually it became clear he would be the primary artist on the project. The first scale drawing of the sculpture Luke produced had the three figures, Joe, Khaltinaht and Kwatleematt, almost 6.5 metres (21 feet) high. "Then Miles looked at the composition and he thought the scale was not very interactive, that the figures were too high up for the viewer," Luke says. "I scaled the figures back to life-size."

Luke explains his working design for the *Shore to Shore* sculpture, with the figures of Silvey, Khaltinaht and Kwatleematt standing under a three-finned cod lure, topped with a carved eagle head that also references the Portuguese *açor* bird.
Photo courtesy of Jeremiah Armstrong

Luke chose for the three figures to stand under a three-finned cod lure, topped with a stylistic Salish eagle head that also referenced the Portuguese raptor, the *açor*. The three fins of the cod lure, with the carved eagle head atop it and a pedestal below the sculpture, came to a total height of just over 5 metres (16.5 feet). The working committee also liked the lower height, especially once they heard estimates of the possible cost of the sculpture.

Jane Marston suggested to Luke, who had begun to bear most of the responsibility for carving the sculpture, that they should retain landscape architect Clive Grout, with whom she had worked on a commission for the Vancouver International Airport. Clive, who had extensive experience in public art installations and working with governments of all levels, was a welcome addition to the team and the working committee. "Carlos de Sousa Amaro wanted the sculpture to be in a place of respect, and my mother and others were really clear that the sculpture had to include the female figures as equally influential figures and to honour their Coast Salish identity," says Luke. There was some consideration of Gastown as a location for the sculpture, since that was where Portuguese Joe had run his Hole-in-the-Wall saloon, but Stanley Park was even more relevant and significant, since Joe had lived there with Khaltinaht, and her people from the Musqueam and Squamish First Nations were among the traditional occupants of that land. And Joe had lived on at Brockton Point with his two young daughters Elizabeth and Josephine after Khaltinaht's death, and then for a few years more with Kwatleematt, after they began to raise their own family. Their two oldest children, Domingo and Mary, were both born at Brockton Point.

From the outset, Luke believed the finished sculpture should be cast in bronze, for its longevity, its lovely patina and its majestic appeal. Clive Grout supported at least partial bronze, although some committee and board members worried about the price tag. "People's jaws were dropping when they heard the bronze could add hundreds of thousands of dollars to the cost of the project," Luke admits, "but everyone agreed it would look absolutely amazing as a bronze monument in Stanley Park."

By the end of 2011, Luke realized that he would have to work full-time on the sculpture for it to become a reality and to meet the high artistic standards that he customarily set for himself. The carving and assembly of the original cedar sculpture would be all-consuming, although Luke got some expert assistance along the way from Jane and his brother John, as well as a young Cree carver named Josh Shaw. Keeping on top of the political, logistical and bureaucratic details, including making sure that he kept in touch with the Musqueam, Squamish and Tsleil-Waututh First Nations and the Silvey clan, became a full-time job for Luke. He told the Portuguese Joe project backers—and disappointed gallery directors—that he would be turning down all other commissions and dedicating himself to realizing his family's dream.

Luke also began doing research on how to integrate a Portuguese influence into the Coast Salish design of the sculpture, talking to Carlos Amaro and researching online and in books. "When Carlos told me about the beautiful designs on sidewalks in Portugal, I thought that would be perfect. There are roads all over Europe made from stone from Portugal. I designed a curving circle of waves to represent 'shore to shore,' from the Atlantic to the Pacific Ocean, and I really wanted that circle around the entire

sculpture to be done from Portuguese stone, using a Portuguese stonemason." Carlos Amaro began negotiations with the Portuguese and Azorean governments to ship the necessary tons of black and white stone for the sculpture's base.

As a fundraising effort, Luke designed a run of four hundred prints of the central *Shore to Shore* design, which were sold for $200 each. The prints were also intended to be gifts to single donors of large amounts, or to organizations. Both sources of money would have to be forthcoming for the project to succeed. The demands of producing the sculpture meant that Luke was taking a financial hit, without enough time away from the project to produce and sell his art to support his family. Luke was living on the hope that his brother-in-law Miles, an adept fundraiser for many community organizations, would be able to find a government program or private donor to underwrite much of the cost. "I kept telling Miles that I didn't have too many financial options left, but he had put in grant applications and he was very hopeful about one from the federal government so he'd say, 'Just hang on, Luke, it's going to come through,'" Luke recalls. "Miles just believed 100 percent in me and the project."

Now that the project backers were certain they wanted Stanley Park as a site for the sculpture, Luke and some of his committee members had to engage in discussions with, and obtain approval from, the Vancouver Parks Board. Luke, Clive and Miles first

This black and white image, created in stone mosaic for the base of *Shore to Shore*, was also produced as a fundraising limited-edition fine art print, selling for $200 or given to donors and supporters as a gift.
Image courtesy of Luke Marston

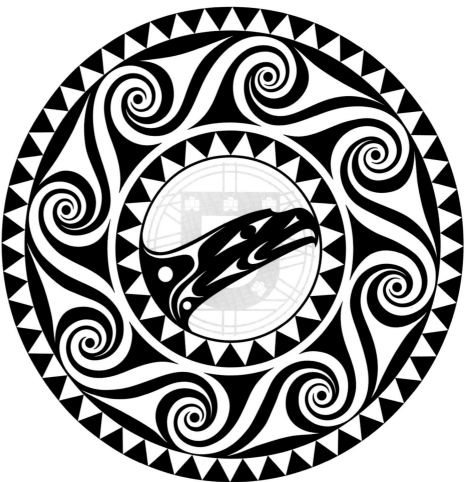

met with jil weaving (she does not capitalize her name), who was the chair of the Parks Board's Arts, Culture and Environment Committee, and other Parks Board staff. Eventually jil also agreed to sit on the Portuguese Joe Memorial Society's working committee but she was very forthright and set out some challenging issues at the outset. "I told jil I wanted to put this fairly big sculpture in Stanley Park, at Brockton Point, and she responded that I had chosen the most difficult site in the city of Vancouver," Luke recalls. "She said getting a piece of public art in Vancouver is hard. Getting a piece of public art in Stanley Park is even harder. I was told that I needed to have art that is visually appealing, that has cultural content or historical relevance to put it where it will be, and to have the blessings of the First Nations." The Parks Board had agreed to consult on every major disturbance in the park with all three urban First Nations. Luke was advised by the Parks Board to go cap in hand to seek approval from the indigenous governments involved, although he had already promised his elders to follow just such a protocol, and had already taken steps along that path. Luke was confident that the *Shore to Shore* sculpture met all of the challenges set out by the Parks Board.

Competition for prime public art placement is also fierce among artists. Almost every person or organization donating public art in Vancouver wants their work to be located in Stanley Park. The standard for public art has to be very high as well, jil weaving told Luke and the committee. Another challenge was presented by the fact that the Vancouver Parks Board has no budget to buy public art outright—all major pieces of public art must be donated. Donors, usually non-profit organizations, must not only apply to the Parks Board for the privilege of donating art, but they must also agree to pay in advance for its upkeep, forever.

Despite that steep financial and political bar, Luke and the members of the Portuguese Joe Memorial Society board and working committee were all certain that Stanley Park was the only option. The Parks Board agreed to enter into a public consultation about the sculpture, and a formal design plan was submitted to the board by Clive, Miles and Luke. In May 2013 the Parks Board announced that the *Shore to Shore* sculpture had the green light and the project received a flurry of attention in the media, including a front-page story in the *Vancouver Sun* on the same day as a provincial election.

With the assistance of a spiritual leader, usually elder Willie Seymour, Luke set about making personal visits to each of the three First Nations, readily obtaining strong letters of support, although no offers of financial backing. "Everyone I spoke to in the three First Nations embraced the project with open arms," says Luke, although the strongest challenges to the project siting had yet to be heard. In the end, the primary objection to the first site came from one of the three aboriginal communities, but all of them had stringent conditions as to where *Shore to Shore* would eventually stand.

For Luke, however, the formidable workload he faced, outside of officialdom and politics, was barely underway. He knew that he wanted the original sculpture to be carved from yellow cedar; its structural integrity and clear, beautiful grain made it ideal for carving details such as human faces and ceremonial regalia. Luke had already amassed a significant stockpile of cedar with his brother John. Luke's father-in-law, John Miller, was a logger with a firewood permit who often found large pieces of cedar

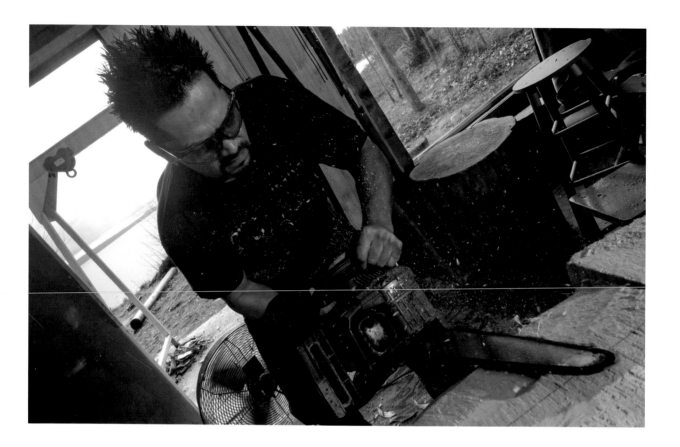

Luke had access to beautiful pieces of cedar, from several sources, including salvaged logs people brought to him and pieces gleaned from old logging sites. Much of the yellow cedar used for *Shore to Shore* came from supplies Luke had on hand.

Photo courtesy of Jeremiah Armstrong

and logs, and would set aside "nice chunks of wood" from logged areas for his son-in-law's carving shed. Much of the yellow cedar to be used came from Luke's longtime stash, but some of it had to be purchased, which was another key expense. Luke decided that the figures would have to be assembled in pieces and laminated or glued together, rather than carved from a single piece of wood, in order to increase the strength of the sculpture and minimize splitting or large cracks.

In Luke's carving shed, the figures of Khaltinaht and Kwatleematt, each holding a fishing net needle and a mat creaser, and of Joe, with his whaling harpoon and salmon in his hands, began to take form, with Jane, John and other members of his family lending a hand. Young men hoping to start a career as carvers came to apprentice and help. Some evenings, the lights burned until late at night in Luke's carving shed, and were reflected through high windows into the calm waters of Kulleet Bay.

And just as Luke was seriously worried about finances, Miles Phillips came into his shop with a substantial cheque in his hand from the Canadian Legacy program run by Canadian Heritage. Jean Barman had written an influential letter supporting the application by noting that the project would commemorate the one hundred and fiftieth anniversary of Portuguese Joe Silvey's arrival in Canada. The cheque was for more than $250,000, and it came as a huge relief for Luke. However, that money had to be matched by the community and every cent would be needed for carving supplies and costs. It was time for major outreach into the Portuguese-Canadian community,

which was following the progress of the project with interest. And Miles's funding coup was a much-needed morale booster, as Jane Marston had been forced to pull back from helping with the project. She was facing major surgery and would be in fragile health for much of the next two years.

Less than a year after Miles secured the federal grant, however, tragedy struck, with a devastating effect on the project. On January 23, 2014, Miles was killed in a single-vehicle accident near Duncan, BC. A non-native man with little birth family of his own who had happily married into the Marstons' large gregarious family, Miles would be greatly missed. He had been close to finishing his MBA studies at Vancouver Island University when his small car left Telegraph Road on a densely foggy morning. The local newspaper, the *Cowichan News Leader*, called him "a quiet, smart push behind Cowichan's emotional, spiritual and economic health." Only forty-eight, Miles left behind a deeply grieving wife, Angela Marston, and the couple's two young daughters. Jane Marston, who by this time was recovering from her second major surgery and was temporarily living with Angela's family, stayed on to help her daughter. At a memorial service for Miles, held in Duncan, the three Marston brothers—Mike, Luke and John—stood up together to talk about Miles's contribution to their lives. In a later interview, Jane reflected: "Miles was a very giving and loving person and he genuinely loved to help people and organizations in whatever way he could." Jane also paid tribute to the help Miles had given Simon Charlie in trying to get a project of his funded. In an interview she gave to a local newspaper, Denise Augustine, Jane's eldest daughter, honoured Miles's cheerful and playful nature, as well as his serious side. "Family mattered to Miles," said Denise. "Miles's loss is a huge one to our family and to the community—he cared about the future of this planet."

The Marston family had lost a beloved husband, father, son and brother, and Luke's project had also lost a key supporter. It required major repositioning to recover some of Miles' important information. Fortunately, Luke could was able to rely on long-time family friends Keith and Judy Scott. Keith, a respected businessman and owner of Beachcomber Hot Tubs Ltd., had been a mentor and major patron of the Marston family. Already a financial backer of Shore to Shore, Keith had become a astute collector of indigenous art after purchasing when he was only 25 a carving from Simon Charlie. Luke deeply appreciated being able to count on Keith and Judy's warm support and advice. Keith donated to Luke the crucial services of his skilled accountant Almero van Wyk, and the project soldiered on.

Even as he toiled away in his carving shed on the slowly progressing sculpture, Luke knew that although the cost and effort of producing the cedar original was going to be considerable, casting it in bronze was going to be equally or more costly. Clive had suggested using the foundry of the late artist Jack Harman, who had created some of Canada's most beloved sculptures, including the *Themis, Goddess of Justice* sculpture at the Vancouver Law Courts; *The Family*, a bronze sculpture formerly outside the offices of the *Vancouver Sun* and *Province* newspapers (now located at their printing press in Surrey); and the striking Terry Fox sculptures at BC Place Stadium, which were designed by Douglas Coupland and finished at the foundry by Harman's son Stephen after Jack's death in 2001. Significantly, Jack Harman had also cast a bronze sculpture

of famous Canadian runner Harry Jerome, which was installed on the water side of the Stanley Park road at Brockton Point, and would be the nearest neighbour, hopefully, to *Shore to Shore*.

Luke's first choice of a foundry, however, was no longer located in BC. In 2009, Stephen Harman had relocated the enterprise to Red Deer, Alberta. The distance would add cost and serious logistical barriers to the *Shore to Shore* project, including the issue of how to get the cedar sculpture to Alberta. It would be used as a mould for the bronze, but Luke very much wanted it returned in good condition, so that he could restore the cedar original to its former glory. Then there was the issue of how to ship from Alberta and assemble in Vancouver a bronze sculpture weighing 1,800 kg (2 tons). However, Stephen Harman was keen to take on the *Shore to Shore* commission, including the transport and assembly of the final sculpture, and assured the committee that he had never missed a project deadline.

The casting process became an ongoing challenge for Luke. The pieces of the yellow cedar sculpture were too large, precious and fragile to send as freight. Luke made several trips to Red Deer to consult with Stephen or drop off cedar figures, and to take them home. Exciting as it was to see each piece emerge from the foundry, there remained the final goal of uniting and assembling the massive bronze sculpture by May 31, 2014—which, like the previous September 2013 goal, clearly was not going to be possible. As the bronze pieces emerged from the foundry, they had to be cleaned, sanded, burnished and polished to the correct patina. When Luke was there to see pieces of the sculpture emerge, however, he was "just blown away": "They were so stunning, the ladies and the details on their clothing and faces, the Chief Joe Kiapilano crest on Khaltinaht's cod lure fin, Kwatleematt's woven cedar bark hat. To see your own work emerge like that, in another medium, it was everything I'd dreamed of."

By early July of 2014, the bronze casting was at last nearing completion, save for a few connecting bolts. Stephen Harman explained in an interview that the finished bronze would weigh close to 1,800 kg (2 tons). It would be assembled in Red Deer and shipped directly to Stanley Park. Harman said he cast the three fins of the cod lure first, followed by the eagle head at the top of the whole piece, known as the Unity Head for its stylized reference to both the Canadian eagle and the Azorean *açor*. Then the two female figures were cast, and finally Joe. Explaining the complex casting process, Harman said the original cedar figures were painted with a silicone rubber, then reinforced with a plaster mix called "the mother." Once it was set, the rubber was peeled off, creating a negative mould. "If I'm doing the head of Joe, it's done in two halves, with the face and head split open, then I paint a quarter-inch of wax on each half, put the moulds together and flush the whole thing with wax to fill the frame," said Harman. Then the piece was covered with a clay mix known as "solid investment," which sets in about an hour. The mould is filled with solid investment and little wax rods or tubes, called gates, are attached to various spots on the sculpture. The whole piece is again covered with wax and more solid investment. Harman explained the goal is to build up both a hard ceramic interior and exterior lining, in layers, which will be reduced in size once the wax has melted away. Once covered, it goes in the kiln for a week, at temperatures rising gradually to 650 degrees Celsius (1,200 degrees Fahrenheit), said

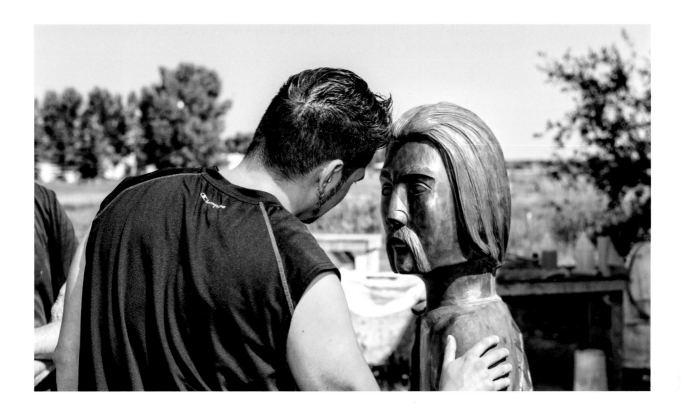

Harman. At such high temperatures, the clay becomes a hard ceramic and the wax melts, evaporates and eventually disappears without a trace. The process is a variation on the ancient "lost wax" technique used in the Aegean region in the Bronze Age, during the second millennium BC by the Etruscans and Egyptians, and then by the gold masters of the Incan, Aztec and Mayan civilizations.

The final stage is when molten bronze is poured in through the gates to cover the entire structure, in a "melt furnace" known as a crucible, fired to a peak of 1,150 degrees Celsius (2,100 degrees Fahrenheit). The crucible is fired for twelve hours overnight, and the next morning the ceramic material is broken away and the gates, now bronzed, are cut off with grinding equipment. Harman said he uses a bronze alloy that is 94 percent copper, and about 4 percent silicon (the element), which is used as a flowing agent. "My bronze gives a beautiful rich, red, metallic colour, as opposed to a purer copper alloy or brass, which is too yellow—it's particularly suited I think to First Nations art," said Harman. There are a seemingly infinite number of things that can go wrong in the complex process of transitioning from cedar to silicone, wax, ceramic and bronze, from too much sand in the solid investment to cracks and ruptures in the firing process. These outcomes can be costly in lost time and money, both for the foundry and the artist.

The bronze casting process was complex, the logistics of site approval from First Nations were challenging and the project constantly needed funding. Not only did Luke have no time to create work for sale, he and his wife Stacy Miller had already invested at least $150,000 of their own money, including remortgaging their home. Stacy, who

At a critical stage in the production of the sculpture, Luke looks into the eyes of his great-great-grandfather Joe Silvey as his bronze figure finally emerges from the Harman Sculpture Foundry in Red Deer, AB. Despite significant challenges in the bronze casting process, Luke admits he gets a thrill from seeing the life-size figures take form.
Photo courtesy of Rob Berrade/Matador Photostudios

had always strongly supported Luke's chosen life as an artist since their earliest days together in their late teens, was essential to Shore to Shore's success, even if after four years of living with the project she preferred another topic of conversation at home. "I am grateful that Stacy, and our girls, were there for me in every way with Shore to Shore, all the time and money I had to put into it, for so long," said Luke. Meanwhile, the stakeholders were clamoring for an installation date. Lead time was needed to issue invitations to the unveiling, especially to First Nations, the extended Silvey family and the Portuguese community, both in Canada and from overseas.

Luke had finally acquired some important Portuguese-Canadian backers of the project, who would bring a much-needed infusion of both energy and cash. It seemed that whenever the project hit a roadblock, another door would open. Fil Jorge, the founder of Avante Concrete, who was very active in the Portuguese-Canadian community, said he first heard of *Shore to Shore* from his wife Maria, who was president of an expatriate group called Amigos do Pico. "She came home all excited about the project," said Fil. So he emailed Luke and offered to donate the construction costs for the sculpture. Working from drawings, Fil estimated site preparation and building the base for the massive sculpture would cost at least $30,000. Clive Grout accepted the estimate and a proud Fil told Luke that "they could count on Avante Concrete and the Jorge family for the in-kind donation." As Fil later put it, "The rest, as they say, is history."

An ebullient and energetic Fil then realized that there were very definite fundraising opportunities in the Portuguese community and began to actively seek funds, assisted by another contractor, Jack Cunha of Astra Concrete. In all, at least $200,000, including in-kind donations, was raised from the large Portuguese-Canadian community, which was galvanized by Fil's enthusiasm for the project. Luke had wanted all along for the mosaic stonework on the base to be done with Portuguese stone, by an Azorean stone-mason—a tall order that Portuguese consul-general Carlos Amaro had been working to fulfill. All over the Azores, sidewalks and plazas sport magnificent designs carefully worked out in patterns of black, white and grey. In fact, the intricate patterns found on roads and walkways all over Europe originate from a Portuguese tradition and almost invariably, Portuguese stone is used. "I thought, my God, it will take forever to get this stone here as the wheels of bureaucracy turn very slow in Portugal, but Dr. Amaro had done a lot of work and the stone came faster than I ever thought!" said Fil. The Portuguese Foreign Affairs Ministry department, through its consular and community affairs department, stepped up to pay a total of $5,500 for the stone and shipping costs to Vancouver. Then the perfect Azorean stonemason was found, a man named Carlos Menezes, who had learned the trade from his father and grandfather. Luis Silva, another friend of *Shore to Shore*, was able to convince the Azorean airline SATA International to pay for Carlos's flight from the Azores to Toronto, and Avante Concrete picked up the tab for his travel from Toronto to Vancouver.

Menezes was known for creating a beautiful plaza in the city of Ribeira Grande on the Azorean island of São Miguel. Luke would later meet Carlos to admire his handiwork and invite him to come to Canada. On the trip home from the Azores, Luke's entourage brought Carlos with them to complete the circular *Shore to Shore* base, of curving waves.

However, the Stanley Park site had not yet been approved by the three First Nations, and there was nowhere to put the 25,000-kg (27-ton) base Carlos was supposed to build. Fil stepped in and made provisions for Carlos to build the base at Avante Concrete's Surrey property, which is also the site of Fil's small working farm. Carlos Menezes,

who had never been outside the Azores and had a humble background, was captivated by the story of Portuguese Joe, and although he used his vacation time to come to Canada, he refused to be paid for his hard labour on the base. Fil and his family provided for Carlos and treated him to a trip to Tofino to see the vast expanse of the Pacific Ocean. "He did a fantastic job with the stonework; it will look great for many, many years, with maybe millions of people walking over his work," said Fil Jorge.

Then the installation site for the sculpture had to be confirmed. Protocol dictated that the three First Nations could have archaeological observers or technicians on site as test holes were dug and the soil was sampled. The Parks Board public consultation on the statue had been based on three possible locations at Brockton Point, and none of them had been ruled out. Clive Grout and Miles Phillips had produced a brochure that set out the preferred site, close to the water on the south side of the park perimeter road. But Luke said when he visited the park to look at the possible sites, he had a gut feeling that the correct place would be south of the road that rings the park, to the left of the pedestrian walkway, facing downtown Vancouver and Coal Harbour, and just southwest of the Harry Jerome statue. It was near there that a First Nations village had been located, and after that it was the site where mixed-race families like Portuguese Joe Silvey's chose to live. Joe had built a house very close to Luke's preferred spot, where he fished for salmon, herring and other bounty in the small bay, according to historical sources such as interviews with his eldest daughter Elizabeth, Khaltinaht's daughter and the first baby of European origin to be born in Vancouver. Elizabeth gave extensive interviews to Vancouver's first archivist, Major J.S. Matthews, about her recollections of her child-

hood and her life, part of it at Brockton Point, for the Vancouver Archives. But both the Parks Board and Luke were adamant that First Nations had to have the final say on a choice of site, and it would be the First Nations' concerns about Luke's preferred site that dictated a new site had to be chosen.

On a bright early morning in March 2014, all parties finally assembled at Brockton Point to test the soil for evidence of archaeological artifacts from First Nations use. Most importantly to Luke, Xalek, from the lineage of Xatslanexw, Squamish hereditary chief and councillor Ian Campbell had agreed to attend before the testing began, to say a prayer and a blessing, thank the ancient ancestors who once lived there and promise they would not be disturbed. Campbell is one of sixteen hereditary chiefs and councillor of the Skwxwú7mesh Úxwumixw (the Squamish people, villages and community), and the nation's cultural ambassador and negotiator for its intergovernmental relations department. A consulting engineer from Thurber Engineering Ltd. and Vancouver Parks Board site manager Steve Wong attended, as did Sarah K. Smith from the engineering consulting company AMEC. Smith had experience working with First Nations on projects where development might clash with aboriginal culture or archaeological interests. Fil Jorge, who had donated all of the site preparation services, was there with a small excavator to open the surface of the proposed site.

Each of the three First Nations sent an observer. Richard Campbell from the Musqueam First Nation had worked as an archaeological technician on the BC government's massive South Fraser Perimeter Road project, which traversed First Nations territory, and had not surprisingly turned up indigenous artifacts and human bones, which were removed to be assessed and stored properly. The First Nations received compensation and land swaps and the ring road was duly completed. Cece Wyss attended the Stanley Park archeological investigation on behalf of the Squamish First Nation and Darrell Guss was the observer for the Tsleil-Waututh First Nation. As the first layer of soil was peeled back, Sarah Smith directed that all the soil be carefully shaken through one sieve set up on a tripod beside the site, along with several small hand sieves used over tarps. Already taped off, the site was further marked with fluorescent orange paint. Almost immediately, the sieving turned up evidence of human occupation, mostly from a "pioneer" or post-European-contact era. There were square nails, and bits of thick, broken green glass and milk glass, indicating the soil had already been disturbed, although relatively recently, probably within the last 150 to 200 years. The first 30 cm (12 inches) of soil turned up mostly settler artifacts, but the next 60 cm (24 inches) of soil quickly revealed what appeared to be an intact archaeological stratum. Bits of nondescript stone fragments looked unremarkable in the sieve, but Sarah immediately recognized them. They included slate knives, fragments of thin stone with a sharpened edge, as well as points that she believed to be from a seal harpoon toggle. A dolphin vertebra indicated other marine mammals had also been hunted in the area for food. Although Sarah was reluctant to estimate an age for the stratum of soil at 30 to 90 cm (12 to 36 inches) deep, she thought it might be from about 2400 to 1600 Before Present, an era carefully explored by eminent BC archaeologist Charles Borden. Dubbed "the grandfather of archaeology," Borden first confirmed that the Marpole Midden in South Vancouver contained ancient artifacts and bones that were directly connected

Opposite: Stonemason Carlos Menezes had never been outside the Azores before, but came to Canada to create the mosaic at the base of the sculpture in the Portuguese style. Although he came during his vacation time, he refused to be paid for his work.
Photo courtesy of Kim Stallknecht

to modern-day First Nations. But Sarah's tentative dates were only estimates, pending accurate carbon dating. The test site was completed all the way down to 90 to 100 cm (36 to 40 inches), in a bid to locate completely undisturbed or sterile beach sand, but even the deeper levels revealed carbon from very old fires. There were also what looked like

traces of reddish-brown ochre, a pigment associated with Coast Salish ceremonial sites. Both carbon and ochre help to determine the age and character of a civilization.

No human bones were found in Stanley Park that day, which was a relief for Luke, who was on the phone from Chemainus with various people at the site. "There is no question that it would not have been right to disturb ancestors if that was their resting place, if anything at all had been found," he said later. In addition to being the site of a mixed-race settler village and a turn-of-the-century graveyard, Brockton Point is known to First Nations primarily as an ancient burial site. Archaeologists called in within the last few years to supervise park roadwork had swiftly discovered human remains, apparently those of a young girl buried inside a little fenced area, beneath a large tree. The original park road that was pushed through in the 1880s while indigenous people and others still lived in the park had been built on top of massive middens, primarily deep caches of white shells, indicating millennia of aboriginal occupation and use. The high calcine content of the middens made them ideal for the base of the perimeter road and the park concession stand, park planners had decided. Roadwork crews came across so many aboriginal burials when the first park perimeter road was built that they either paved over them or boxed up the bones and put them by the side of the road for indigenous people from the Musqueam, Squamish or former Burrard communities to pick up at night.

Jean Barman, also the author of *Stanley Park's Secret*, pointed out in an interview that she had walked through the park with an archaeologist who told her that virtually anywhere he put a shovel, he would uncover artifacts. The park peninsula was so heavily used, for so long, by First Nations that it was virtually all a midden. At the same time, all the park buildings, such as restaurants, pavilions and gift shops, not to mention monuments, sports facilities and the large Vancouver Aquarium, have all gone ahead with little to no consultation with First Nations. Nor was the Parks Board ignorant of the First Nations heritage in Stanley Park, from the time that the first Coast Salish village sites were knocked down to build the Park Drive perimeter road, to a series of archaeological surveys done over the years. Just one, by Sheila Minni and Michael Forsman in 1995, found four new archaeological sites, expanded the boundaries of five of the seven previously known sites and recommended further investigation of the historic uses of the park by First Nations.

Although the *Heritage Conservation Act* in BC purports to cover protocol in the event that First Nations artifacts or human remains are discovered, the act has weak spots and loopholes. First Nations complain that the discovery of one of their burial

sites means a slight delay for the developer, before the bones are removed, in stark contrast to a dead stop should a post-contact graveyard be disturbed. The conversation at the sunny Stanley Park site that day in March turned to many examples of such perceived inequity. One technician had recently found a nicely carved stone adze, at a Fraser River site, while others had come across at various digs in BC some of the famous Coast Salish stone bowls, tools and even human bones. The BC government's South Fraser Perimeter Road project, which found a great deal of significant First Nations material, didn't stop, however; the artifacts were just removed for lab testing and cataloguing, mostly to UBC. Ian Campbell cited an ongoing case of an indignant homeowner seeking to enlarge his home on a multi-million-dollar site near a Vancouver beach, who was furious at the delay required to remove human remains of First Nations origin. The beach was the site of a large ancient village known as Iyelmexw. Now it is covered by mansions.

"Where's the fairness in that?" demanded Ian Campbell, when I met him a few weeks after the first Stanley Park dig, at the North Vancouver offices of the Skwxwú7mesh Úxwumixw (Squamish Nation). (Campbell, who learned the Skwxwú7mesh language as a child from his grandparents, prefers the correct traditional spellings.) "The Canadian government's *Cemeteries Act* is very specific, but our government's archaeological branch tells people they can exhume our bones and move them." Campbell then noted, "In one sense it's brought us closer together, because the three Nations who are linked to the park have developed better relations and protocols, instead of looking at ourselves as competing bands divided by *Indian Act* definitions." As an intergovernmental ambassador for the Skwxwú7mesh Úxwumixw, Campbell said he has lobbied all levels of government to get more input into decisions that affect the park. Campbell said the Vancouver and Whistler area First Nations learned a great deal from the 2010 Olympics, which showcased aboriginal culture extremely well: a popular pavilion in downtown Vancouver featured entertainment, a restaurant and aboriginal art and design, and the permanent Squamish Lil'wat Cultural Centre was established in the mountain resort town of Whistler.

The Coast Salish peoples make up a diverse group with numerous distinct language groups, and have a history in southwestern BC dating back six to eleven thousand years, said Campbell. In his ambassadorial role, he has travelled to more than twenty-seven countries around the world, meeting with other indigenous nations and promoting enlightened tourism to First Nations destinations. Campbell is adamant that the traditional indigenous names should be used for sites within what is now called Stanley Park, much as First Nations language place names are now used on Highway 99 throughout Skwxwú7mesh territory from North Vancouver to Whistler. Some of the Skwxwú7mesh place names may be found in the "Xay Temíxw (Sacred Land) Land Use Plan," referenced on the website and other documents of the Skwxwú7mesh Úxwumixw. Significantly, Campbell is himself an authoritative source for many of the traditional place names, as one of the few fluent speakers of Skwxwú7mesh Snichim, his indigenous language.

As Campbell explained, the site known as Stanley Park was well used by First Nations, and was considered the ancestral territory of Xalek, the third son of Xatswlanexw,

Opposite top: Richard Campbell from the Musqueam First Nation (left) holds slate knives and spear points that were found at the first archaeological testing site in Stanley Park. To the right is Vancouver Parks Board site manager Steve Wong.

Opposite bottom: A dolphin vertebra, discovered at the first testing site, was deemed by archeologists to be evidence of historical First Nations hunting and consumption of dolphins and other marine mammals in the area. *Photos from the author's collection*

or Chief Khatsahlano, who lived on the park peninsula, whose name Campbell has inherited. In 1917, the city of Vancouver came "knocking on the door." The removal of First Nations people was "very coercive," said Campbell. "They told our people that they were confiscating Stanley Park and they planned to burn all the houses down, with smallpox as the excuse."

There were permanent village sites in what is now the park, said Campbell, although a large number of people with kinship ties also moved seasonally up and down the southern coast and around the islands. "They would move households with two big canoes, with cedar strapped across like a catamaran, and move everything, food, supplies, elders, dogs, kids." As the non-native population grew, and aboriginal people were displaced, construction in the park revealed middens, artifacts and even human remains. Campbell recalled that recent water pipeline construction revealed three sets of ancestral remains. "These people had the sloped foreheads, which shows they were high-born, about 3,500 to 4,500 years old—they were in a drawer back east but now they've finally been repatriated to us, thanks to Squamish hereditary chief Janice George and Buddy Joseph. It's not about Indian against settler—we have tried to engage in discussions. It's time for cleansing, time to start again in Stanley Park, to make it more representative of our culture. We know it's a crown jewel of a park and we have to handle it carefully, at the same time we've been treated like intruders in our own land."

The *Shore to Shore* sculpture, Campbell emphasized, will be a key part of the emerging aboriginal presence in Stanley Park. "To have a monumental piece like this, that pays tribute to the Coast Salish culture, is very, very important. But we have to make sure that it is done right, and that no unfortunate precedents for accommodation are set."

Brockton Point, Campbell told me, "was known as Papiyek, which means white markings on rocks, and it was our burial ground for thousands of years." The mixed-race village that sprang up post-contact was in or near that burial ground. Skwtsa7ts, now known as Deadman's Island, along the foreshore, was also a burial ground. "Ancestors were buried [interred] in bentwood boxes in the big Douglas firs and cedars, but post-contact, they did bury people in the ground," especially as successive waves of smallpox hit the indigenous peoples of the southwest coast, he said. Brockton Point also was a good fishing ground, where people would jig for octopus (*stelxwets*); they would also chase porpoises (*kwunut*) into the bay and catch them, as a prized food.

Although it has a remarkable indigenous history, the whole Brockton Point area is now completely disrupted. However, Campbell believed the *Shore to Shore* sculpture could still be installed on Luke's first preferred site, with proper cultural protocol, including a ceremonial cleansing and burning of food. "It is an offering to our loved ones, to seek permission to continue, and saying that we won't cause you any disruption or danger," Campbell advised. "We have to let them know that we remember them and we honour them. The major chieftains who lived in the area even prior to glaciation, about 11,000 years ago—we had the big chiefs, those with the "ahlano" names such as Kiapilano and Khahtsahlano—they are our authorities. Today the Squamish, Musqueam and Tsleil-Waututh, we are all connected by family and cultural ties." Chief Joe Kiapilano, whose granddaughter Khaltinaht married Portuguese Joe Silvey, was

an aristocrat, connected to Campbell's family on his father's side. "Khaltinaht would be my great-great-aunt," said Campbell. Coast Salish society traditionally had *a swa7s ts'itsap*, or specialists, who were professionals who offered their services in particular areas to other Salish communities. The Coast Salish also share similarities in creation stories, such as the origin of the Sxwey'xwey masks, the highly sacred, and secret, ceremonial masks. For the Squamish, those masks came from Axachu7, now known as Beaver Lake. Stitewekw, on the west side of Lost Lagoon near Second Beach, was the site where people obtained the white clay that was mixed with mountain goat wool to preserve the oil in garments and make them waterproof. The village of Chelxwa7elch was near Lost Lagoon, while Iyelshn, or "Little Foot," was on English Bay, on the tidal flats where people fished and gathered food at low tide.

Along with Luke Marston and others involved, Ian Campbell also felt that the First Nations had to unanimously agree on the site for *Shore to Shore*. And that approval would not come until about a month and a half later, in May of 2014, after representatives of the three First Nations walked the Brockton Point area and approved a new site, just west of the existing totem poles. Their approval was still subject to soil sampling, but testing showed that as anticipated, the soil had already been thoroughly disrupted. For the *Shore to Shore* working committee, it was still a highly desirable site: immediately to the north of the tour bus stops, near the Legends of the Moon gift shop and close to the park perimeter road. It was also set back amid big firs and cedars, where its height would be especially striking.

Chief Ian Campbell, Xalek, a strong supporter of the *Shore to Shore* project, is one of sixteen hereditary chiefs of the Skwxwú7mesh Úxwumixw (the Squamish people, villages and community). Campbell welcomes *Shore to Shore* as a powerful tribute to the Coast Salish peoples who lived for millennia in what is now Stanley Park.
Photo courtesy of Lisa Wilcox

While the site selection process and other efforts were proceeding at a slower pace than hoped, Luke was well on track with his carving. Although the installation of the sculpture had not occurred the previous September, Luke had completed most of the carving of the large original sculpture by late 2013. He had also completed an exquisite 36-cm (14-inch) maquette, also in yellow cedar, that was a perfect replica of the full-sized sculpture. "It took almost as much work to make the small maquette as it did the large sculpture," Luke admits, "but I thought it would be so much better to show the actual sculpture to potential investors, and members of the family, and have it to take

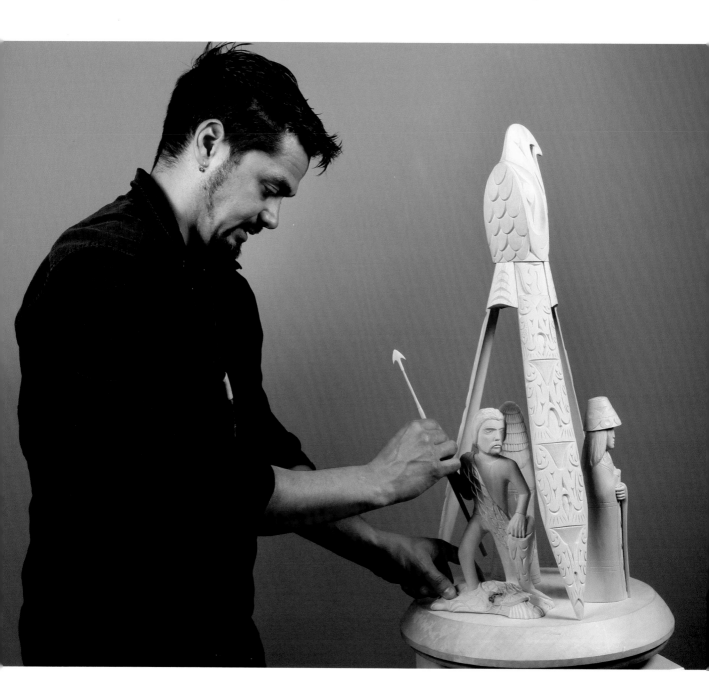

to the Azores with us. It is an identical representation, in cedar, of what the sculpture will be like, and will have more impact on people than some flat drawings on paper."

Luke was right. By the spring of 2014, he had presented the maquette countless times to rapt audiences, travelling with the small, perfect sculpture all wrapped up in boxes lined with soft fabrics, carefully contained and protected. He presented it to the extended Silvey family cousins, in the basement of cousin Chris Thompson's Occidental Hotel in Nanaimo, and to various prospective investors and interested organizations. In the Azores, Luke put together the sculpture for many people, from as few as half a dozen in the home of his hosts, and before Azorean government officials, including the president, to large groups in museums and at public meetings. Each time, Luke would assemble the maquette and describe in detail what each line, symbol and design on the sculpture represented or symbolized.

The Symbols of the Sculpture

For Luke, the power of *Shore to Shore* lies not only in what it symbolizes as a whole, but how all of its parts work together to convey a deeper understanding about the cultures he is representing. There are three figures on the sculpture, which are placed beside each of the three fins of an oversized cod lure, topped by the carved head of an eagle, which also represents the Portuguese *açor*, a large raptor. The sculpture, including the eagle head and the pedestal it sits on, is over 5 metres (16.5 feet) high.

The sides of the inside pedestal on which the sculpture is placed are finished in Portuguese stone. The floor of the pedestal lies beneath the feet of the three figures, and as designed by Luke and executed by Azorean stonemason Carlos Menezes, has an eagle/*açor* design. The design of the outside circle of the sculpture's base, at about 6.4 metres (21 feet) wide, is a striking black-and-white stone mosaic Coast Salish/Portuguese motif of swirling waves, to symbolize the *Shore to Shore* theme—from the Azorean Atlantic shores to the shores of the Pacific Ocean off Stanley Park. Viewers can walk on those waves to view the sculpture from all sides.

The bronze sculpture itself weighs close to 1,800 kg (2 tons). The entire base, which was completed in Fil Jorge's Surrey contracting yard, adds up to 25,000 kg (27 tons) of concrete, stone and rebar. Finished in April 2014, the massive base sat at the Avante yard for several months, awaiting installation. Then the base was cut into pieces like a pie, picked up by construction cranes and shipped to Stanley Park on flatbed trucks. The original cedar sculpture, which belongs to Luke and will ultimately find a home with a museum or private collector, weighs about 295 kg (650 pounds).

Each stroke of his carving knife into the yellow cedar sculpture was meaningful to Luke. Just as he weaves oral history and legends into all his work, Luke researched the three historical figures and their lives to choose symbols that portray them. Here are the symbols that Luke used to convey the meaning of their lives.

Opposite: Luke carefully places a whaling harpoon in the hands of Portuguese Joe Silvey on the 36 cm (14 in) maquette of the *Shore to Shore* sculpture. Luke travelled with the maquette to the Azores in Portugal and throughout BC where he assembled it countless times for large and small audiences. *Photo courtesy of Kim Stallknecht*

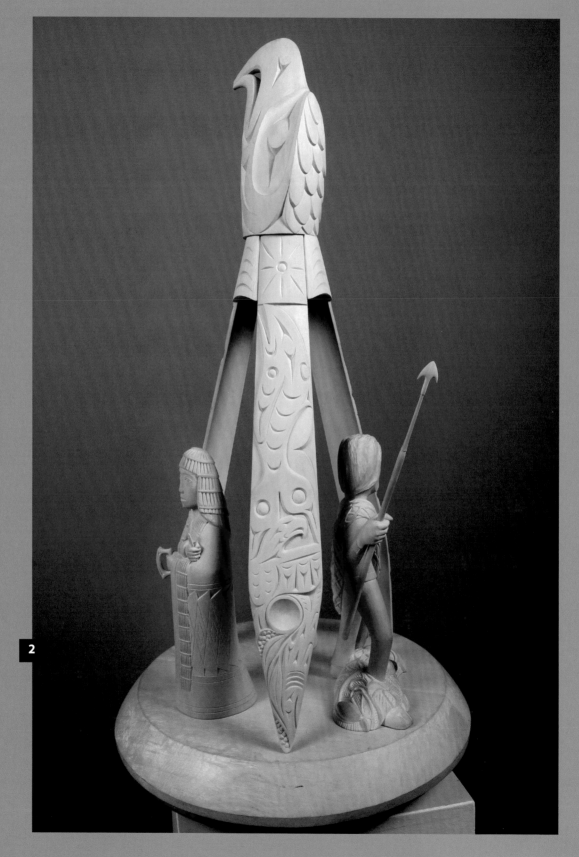

2

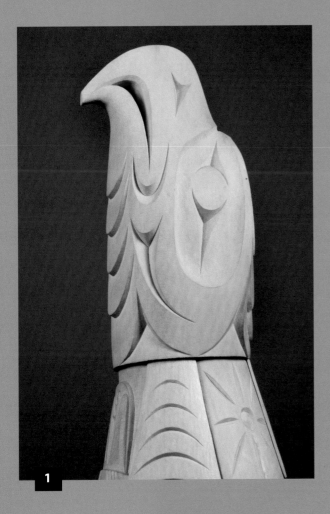

1

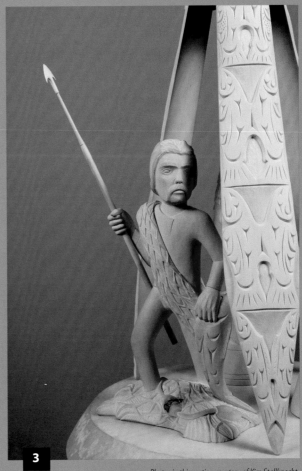

3

Photos in this section courtesy of Kim Stallknecht

1. The **cod lure**, in reality much smaller in proportion at less than 30 cm (12 in) high, represents a wooden fishing implement used by First Nations. It was pushed down into the ocean with a long pole from a canoe or even from shore. The pole was released and the lure would twist and turn as it rose to the top, bringing a stream of cod behind it. The indigenous fishers stood at the ready to spear the fish as they rose to the top.

2. The sculpture forms a triangular shape or peak; this represents the form of the volcanic Mount Pico, which looms over the island of Pico, where Joe Silvey was born. As Luke notes, the sculpture "has many cross-cultural references, from one fishing community to another, from the Azores to British Columbia." All the West Coast locations where Joe lived—in Stanley Park, on Reid Island and on the Sechelt Peninsula—had mountains looming over them, which must have reminded Joe of Pico.

3. **Portuguese Joe Silvey**: He stands with his whaling harpoon at the ready in one hand and holds a spring salmon by the gills in the other. The seine nets he used are pooled at his feet. Joe took out the first seine fishery licence in BC. He also holds a short throw net, used mostly for fishing from shore.

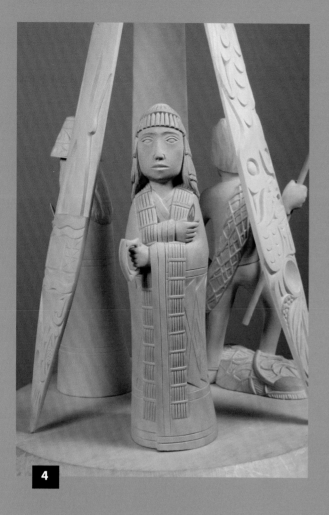

4

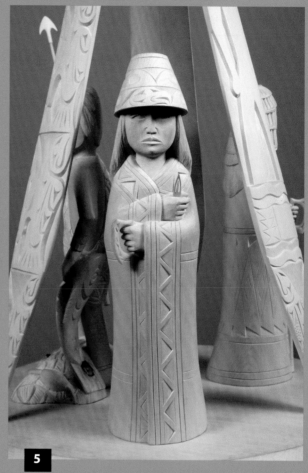

5

4. **Khaltinaht**: She wears a headdress made of dentalium shells, denoting her high-born status as a granddaughter of Chief Joe Kiapilano. Dentalia are small white shells obtained in trade, that are rare and therefore considered valuable. The shells also decorate the front of her robe, a traditional Coast Salish weaving embellished with her crests, which also indicates her rank. Khaltinaht holds a fishing net needle in one hand and a mat creaser, *lhuntun* in Hul'qumi'num, which was used to give a sharp edge to cedar weavings. Mat creasers were often beautifully carved. Luke used images that appear in archival material about the Coast Salish to carve these examples.

5. **Kwatleematt**: Joe's second wife, whom he married after Khaltinaht's death from tuberculosis, wears a traditional Coast Salish hat woven out of cedar bark. These cedar hats and baskets were so tightly woven that they were waterproof, and the baskets could be used to hold shellfish or even water. Like Khaltinaht, Kwatleematt also holds a needle used to mend or create fishing nets, and a mat creaser. Both women were proficient in these and many other traditional Coast Salish skills, which were essential to support their families.

6. Each of the three fins of the cod lure contains the symbols and crests of each of the three figures. The symbolism of the number three is important as well, because it refers to the three human figures of the sculpture and the three First Nations whose traditional territory lies in Stanley Park.

a) **Joe's cod lure fin**: A grey whale represents the industry that brought Joe from the Azores to North America and then to BC. At the top of the fin is a morning star, which represents the name Joe gave to a boat he built himself on Reid Island; *Morning Star* is also the name of an American whaling ship that completed dozens of voyages from the Azores to New England. The hole in the centre of the star refers to Joe's Hole-in-the-Wall saloon, which

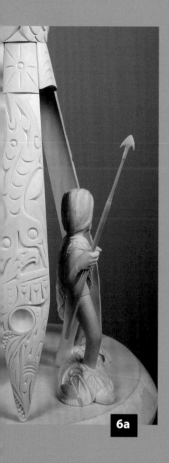

6a

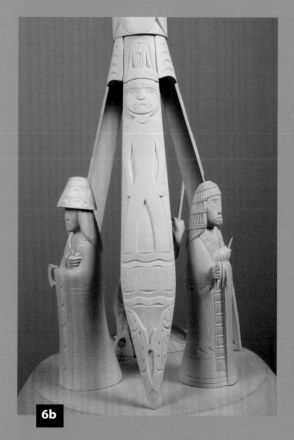

6b

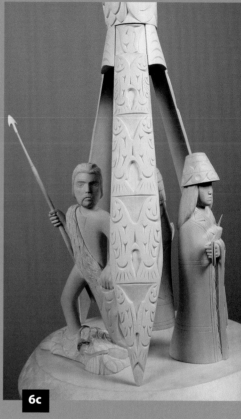

6c

he ran in Gastown before moving with his family to Reid Island. Vines that twirl along the fin represent the grapevine from Joe's native Pico Island. "The legend is that he brought a vine with him, in a potato, to replant in the new world," says Luke. Today Joe's grapevines, planted to yield grapes for the table and for winemaking, still climb 12 metres (40 feet) up giant trees on Reid Island and along what remains of wooden fences around Kwatleematt's garden. Since most people called Kwatleematt "Lucy," the field is still known today as "Granny Lucy's field." The mud shark, or dogfish, represents those Joe caught in BC to extract oil for miners' head lanterns, which was a lucrative sideline at one time.

b) **Khaltinaht's fin** carries the crest that appeared on the house posts of her grandfather, Chief Joe Kiapilano. Khaltinaht and Joe

Silvey had a large traditional wedding, and the two canoe loads of traditional woven blankets they were given were considered highly valuable because the blankets were made from mountain goats' wool, obtained in trade, or from the fur of a now-extinct small dog, bred and kept by the Salish. Each blanket took from six to eight months to weave. "We know Joe was accepted into our culture by Khaltinaht's people because having a traditional marriage would cost a lot of money and everyone would contribute," notes Luke. Her cod lure fin is also carved with two female salmon, representing the couple's two daughters: Elizabeth, born in 1867, and Josephine, born in 1872.

c) **Kwatleematt's cod lure fin** is carved with nine salmon: three female salmon to represent her three daughters and six male salmon to represent her sons. The children born to her

and Joe were the eldest, Domingo, born in 1874, then Mary, Joseph, John, Antonio (Luke's great-grandfather), Manuel, Clara, Andrew (Henry) and finally Lena, born in 1895.

The three figures below the cod lure have the mosaicked head of an eagle or *açor* beneath their feet, and are surrounded by the swirling black and white waves of Portuguese stone, set in a pattern with elements of both Coast Salish and Portuguese design. Viewers of the *Shore to Shore* sculpture may walk the circumference of the sculpture on either the mosaic pathway or an outer row of bricks. The bricks will be available for purchase and engraving to Silvey descendants, Portuguese Canadians and the people of Vancouver, to whom *Shore to Shore* has been donated.

TRANSFORMATIVE SALISH ART AND THE WORK OF LUKE MARSTON

3

When Luke Marston was just seven years old, watching his parents carve at their kitchen table, in Stz'uminus territory on Vancouver Island, he was immersed in art and living close to the epicentre of a renaissance in Coast Salish art. Over the next three decades, Salish artists stepped into the spotlight with their own unique traditions in art. Coast Salish style was ignored and subsumed for many years by the prevalent Northwest Coast art forms—Haida, Gitksan, Tsimshian and Kwakwaka'wakw art—in museums, in collectors' homes and for sale in galleries around the world. In the late 1970s Salish artists began to deliberately seek out their ancestors' legends and artwork, for inspiration and context. Jane Kwatleematt Marston, as her seven children grew older, turned to Cowichan elder Hwunumetse' Simon Charlie for cultural and artistic mentoring. Charlie, who lived in Duncan, close to the Marston family's home, "has often been credited with the revival of the Coast Salish style," notes Snuneymuxw (Nanaimo First Nation) elder and medicine woman Dr. Ellen White Kwulasulwut.

One of the keys to understanding Salish art is to know that it springs from a strong connection between generations and the tradition of oral history. "We have seen the vigour and interest that elders can engender in their younger relations," says Seattle curator Barbara Brotherton in her book *S'abadeb, The Gifts: Pacific Coast Art and Artists.* The art world finally began to pay attention as a dynamic new wave of artists began to re-create Coast Salish art, honouring the old designs, yet moving in an exciting and contemporary direction. Jane Marston, already an acclaimed artist in Salish design, and Simon Charlie encouraged each other to abandon some of the art precepts both had learned from other First Nations. "I would say to Simon, why should we use this style or that, when we have our own Coast Salish art," recalls Jane. "Then he would ask me to go to the museum in Victoria or other places to look for Coast Salish work and I'd take back pictures and we would just pore over them. Most native artists at the time were

Opposite: A close-up of Luke's *Tzinquaw/Dragon Bracelet.* It was made from 22-karat gold.
Photo courtesy of Jeremiah Armstrong

pretty much working in the Haida or Tlingit or Kwakwaka'wakw styles, whether it was their traditional heritage or not."

As Rebecca Blanchard and Nancy Davenport observe in their 2005 book *Contemporary Coast Salish Art*, Jane Marston immersed her children in "artistic expressions of First Nations legends." Growing up as he did, with his family, culture and art so integrated that he took in teachings as holistically as he shared meals, Luke Marston's art practice began with cultural stories and teachings, and remains embedded in that context today. Luke will frequently begin a work of art by viewing an old Salish design, or with a story or legend in mind. "I am always inspired as I work by the legacy of my ancestors," he says. And while he respects the precepts of Coast Salish design, he does not feel restricted by them. "My art definitely is a reflection of the respect I feel for the master carvers, both those who are working now and those of long ago, whose work I saw or looked at in books. I believe as an artist though that we have to find a balance between traditional and contemporary art and we have to grow as Coast Salish people." As acclaimed Haida artist Bill Reid often said, "the art cannot stand still." Both Reid and fellow Haida artist Robert Davidson researched their ancestors' artworks in museums or books and learned the style conventions before they felt confident to break free.

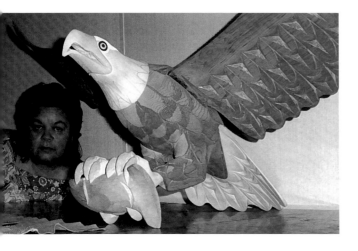

Jane Kwatleematt Marston proudly poses with her son Luke's carving of an eagle holding a salmon in its talons, carved when elder Hwunumetse' Simon Charlie was a strong mentor to the Marstons and other Coast Salish artists. Luke would go on to further refine this image in elegant and precise cedar carvings.

Photo courtesy of Denise Augustine

The reasons why Coast Salish art, which existed for millennia, took so long to break into the public's consciousness are complex. Northwest Coast art, with its bold designs and saturated colours of mostly black, red and blue, with the occasional green and yellow, had been recognized and coveted worldwide since the 1890s. Ethnographers and collectors were often allowed to attend longhouse ceremonial dances along the Northwest Coast. Many either purchased or "collected" boldly designed masks and totems. Franz Boas, the controversial anthropologist, documented as early as 1897 a multitude of Northwest Coast masks and designs, but did not reference a single piece of Coast Salish art. Although he later cited deeply triangular incisions in some pieces, clearly Salish in origin, Boas decreed that the far superior art was that of the northern Northwest Coast, and for decades that opinion prevailed. Missionaries decried the potlatch system yet scooped up its artifacts, many of which made their way to the world's museums, leaving the hands of First Nations forever, or at least until the relatively recent repatriation movement. Yet in the first two hundred years after European contact, collectors of all kinds tended not to amass pieces of Coast Salish art, leaving the functional and ceremonial artifacts to continue to exist in the homes and hidden dance houses of the Salish people who created them.

It was not until 1980, some ninety years after Boas's initial work, and just before Luke Marston began to pick up his carving knife, that historians such as Michael Kew, who was closely associated with the Musqueam First Nation, began to publicly celebrate Salish art. Other ethnographers and art historians wrote only about isolated

elements of Coast Salish style. "Why did it take so long to look seriously at Coast Salish art?" asked the eminent anthropologist Wayne Suttles, who studied Northwest Coast history and art but also paid attention to Salish legends, history and design. One answer to Suttles's question is that there was much less Salish art on display. "The causes of this were probably historical and cultural: earlier European exploration and collecting on the northern coast leading to the development there of art produced to sell; the Northern tradition of producing art for public display versus the Coast Salish tradition that some kinds of art are for very limited public display," Suttles concluded. Boas himself deliberately travelled from the southern territories that he deemed heavily affected by European emigration, to seek out the "purer" Northern art forms. That tendency ironically gave "some protection against the tyranny of agents and missionaries and allowed the Coast Salish to continue their traditional ceremonialism," Suttles said, meaning Salish art was in use, not on display. As for the prevalent European attitude that the Northern tribes were taller, lighter-skinned and "physically and intellectually superior," capable of producing a more elevated art form than the southern coast First Nations, Suttles ascribes that view to "pure racism."

The 1884 potlatch ban enacted under Canada's *Indian Act* outlawed all "artistic practices, such as song, dance and all related tools (regalia, masks and musical instruments)," explained guest curators Cathi Charles Wherry and Andrea N. Walsh in the book accompanying the Art Gallery of Greater Victoria's 2007 show *Transporters: Contemporary Salish Art*. It was the first show by the Victoria gallery, located in traditional Coast Salish territory, "dedicated solely to works by artists of Coast Salish ancestry." The curators argue that the pervasive settler "invasion" and occupation of southwestern BC lands made the Salish more vulnerable to laws outlawing cultural expression. Northern First Nations were more remote and so could potlatch with less danger of being apprehended than the Salish, who also practised "an intense cultural and spiritual privacy, which continues to create challenges for artists to navigate what is and is not appropriate to share."

Even in residential schools, aboriginal students were told to make handicrafts for sale in recognizable northern style—to churn out brightly painted small totem poles for curio shops. Some shop proprietors, such as J.E. Standley of Ye Olde Curiosity Shop in Seattle, advised prospective vendors to model their items for sale after the illustrations in Franz Boas's *Kwakiutl Ethnography*. Well-meaning curators in subsequent decades, trying to alleviate First Nations poverty in both the US and Canada, sought exemplars of indigenous art to sell, but it was almost exclusively in Northwest Coast style. In 1962, fifteen world museums and a private collector contributed to an important exhibition of indigenous art for the Seattle World's Fair, in the heart of Salish territory, yet only 10 of the 334 works cited were Coast Salish. Understandably, artists of Salish origin often chose, including for financial reasons, to produce art in the dominant northern style.

"Once the laws prohibiting cultural expression were lifted, artists like Cowichan Elder Simon Charlie worked tirelessly, and often in obscurity, to keep the classical Salish forms alive and to share them with younger artists," observe Wherry and Walsh. "It is only recently that Salish artists have received the critical attention that has been paid to their northern counterparts." The curators note that "Chris Paul, Maynard

Johnny, Qwalsius Shaun Peterson, Luke Marston, John Marston and lessLIE represent an emerging generation of artists whose understanding and experimentations with Coast Salish concepts and design are recognized by their own communities and who have attained national and international recognition."

Stan Greene, a Semiahmoo First Nation carver and painter, has built an international reputation through his artistic reveal of Salish traditions, says Gary Wyatt, a director of the Spirit Wrestler Gallery in Gastown and the author of several books on indigenous art, including a recent major retrospective show and book on the work of Susan Point. Or as it is said more poetically on his gallery's website: "Stan Greene's Salish culture was sleeping, and he has spent his life helping to wake it up." Greene too combed through museums, including the University of BC's Museum of Anthropology, searching out examples of Salish art and design, "and took them to the elders and asked what they meant, but they couldn't help much—a lot had been forgotten because of the residential schools and because some of the traditions were kept private." Greene taught himself Salish design, learning from the everyday objects, such as spoons, canoes or spindle whorls, that were traditionally decorated by Salish carvers.

Historically there were at least twenty-three separate Coast Salish languages; today at least twelve are recognized, including dialects of Halq'emeylem spoken by the Stó:lō along the Fraser River, the Hәn̓q̓әmin̓әm̓ dialect of Musqueam people and Hul'qumi'num, spoken by Stz'uminus and Cowichan people. Some Salish languages are as unlike each other as German is to Chinese. The Squamish Nation, which is actually a federal *Indian Act*–created amalgam of sixteen different tribes, speak variations of Skwxwú7mesh Snichim, a language unique to southwestern Canada, but one that is also recognizable to Nooksack tribe members in Washington state. The original Salish languages communicate unique understandings of life, yet they share certain "elemental forms and ideas unique to Coast Salish visual language," say Wherry and Walsh. Many of the classical Salish art forms of "crescents, circles and ovals, and darts or trigons," refer to elements of traditional Salish life, such as weaving using round spindle whorls made of stone or wood. The ceremonial blankets produced using spindle whorls are of enormous spiritual, ceremonial and economic significance. Salish weaving has also enjoyed a resurgence in its appeal, following a concerted effort by people such as Musqueam artist Debra Sparrow and her extended family to revive weaving techniques while elders could still teach them.

Unlike the filmed and photographed dances and regalia of some Northwest Coast indigenous groups, the most sacred dance masks of the Coast Salish remain cloaked in secrecy. The winter dances that still take place, virtually uninterrupted in time in the Bighouses of the Salish, remain off-limits to visitors or the uninvited. Dance regalia, including the highly ceremonial Sxwey'xwey masks, which have a unique origin story in every tribe, come with serious hereditary rights and responsibilities. The sacred Sxwey'xwey masks appeared to each Salish tribe in a different way—from the sky, from lakes and on mountaintops—yet all share similar features, of bulging eyeballs, animal-horned heads and protruding tongues. They are masks rarely, if ever, seen for sale, and even in today's electronic era, there are few images in print or on film or video. "With Coast Salish art, the renaissance was long in coming and a lot of it was

attributable to (cultural) property and ownership issues; ceremonial art was incredibly private," says Gary Wyatt, of the Spirit Wrestler Gallery. "Coast Salish artists were not allowed to put much on display." That left flat work: the celebrated Salish weaving of blankets and basketry, house frontals, canoes, paddles and rattles. Artists like Stan Greene and Susan Point were "ahead of the curve" and opened doors for many Coast Salish artists by taking quintessentially Salish forms like the spindle whorl and making them monumental, by playing with curving Salish forms and lines and adding interlocking patterns that were modern in appearance. Susan Point's colours are unique in hue and value, with some designs pastel and minimalist, giving them an enormous modern appeal.

Luke Marston, for his part, has stated: "I will neither make nor sell ceremonial Coast Salish art that is not intended for audiences." Rather, Luke has used the Salish design conventions and drawn on traditional legends and stories, choosing to illustrate what Wyatt calls "a moment in time" in a legend. "Luke Marston is relatively young but he has perfected a design style which is very much culturally rooted for him. He begins with an idea that is from a Salish legend and then proceeds to illustrate it, whether in a mask, or a panel, or a bracelet," says Wyatt.

The ancient, intricately carved spindle whorls that Luke Marston and other artists researched in museum collections or books inspired many modern Salish artists, particularly Susan Point, who used designs on everyday objects to make an implicit statement about the value of women's work. She also uses the flowing Coast Salish lines to represent the interconnectedness of all forms of life, such as people, salmon, whales and birds.

Although Luke Marston does not consider Susan Point a direct influence on his work, he deeply respects her key position in reframing and making known the true elements of Salish art. Both Luke and his younger brother John, as well as their mother Jane, continue to look to Salish tools and elements of life for inspiration. "The canoe and associated paddles are deeply significant icons of Coast Salish culture," say Wherry and Walsh. "The paddles in *Transporters* by artists John Marston and Luke Marston remind us of the enduring relationship with the salt waters that have sustained and transported the people since the beginning." The curators noted that the Marston brothers "emerged from a home that might be seen as an artistic incubator, and this instilled in them a deep sense of the value of their individual artistic gifts, which was later strengthened by the influence of their cultural and artistic mentor, Cowichan elder Simon Charlie."

Other iconic elements of Salish life also made their way into Coast Salish artwork, from animals real and imagined carved on ceremonial objects, such as drums, bowls, masks, woven clothes and blankets, to elements essential for life, such as fire, water, other humans, canoes and paddles. It was against this backdrop that the work of Simon Charlie, Susan Point and Jane Kwatleematt Marston, as well as a whole group of new young Salish artists, began to emerge and draw acclaim. In the *Shore to Shore* sculpture, Luke deliberately placed in the hands of the two Coast Salish women figures their traditional needles for creating fishing nets, and mat creasers used while weaving cedar. There are many historic examples of Salish mat creasers that were things of beauty. And

the needles could be considered a cross-cultural item—although indigenous people clearly wove nets, Joe Silvey introduced the larger seine nets and taught his spouses and children how to make them.

As Luke reached a mature phase of his own artistic practice, he was well versed in Salish art conventions and history, both through his own family and elders and through rigorous study. Every established artist tends to conduct research as part of developing their own artistic style. But a gap between First Nations generations and a lapse in oral history occurred during the residential school era, when it was illegal to speak one's own aboriginal language, to conduct a potlatch ceremony or to advance aboriginal interests in a court of law. The disruption between generations persisted into the post-war decades, in part due to what has been dubbed the "Sixties Scoop," which refers to the rapid rate at which aboriginal children were removed from their homes and taken into the care of the state during that decade. Such hugely disproportionate rates of aboriginal children-in-care continue today, as more than half of all BC children-in-care are of First Nations ancestry, though indigenous people form less than 4 percent of the overall population. Luke's family was deeply affected by the residential schools' chilling effect on the practice of aboriginal culture, with perhaps a generation or two of Salish relatives who did not exhibit or create works related to their culture in public.

Luke was able to overcome any generational gaps by looking at historical Salish art, learning from working artists and listening to his elders. If there are themes consistent in Coast Salish art, they are the direct acquisition of cultural knowledge from elders through oral history; and the concept of transformation, which lies at the heart of Salish creation stories and underlies many legends and stories of humans and animals. Both themes recur frequently in the work of Luke Marston.

At the same time, Luke notes that the Marstons did not grow up on-reserve, where they might have been more immersed in the Coast Salish carving culture. "My mum still had to deal with the influence of her mother, and her aunties, telling her she couldn't be native," Luke recalls. "She was really clear she wanted to be a carver, but everyone was telling her to leave it alone. My mother went to the Bighouse from time to time. We sought out the carving culture and we saw the masks that Simon Charlie was working on. But we were motivated, we had to be," Luke points out.

The Art of Luke Marston

In just a few short decades, Luke Marston has emerged as a distinctive artist from what was in many ways a creative crucible in the renaissance of Coast Salish art. With his mother as mentor, fellow artists from many tribal groups as teachers, and his brother John and some of their contemporaries as fellow students, Luke has come a very long way. He now excels in a range of media, and although the *Shore to Shore* sculpture dominated his life for a few years, he has amassed a considerable body of work. With his major public art installation now accomplished, Luke has enthusiastically returned to his carving shed, full of ideas, concepts and puzzles that he is turning into exciting pieces of art, in his next stage as a mid-career artist. It is worth reviewing, in images and words, a representative collection of Luke's artwork to date.

A mask that Luke created in 2007 illustrates the Salish concept of acquiring both

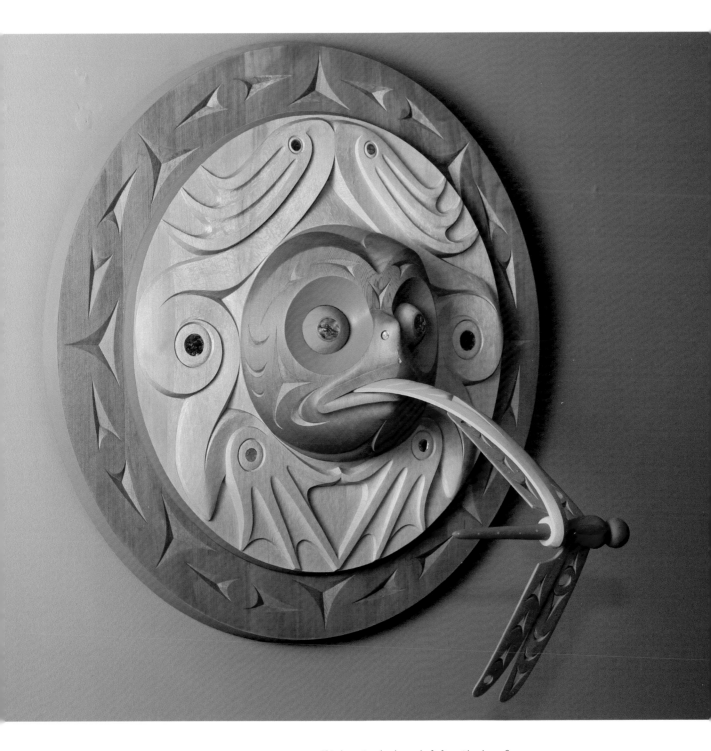

This dramatic red cedar mask of a frog with a dragonfly caught by the tip of its tongue is called *Making Oneself Knowledgeable*. The mask references a Coast Salish tradition of sharing teachings and legends during a meal.

Photo courtesy of Kim Stallknecht

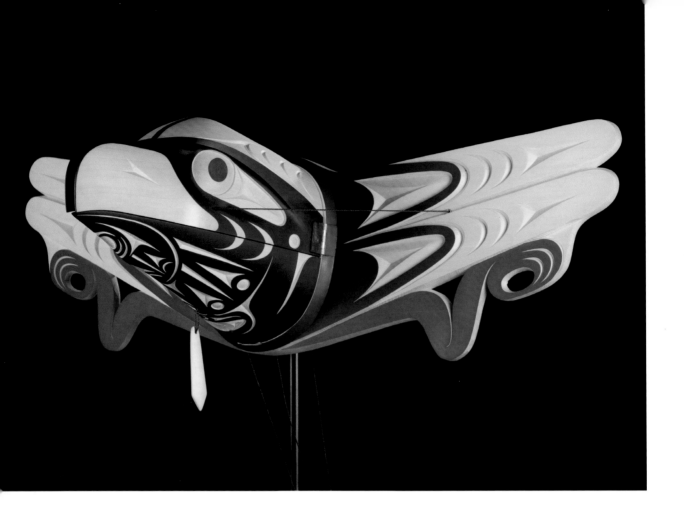

knowledge and sustenance at the same time. It is a dramatic round red cedar mask of a frog, its long tongue protruding, with a three-dimensional dragonfly balanced on the tip. Luke calls it *Stetul' nam'ut, or Making Oneself Knowledgeable* (page 65). He explained in an Inuit Gallery catalogue: "Within our culture sharing a meal is an old tradition. When people are eating during a meal this is when our elders or anyone who wants to talk can talk, share teachings or tell legends. Other cultures might think this was rude to keep eating or that they should talk after the meal. We are taught that when you listen to these teachings and keep eating, as you swallow down your food you take with it all those teachers and you're making yourself knowledgeable, 'stetul' nam'ut.' You keep eating and you nourish your body, mind and soul. This piece is a reminder to always keep an open mind and to always work on expanding your mind and to continue to learn."

The red border of the whimsical piece represents the water, which is "a powerful cleansing element used for many purification ceremonies in our culture," Luke relates. "The frog, a communicator with the spirit world, is always cleansing and going back and forth between land and water." A person who has a frog as a spirit helper is believed to be close to the spirit world and could therefore become a good healer. Luke's design of the frog follows formal Salish style, with its curving lines, circle border and Salish symbols like trigons and crescents. The dragonfly balancing on the frog's tongue is a whimsical play on the concept of learning while ingesting sustenance.

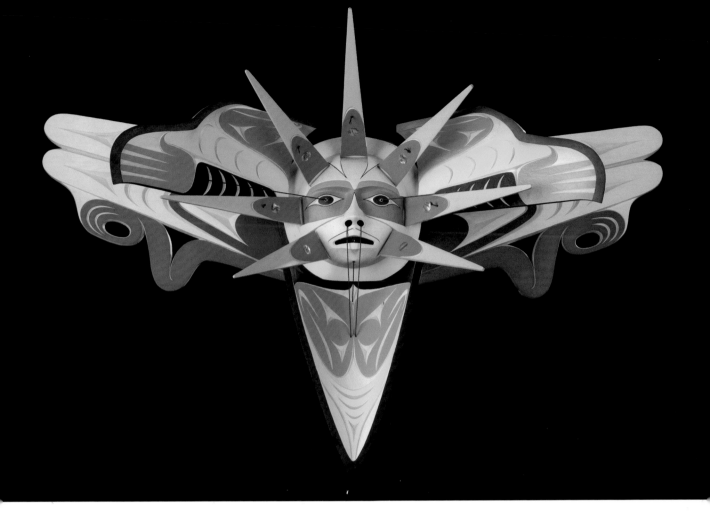

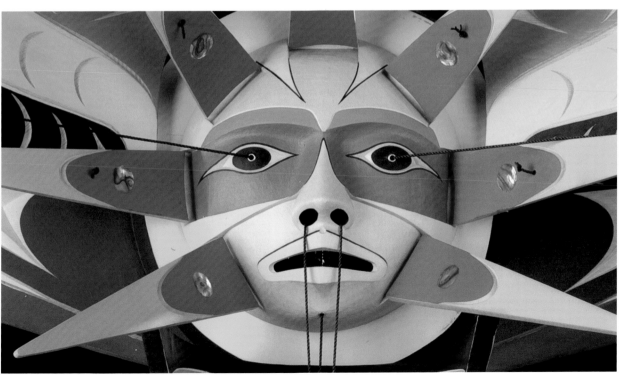

Luke's *Serpent and Moon Mask*, carved in 2007 from red cedar and painted in a restrained palette of reddish-brown, white, blue and black, references the traditional Salish spindle whorl shape and follows a symmetrical Salish format. An inspiration for this mask was an iconic spindle whorl "collected" by William Fraser Tolmie in 1884. A physician, scientist, fur trader and politician, Tolmie studied indigenous languages and was for many years in the employ of the Hudson's Bay Company. Seattle curator Barbara Brotherton calls this particular whorl "certainly one of the finest examples of the exquisite skill of the Salish carver in organizing a complex composition of motifs and elements with the confines of a circular form." On the spindle whorl—artist unknown, yet believed to be Cowichan—are a central human figure carved in relief and set against a beaked bird with bold feather designs, and a downward-facing unknown quadruped and an upward-facing bird's head. "The mastery of composition and vitality of the carving displayed on whorls has inspired many artists—e.g. Susan Point, Stan Greene, Maynard Johnny Jr. and Luke Marston—to adopt the circular format in their carvings, paintings and prints," Brotherton notes.

Luke uses a contemporary streamlined style in his *Serpent and Moon Mask*. The human visage in the centre is that of the moon, with white-masked eyes set with abalone and deeply carved crescents on the black-painted rim. The powerful body of a double-headed serpent winds around the perimeter of the moon, and has eyes inset with abalone and curving lines, including the serpent's claws, which clutch the moon near its ears. Even the spikes on the serpent-like creature's back are curved and the serpent's body is incised with curving crescents and trigons. The blue-painted swirl in the centre of the moon's forehead represents the whirlpool between the islands where the double-headed serpents are said to gather. In this mask, says Brotherton, "Luke Marston references the spindle whorl shape and the often symmetrical format of Salish design yet invokes a modern approach to visual storytelling."

Transformation is key to understanding Coast Salish culture. Many Salish legends centre on the Transformer, or Transporter, as the deity may be called, known variously as X'eels, X'aals or Xa:als, depending on the dialect and the region. The deity came back to earth, legends say, when the first people displeased it or were not living correctly. People were punished by being turned into rocks or animals. The deity also left significant traces of its travels through Salish country, leaving large scratches on rock faces and giant rocks standing alone, such as Siwash Rock, northwest of Stanley Park, or the Transformer Rock (also known as the Hatzic Rock) at the Xa:ytem Longhouse near Mission BC, now a sacred ceremonial site, where three ancient Stó:lō chiefs were turned into stone by the Creator, Xa:als, on a visit to earth.

Luke's intricate transformation mask *Raven Stealing the Light from Seagull* (pages 66–67) was shown at the Inuit Gallery's 2009 Marston brothers show, *Honouring the Ancient Ones*. It embodies a Salish origin legend and transformation, and is carved from yellow cedar and embellished with abalone. When closed the mask depicts the bold black face and beak of the raven, thrusting forward from its wings. When the mask is opened, the bright face of the sun is revealed, painted in orange and yellow with outstretched palms and a starburst of bright sun rays.

The legend behind the mask is an old one, Luke recounts: "Seagull kept the light in

a box in his home. Raven really wanted the light and plotted for days to find a way to get the light. Finally, he came up with a great idea. He asked the children of the village and they said they would help. He asked the children to get sea urchins and sprinkle them in front of Seagull's door. Then Raven yelled at Seagull to come outside. When Seagull came running outside, he stepped on the sea urchins and their spines stuck to the bottom of his feet. He cried and pleaded for help to get the spikes out of his feet, but he couldn't see very well. Raven said, 'I will help you if you get the box of light from inside the house so we can see.' Seagull didn't want to share the light, but Raven told him he couldn't see the sea spines in his feet. Seagull hobbled in and got the box of light. Raven started to help but then told Seagull to open the box more so they could see better. Moaning and groaning in pain, Seagull opened the box wide, desperate. Raven reached in and grabbed the light with his claws, but he dropped it so he picked it up with his beak. He flew out of the house and up into the sky. Raven burnt his beak with the light and that is why he always *caw, caws*." That's how Raven brought light to the heart of the world."

Two masks that Luke has carved bear the title *Being Mindful* (page 70). One of them appeared in the 2009 Inuit Gallery show and the second was carved in 2014. Both represent to the artist the need to find a contemplative place in our busy lives. The 2009 mask has a peaceful sense of self-possession. The yellow cedar face remains unpainted, with its eyes closed and mouth slightly open, carved with deeply incised curving lines, circles and trigons. Hair made of strands of yew curves down from both *Being Mindful* masks. On the need for mindfulness, Luke also wrote a poem in which he reflects that "inner peace is coveted most of all, being at one with your self mind body and soul. Though material possession of life is why we see, true happiness is always free." Those words still resonate with him, Luke says, adding, "whenever I feel I need to be mindful, I always go back to that mask. It's of a portrait style that my brother and I have developed—it's elegant and contemporary but totally references Coast Salish work, with the graphic designs on it and the bold eyebrow line."

In a time of his life where he was working with Robert Davidson in White Rock, while staying away from home with his older brother Mike Marston and Mike's wife Terry Bottomley in Vancouver, then travelling to Japan in 2008 with his brother John, Luke said he needed to learn how to be calm and mindful.

In keeping with Coast Salish tradition, Luke Marston's evocative designs often harken back to the spirit world. Stories exist through telling and re-telling; if a child or young adult objected to hearing a familiar tale, they would be told to listen again and pay attention to what words might have changed. Later, European settlers inevitably probed and transcribed stories intended to exist only in oral history. Although some were distorted to carry a religious message, or simply misunderstood, others were more carefully recorded. Interruptions in oral history perhaps created a place for the capture of legends by people such as Beryl Mildred Cryer, who recorded and published Coast Salish stories in the early 1930s, often in Victoria's *Daily Colonist* newspaper. Luke acknowledges the legends he turns to in his work come from stories he may have heard from his mother, relatives or from elder Simon Charlie, but he also consults published tales such as Cryer's.

Luke's *Grandmother Blue Jay* mask (page 72), carved in 2008 from a single piece of alder and embellished with black onyx, is a striking work. The ears of the female face hold a labret-like earring and hoop, all carved from the same warm yellow alder. The legend, one revealed by Beryl Cryer, tells how "many, many years ago" a grandmother and her grandson, both of them very tiny— just tall enough to reach a man's knee—lived alone together, catching and drying fish in the summer for the long winter months, when they will move to their Bighouse. At the grandmother's instruction, the grandson is told to soak the fish in the river to soften them, but day after day the fish are stolen, until the last fish is gone. Finally the boy hid and saw a huge elk steal his fish. The elk laughed when the little boy threatened to kill him. But the boy jumped into the elk's mouth, pierced his heart with a spear and killed him. He ran back to tell his grandmother what happened and they both grabbed their knives to skin the elk. They were so hungry they grabbed a few pieces to cook on their fire and eat right away. The grandmother ate too fast, and got a piece of bone stuck in her throat. She made horrible squeaking noises trying to get the bone out. Her grandson told her to stop but when she did not, he transformed his grandmother into a blue jay. She flew around and told her grandson, "You transformed me into a blue jay so I will transform you into a black-headed sparrow." "Ever since then," the legend concludes, "the two birds fly around searching for food, one squawking and the other one following close behind."

For the 2009 Inuit Gallery show, Luke carved a striking *First Woman* mask (page 73) out of yellow cedar, drawing from a legend that he first heard from Simon Charlie. Although it is based on a creation story central to Salish culture, the mask itself is a visually remarkable form of a stylized portrait mask, with the face and head surrounded and partially obscured by yellow cedar flames with a flowing, stylized Salish style, which end at the head in sharp points. "It's almost unrecognizable as Coast Salish art but as you look at it closely, you begin to recognize the crescents and trigons that are Coast Salish design," says Inuit Gallery director Melanie Zavediuk. "Luke is very ambitious in his work—he will take Coast Salish style and stories and turn them into a beautiful and contemporary piece that is all his own, but recognizably Coast Salish."

The legend behind the mask tells the story of where the Cowichan people come from. It begins with the first Cowichan man on earth, who was so lonely he prayed to the Creator, every night, in front of his fire. He saw a vision of a beautiful woman in the flames, chose a fine piece of wood and turned it into the woman, praying to the Creator to transform his wooden carving into a live woman. "He was so happy. Here at last would be a friend, companion and helper," Luke relates. Then every day, the man goes hunting, leaving a fire and materials for the woman to make a basket, but she does not come to life. Birds who watch him took the word to the people near Sooke. Two women hurried over to Cowichan and saw the wooden woman by the fire. They kept the fire burning all day, finished the basket, and even cooked the man his supper. The man was happy when he returned. The women continued this in secret until the fourth time he went hunting. That day they threw the carving into the fire, where she burned with a loud noise. Then they did their work. Coming home, the man was happy to see his basket done and supper cooked, but he could not find his wooden wife. He searched inside and outside his home and finally found the two women, who confessed

Opposite: This mask, one of two that Luke has given the title *Being Mindful*, represents to him the need for contemplation and a peaceful sense of self-possession. The tranquil unpainted yellow cedar face is elegant and contemporary but includes Coast Salish formlines. Both *Being Mindful* masks feature hair made of curving strands of yew.
Photo courtesy of Jeremiah Armstrong

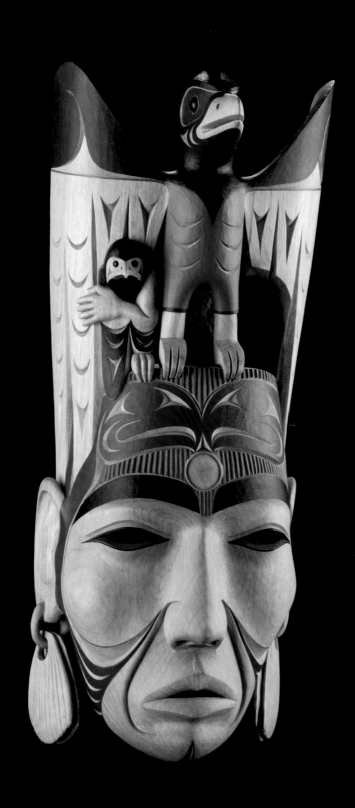

Opposite: Luke's *Grandmother Blue Jay* mask, carved from a single piece of alder embellished with black onyx, shows the face of a grandmother from a Coast Salish legend. The mask represents the grandmother's transformation into a blue jay and her grandson's transformation into a sparrow.

Left: Luke's remarkable *First Woman* mask embodies a Coast Salish creation legend and follows traditional design conventions, but moves in an exciting direction close to the crossover between First Nations artwork and contemporary art. The strongly flowing buttery yellow cedar lines attracted much collector interest when the mask was displayed for the first time at the Inuit Gallery in 2009.

Photos courtesy of Jeremiah Armstrong

what they had done to the wooden figure. "He liked them so much he asked them to stay with him as his wives," the legend concludes. "They lived very happily together and from them the Cowichans are descended."

Luke loved the legend when he first heard it from Simon Charlie and thought about it for about a year before he began carving the *First Woman* mask. "As I was carving her, I was thinking, does my piece even look like native art? The eyes are really stylized eyes, like Simon used to do, but the eyes I carved are more 'realistic.' I also added the trigons and crescents, but I recognize it's a unique piece," said Luke. He acknowledges that from time to time he considers leaving the conventions of aboriginal art altogether, to make his work more mainstream, but finds not only the designs but the stories of Coast Salish art to be thoroughly compelling. "There is so much meaning behind our art, and it's a continual learning process," Luke says. "It's not like making art for no purpose or to shock people. As indigenous artists we're not making art in a vacuum, it lives in our culture, but we're also free to express our own beliefs or feelings. The art is also a link to earlier generations, a link that in some cases has almost been lost, and as young artists, we have to reach back. I also feel I'm reaching forward, to tell my daughters and my nieces and nephews about our traditions and about our art."

A striking mask called *Mind, Body and Soul*, which Luke carved in 2010 and sold through the Alcheringa Gallery, represents a Salish legend of a shaman's ritual that is performed on someone who has lost his or her soul, Luke notes. "If a person has lost their soul they could be in a state of depression, or have suffered a stroke or lost their spirit helper. Only a shaman can tell when someone has lost his or her soul." The shaman typically uses a soul catcher made of ivory or bone, hollow inside with a plug at each end. "The shaman enters the spirit world to retrieve the soul, then places it inside the soul catcher and returns to the victim. He uses the soul catcher to blow the soul back into the person through the top of their head," Luke explains.

A tiny female figure at the top of the mask represents the lost soul, while three circles behind her, in a design borrowed from a Musqueam house post, represent the doors to the spirit world. Under the chin of the shaman is an abstraction of the soul catcher necklace with a split-designed frog. Owls cover the shaman's chin and earrings set in long dangling ears. The owl and the frog are often spirit helpers to the shamans.

The *Mind, Body and Soul Mask* was also influenced by the 2008 cultural exchange that Luke, his brother John Marston and two Victoria artists attended in Japan, the Ome Art Jam. The sixteen artists taking part shared a series of exhibitions, demonstrations and collaborations. During his three weeks in Japan, Luke stayed in the ancient farmhouse of artist Ito Kojiro, a noted carver of temple statuary. Luke says he was struck by the similarities between his *Mind, Body and Soul Mask* and some Buddha figures that had long pendulous ears and headpieces. He had roughed out his mask and brought it with him, and he worked on it in Japan and then finished it back at home. "The man we stayed with was a Buddhist and a master carver, and I was so inspired by the high standards of his carving," says Luke. The Japanese carver's shop was full of half-finished traditional sculptures of Buddha and other guardians, as well as his more contemporary pieces. "When I was finishing this mask, I thought continually of Japan and the masterfully executed carvings I saw there," says Luke. "I was greatly influenced

Opposite: *Mind, Body and Soul*, a 2010 mask sold through Victoria's Alcheringa Gallery, represents a shaman's ritual that is performed on someone who has lost his or her soul. The tiny female figure at the top of the mask represents the lost soul, while the three circles behind her display the doors to the spirit world. A shaman enters the spirit world, uses a soul catcher to collect the soul and blows it back into the soul-less person through the top of their head.

Photo courtesy of Jeremiah Armstrong

Top and bottom right: The *Man Who Fell from the Sky Bracelet* is made of silver and abalone shell and alludes to a Salish creation myth. Luke created this piece after learning repoussé techniques from Robert Davidson.

Photo courtesy of Jeremiah Armstrong

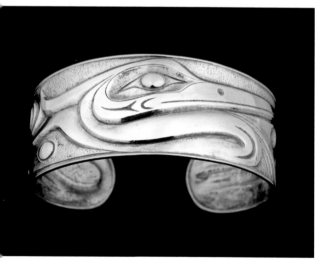

Above: The *Blue Heron Bracelet*, made of silver and 18-karat gold, illustrates a Transformer myth. When X'eels, the Salish Transformer, meets a woman searching for food, he turns her into a blue heron and tells her that she will become a powerful guardian spirit. People guided by Blue Heron perform every task to the standard of a perfectionist.

Photo courtesy of Jeremiah Armstrong

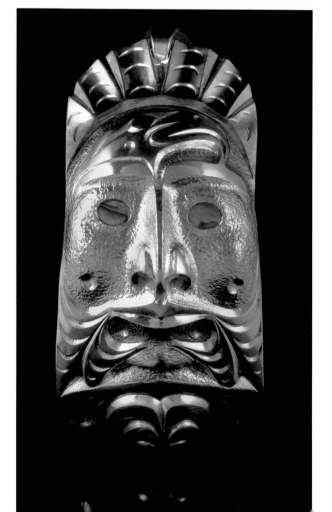

by the precision of the knife finish and the complex composition of the subjects." The finished mask/head had dangling earlobes and earrings that were carved from a single piece of wood, without a seam or join. The trip to Japan was a marvellous opportunity that changed his life, Luke believes. "It opened my eyes to a rich and abundant culture. There was such a precise aesthetic and attention to detail in everything, from the temples to farmhouses, even in the presentation of a simple meal; it was really inspiring."

Although woodcarving has always been Luke's first love as an artist, and the medium to which he returns again and again, he has also created exquisite pieces of jewellery, in silver, gold, goat horn, abalone and copper. After learning repoussé techniques from Robert Davidson, Luke produced the remarkable *Man Who Fell From the Sky Bracelet* in heavy silver with abalone inlays. The head of one of the first men—from the Salish creation myth—boldly juts out from the bracelet, while chased silver designs on the side evoke Salish motifs.

The *Blue Heron Bracelet*, created in silver and highlighted in 18-karat gold, refers to a Transformer myth, a story about when the Salish deity called X'eels came back to the world. "When he met a woman who was digging for her food, he changed her into a Blue Heron," Luke wrote of the piece. "He said, 'You will become a powerful guardian spirit, helping women to be hard workers so they will always have a good home and lots of food for their families." Luke notes that anyone who has Blue Heron for a spirit helper is known as a perfectionist.

Another bracelet in the Inuit Gallery's 2009 show, the *Owl Bracelet*, created and chased in 22-karat gold, depicts an owl's face with prominent eyes and a curved beak. The owl, says Luke, was believed to be a powerful spirit helper who gave the person the qualities of being a good hunter on land and sea, but also gave the person spiritual qualities so they could enter the spirit world in order to bring back lost souls. "Our people believed if you got a sudden scare the soul would be jarred from your body," Luke says. "The person who had Owl as a spirit helper could then use his keen insight and vision to get the soul back." Shamans especially valued Owl as a helper, due to its close contact with the spirit world, and its ability to travel back and forth.

Luke's *Hummingbird Woman Pendant*, a silver face encased in carved cedar, is currently displayed at the Spirit Wrestler Gallery in Gastown. The gallery's curator, Gary Wyatt, was very supportive of Luke's new project, and in the fall of 2013 spontaneously organized one of the first unveilings of part of the *Shore to Shore* sculpture: the Unity figure, which is the carved raptor that represents both the BC eagle and the Azorean raptor, the *açor*.

The ancient Salish stone bowl, more than sixty of which have been found in middens and village sites of considerable antiquity, is a vessel that many contemporary Salish artists, including Luke, have reinterpreted. The original bowls range in age from

The Owl Bracelet, carved in 22-karat gold, depicts Owl, who is both an aid to hunters on land and sea and a powerful spirit helper. Owl is able to guide shamans in the spirit world and helps them retrieve and return lost souls.

Photo courtesy of Inuit Gallery of Vancouver Ltd

2,500 years old to those unearthed at carbon-dated sites that are closer to 9,000 years old. The ancient bowls vary in design but often incorporate seated humans or anthropomorphic figures, and are believed to have been associated with ceremonial use, particularly shamanism. They have been discovered in Coast Salish ancestral sites from southeast Vancouver Island to the Gulf Islands and as far south as Washington state.

After viewing some of the Salish stone bowls in the property of the Royal BC Museum, Luke researched the form, and learned the ceremonial purposes of the bowls. "Although these bowls are found throughout Coast Salish territories, their exact meaning and use, other than ceremonial, are fairly unknown. It is up to us as Coast Salish artists to find out this knowledge and bring it back, through our work."

In 2006, Luke carved a stone *Shaman and Serpent Bowl*, which has a seated shaman, with an animal over his shoulders, and deeply incised carvings of crescents and spirit figures. Another stone bowl representation of Luke's, of a figure seated with a frog, whose hind legs are cradling a stone bowl, was shown in Seattle's Stonington Gallery. Blanchard and Davenport called the piece "a contemporary rendition of the mysterious seated figure bowls believed to have been a sacred art form used by shamans." It is a glossy black figure made of wonderstone (rhyolite), 14-karat gold and ivory, with long hair twisted into a topknot, with his spirit helper Frog head-down at his feet.

Touching again on the theme of spirit helpers, Luke carved a whimsical, beautiful *Mink Bowl* (pages 80–81), of alder, that was shown and sold in the Marston brothers' show in 2009. The deep bowl, carved with Salish trigons, circles and crescents, features two symmetrical mink figures, clinging to each side of the bowl's rim with front paws on the top and long curving tails below their back paws. The beautiful yet functional *Mink Bowl*, traditionally used in a coming of age ceremony for young women, "might belong to a person who has Mink as a spirit helper and that person would become a great fisher," says Luke. "If all the other fishermen come up without fish, the person with Mink as a spirit helper will go out and get enough fish to feed the whole village." The bowl is situated in Salish ceremonial tradition but it also stands alone as an exceptional piece of artistry, regardless of meaning. The pure unpainted piece relies wholly on the warm tones of the alder and the carved forms of the two mink for its appeal.

Luke also carved a *Beaver Bowl* (pages 82–83) in 2008, which features a stylized yet realistic-looking beaver carved of alder, with abalone-inset eyes and nose, outlined with dark red paint. The small oval bowl set into the beaver's back is also outlined in red and inset with white operculum shells along the sides. The black-lined oval eyes, and prominent black eyebrow, together with deeply carved crescents and trigons along the back, sides and limbs, reflect Salish design. The beaver's flat tail, carved and cross-hatched in wood, bends back slightly over the lip of the bowl, while the beaver's front teeth firmly clutch a small piece of wood. As Luke explains, the *Beaver Bowl* illustrates a story about "the early days when we were Animal People and had no fire. The Animals hold a meeting and all try their resources to obtain fire, forgetting about Beaver, who is trapped and skinned, but plays dead." In the end, the humble Beaver gets his skin back on and hides fire in his fingernails, so no one can see it. "Beaver stored the fire in the wood of many trees," the story concludes. "Fire is in every tree. Whenever we want fire we can get it from the wood."

Several artists in the Marston family have produced carved and painted paddles. It is a form that resonates deeply with Luke, whose paddles have been shown in many key galleries. Guest curator India Young, commenting for the Art Gallery of Greater Victoria's 2007 *Transporters* show, said that with his paddles, Luke has put his special stamp on a Salish art form: "Although Luke Marston has researched the highly developed and specialized paddles of the Salish people—oceangoing, river, war, clamdigging— the 'dance paddles' are more conceptual, and the familiar and elegant form itself offers an opportunity to set specific challenges for himself as artist." For the show, Luke carved a *Tzinquaw and Thunderbird Paddle*, which Young said links "two supernatural beings from the Sky Kingdom that are usually spoken of together. Tzinquaw being the younger fire-breathing brother of Thunderbird." Luke's stylized paddles, which he has carved in many variations over the years, are typically altered to offer "optimum space" for design. Young noted with respect to the paddle in the 2007 show that "the benefit of this freedom is evident in Marston's rendering of Thunderbird, who appears to be in a state of fluid and energized flight."

One of Luke's most beautiful paddles is the *Killerwhale Paddle* (page 84), made of yew wood, operculum, twine and jade that glows in the light and is painted in water tones of blue and green, as well as the black that outlines the orca's body. Luke notes that the killer whale holds a special place in Salish society and it is believed that "if a person has Killer Whale for his spirit helper he will be a good fisherman and look after his community." The killer whale was created when X'eels saw people out paddling in their canoes, with their faces painted black and white, and he changed them into killer whales, which are always black and white and travel in groups.

The *Cleansing Water Paddle* that Luke carved in 2010, made of yellow cedar and abalone, recalls the story of the first man, S'iulutsa, who fell from the sky, and was told in a dream to bathe in all the streams, lakes, rivers and oceans. S'iulutsa told his next brother and each of the first eleven men in turn to use water "to cleanse our bodies, minds and souls." Many Coast Salish still practise the tradition of ceremonial bathing, says Luke, preferably "at the crack of dawn when the wall between this world and the spirit world is the thinnest. You give thanks for the day and dunk four times under the water, facing all four directions, and use hemlock or cedar boughs to cleanse yourself." In his *Blue Heron and Frog Paddle* (page 84), made of yew wood, jade and twine, Luke recalled the story of Frog, who was a guardian spirit for the villages. As strangers approached, the frogs would quit singing and alert people. Shamans believe Frog's power to go into the quiet of our minds and listen to ancestors will help shamans to gain entrance into the spirit world. The heron was often a close companion in the frog's aquatic world. "These two spirit helpers," says Luke, "open doors for connection to the spirit world, give us spiritual wisdom and teach us to work for perfection."

Rattles are a traditional tool for Coast Salish and many other First Nations, and Luke has made several, lavishing much design and effort on the comparatively small canvases. The *Salmon People Rattle* (page 85) made in 2010 of yew wood, cedar bark twine, copper and beads, shows a salmon's body with its prominent carved head trapped at the neck in a Y-shaped wood snare. The *Bear and Salmon People Rattle* (page 85) depicts a carved bear holding a salmon in its mouth with claws and teeth, atop a

Next spread: The *Mink Bowl*, carved from alder, features Salish trigons, circles and crescents, and depicts two symmetrical mink figures. The Mink spirit helper guides its charges to become great fishers.

Pages 82–83: Luke's *Beaver Bowl* features a beaver carved from alder. The eyes and nose are inset with abalone and white operculum shells line the small oval bowl on the beaver's back. The *Beaver Bowl* illustrates the legend of how the Animal People obtained fire.
Photos courtesy of Jeremiah Armstrong

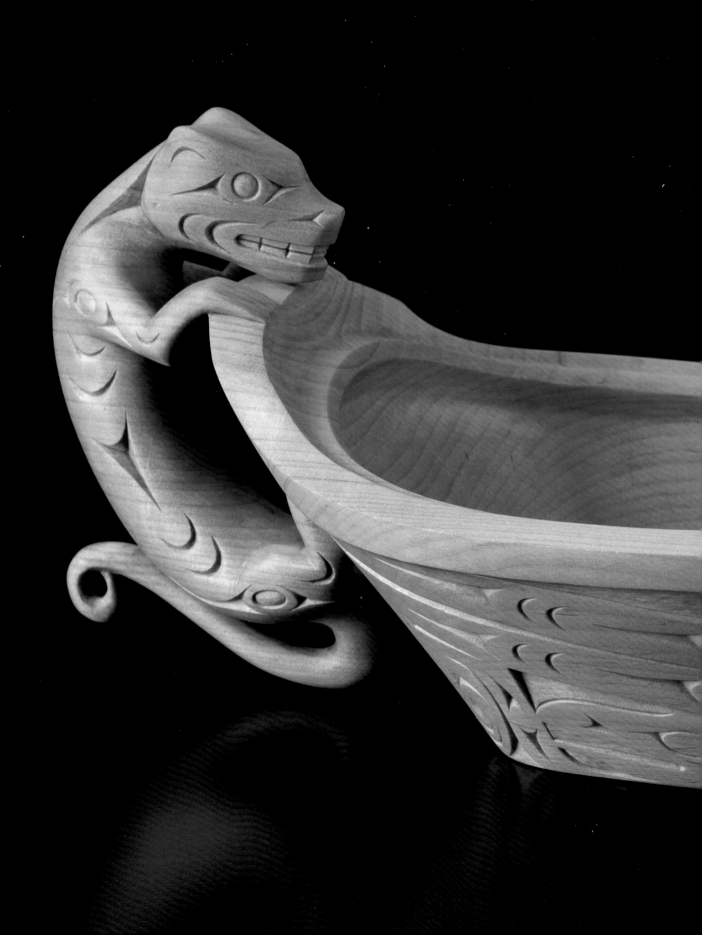

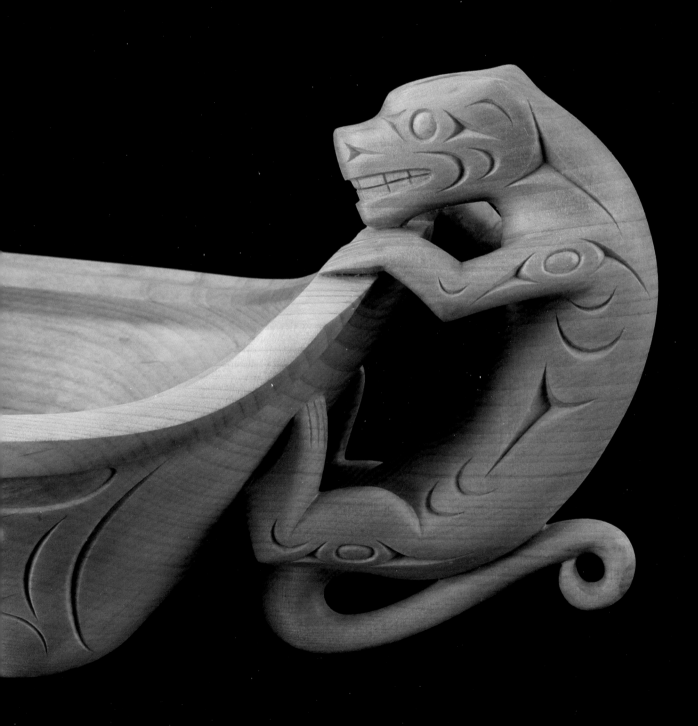

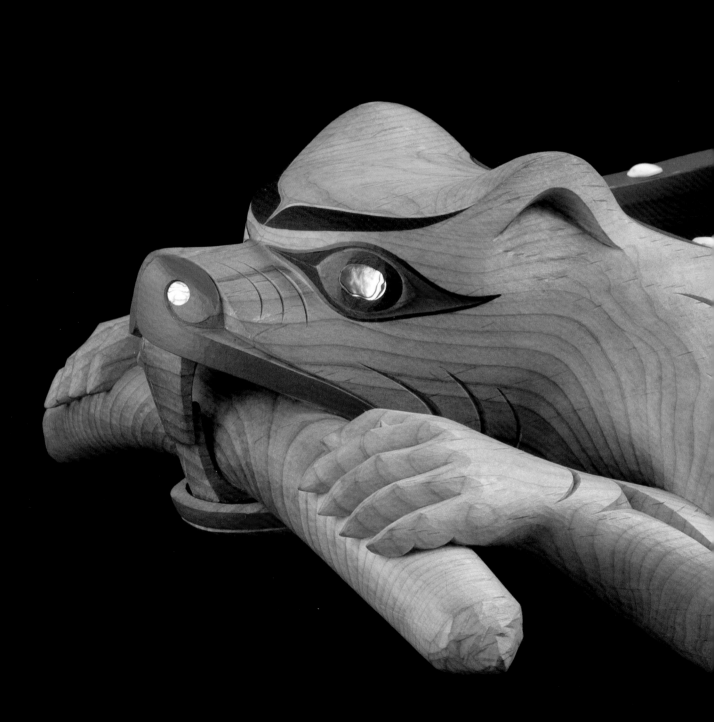

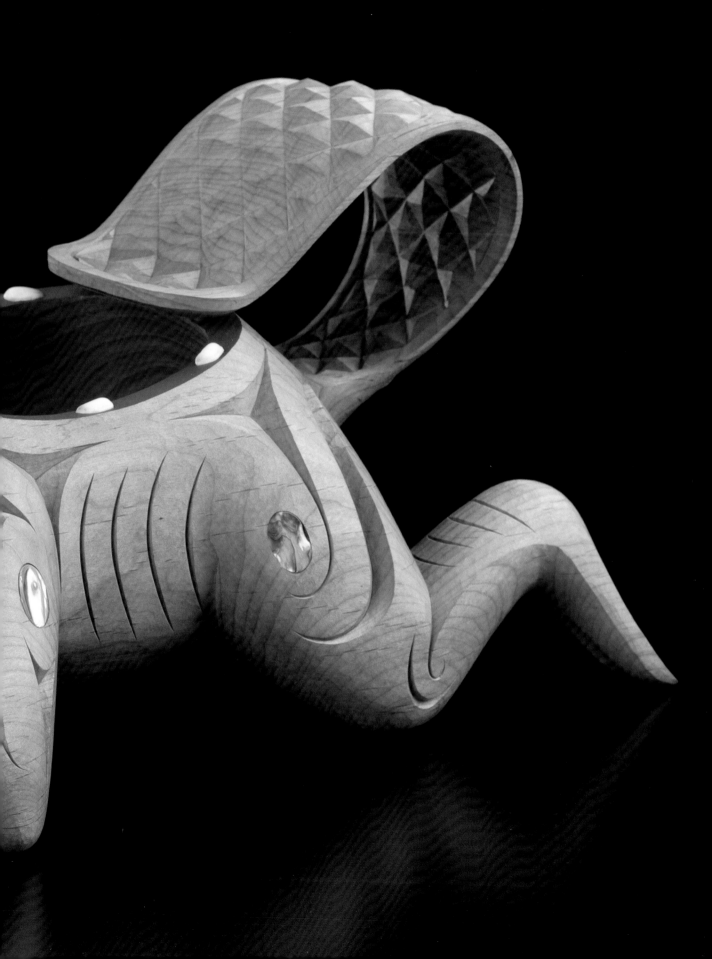

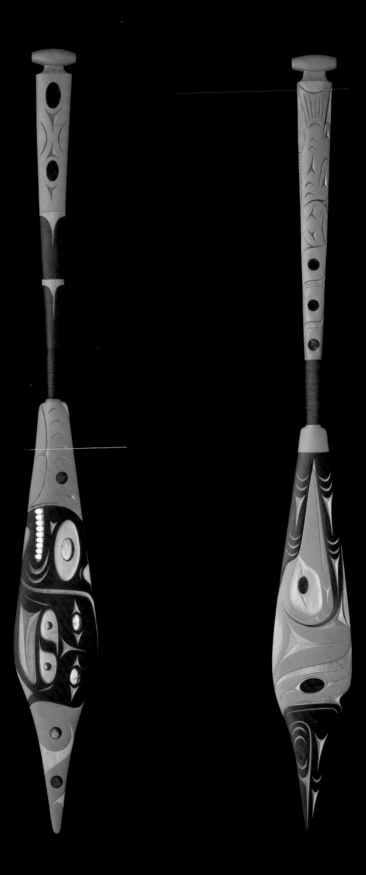

Left: *The Killerwhale Paddle*, created from yew wood, operculum , twine and jade, is painted blue, green and black. Legend says that when X'eels, the Salish Transformer, visited Vancouver Island, he encountered people singing paddling songs in canoes with black paint on their faces. X'eels changed the people into killer whales, and told them they would be black and white, travel in groups and sing the songs of the killer whales.

Right: This *Blue Heron and Frog Paddle*, carved of yew wood with jade insets, represents two strong spirit helpers who offer a close connection to the spirit world and encourage perfection in all things.
Photos courtesy of Jeremiah Armstrong

Left: The *Salmon People Rattle*, created using yew wood, cedar bark, copper and beads, shows a salmon's head trapped in a Y-shaped wood snare.

Bottom right: *The Last Salmon Rattle*, a striking yellow cedar salmon head, makes a political as well as visual statement. "How long can we abuse the salmon, continue to abuse the ocean, continue to ignore and deny climate change?" Luke asks with this piece.

Bottom left: The *Bear and Salmon People Rattle* depicts a carved bear eating a salmon. The bears stands atop a pedestal.

Photos courtesy of Jeremiah Armstrong

pedestal. In his life-sized rattle called *The Last Salmon* (page 85), which Luke made for an Inuit Gallery show called *The Return: Salmon Imagery in Northwest Coast Art*, Luke made not only a striking yellow cedar salmon head painted in dark red, blue and white, but a political statement, which he admits was "outside his comfort zone," since he resists using his work for overt or stark political commentary. "I was making a statement by saying how long can we abuse the salmon, continue to poison the ocean, continue to ignore and deny climate change?" says Luke. "Clean water and especially the salmon are valuable gifts given to us and I wanted to say it's time that we respect and protect them."

The *Shore to Shore* sculpture is the most commemorative of Luke's public art pieces, carved to represent a complex history. Gary Wyatt commented that Luke is "one of the few artists who has been willing to take on a major piece of public art such as the *Shore to Shore* sculpture. This is a sculpture going into Stanley Park that is monumental, it's very much a part of his personal story, and it respects the First Nations who are tied to Stanley Park.

"Public art requires an enormous amount of time, and not many artists want to learn how to negotiate with different bodies, how to navigate all the proper channels. Luke has had to seriously pay some major dues on the *Shore to Shore* project. But it's going to be huge for him and his career, it's at a spot that receives millions of visitors a year, and it's tremendously culturally significant."

Luke has also created a Healing Pole, which was commissioned by then Lieutenant-Governor Steven Point, a Stó:lō leader who has been a judge and lawyer as well as the Queen's representative in BC. Point continues to be a much respected cultural leader in Coast Salish society. Luke's design was chosen from a juried competition. "I wanted to meet the mandate to create a truly Coast Salish house post, that would represent bringing cultures together, healing and breaking down stereotypes," Luke explained. "It's a three-dimensional sculpture. The top represents the Coast Salish creation story, of the twelve people who fell from the sky, and this is the third person, Stut'sun. On the front is an owl, and on the back is a half-man, half-owl, because people fell as birds and were transformed into humans. They are standing on a rainbow, which represents the bridge between native and non-native cultures." A female shaman is carved on the pole, holding a butterfly, because Coast Salish history was traditionally matrilineal, Luke noted. A woman shaman, or doctor, was chosen "because in order for us to break down stereotypes, and bridge cultures, we have to heal first." The shaman stands on top of a frog, who represents the cleansing and communication with the spirit world, Luke added, and "The butterfly represents new life, starting again, and although the owl is a representation of death, that is not always a bad thing; sometimes the old ways are not good and need to be replaced."

That message of remembering the past yet acknowledging the responsibility to move forward is a motif for Luke. As he said about the TRC box he created, "It was able to receive these sad, tragic stories that no one wanted to hear, but that have to be told. By telling these stories, people will be heard and healed. I feel it's my responsibility as an artist, and a descendant of generations of people who suffered as little children in residential schools, to hear and honour that past. It's about the healing, and the medicine

box bringing that healing to each of the survivors. And reaching out to the generations coming up after the generations that were not in residential school, the secondarily affected. To find a way to heal and reach out to other generations."

The *Healing Pole* was commissioned through a juried competition by then Lieutenant-Governor Steven Point (right), a Stó:lō leader, lawyer and judge. Gwen Point, Shoyshqelwhet, a respected Stó:lō educator, stands between Luke and her husband. The pole, a Coast Salish house post, tells the creation story of the twelve people who fell from the sky. The front shows an owl and the back depicts a half-man, half-owl creature, because people fell as birds and were transformed into humans. The butterfly held by the female shaman represents new life, and the owl represents death, which "is not always a bad thing," says Luke, as some old ways need to die to be replaced by better ones.

Photo courtesy of John Yanyshyn

Exploring Azorean Roots: The Atlantic Shore

<div style="text-align: right">4</div>

In April 2014, about 165 years after his great-great-grandfather Portuguese Joe Silvey left the Azores on a whaling ship, never to return, artist Luke Marston travelled to the islands off the coast of Portugal. Luke had long dreamed of visiting Joe's birthplace, on the island of Pico, and the opportunity had finally come. This would be an official visit, though, during which he would meet the Azorean president, other politicians, civic leaders and everyday islanders in formal and informal settings. He brought with him, carefully wrapped in blankets, his ceremonial drum and in a duffel bag he rarely let out of his sight, the small cedar maquette that was an exact replica of the full-size *Shore to Shore* sculpture. Luke's goal in the Azores was to be an ambassador for the *Shore to Shore* sculpture and Joe's Canadian family, but he also planned to climb the Mount Pico volcano, the highest peak in all of Portugal. He also hoped to see an old whaling ship, visit the town where Joe had been born and perhaps find some long-lost relatives.

Accompanying Luke were two Pico-born Portuguese-Canadians, Fil Jorge and Manny Dacosta, Canadian filmmaker Peter Campbell and camera operator Jules Molloy, and myself and my husband, Art Moses, both of us veteran journalists who loved Portugal but had never been to the Azores. Fil and Manny had played a key role in raising funds and support for Luke's project among the expatriate Portuguese community in BC's Lower Mainland. Fil's company, Avante Concrete, donated all the site preparation costs for the sculpture, including the costs of constructing the base, and Fil had also been a ferocious fundraiser for the project. Manny, also a prominent Vancouver-area contractor, had purchased one of the $50,000 replicas of the bronzed eagle head that tops the *Shore to Shore* sculpture, as had David Jorge, Fil's eldest son.

Fil had our itinerary on Pico and the nearby island of Faial thoroughly organized, although with lavish helpings of the genuine warmth and generosity that appears integral to Azorean culture. Fil hosted Art and me at his own oceanside home in Pico, just

Opposite: Luke stands on the shores of the Azorean Island of Pico in April 2014, about 165 years after his great-great-grandfather Joe Silvey left the Azores on a whaling ship at the age of twelve.

Photo courtesy of Jules Molloy

outside the town of Maddalena, right above dramatic black lava rocks that the turbulent spring waves crashed onto ceaselessly, sending up huge geysers of ocean spray.

Our first clue as to the grand scale of Azorean hospitality came as our group straggled in, exhausted from a long overnight flight, to Fil's home, only to be greeted with a huge feast of meat, fish and bread, with a choice of several rich desserts, all served up by Fil's wife Maria's relatives Manuela Moniz Silveira and her daughter Teresa Maria Silveira. Jules began counting the bottles of wine opened at that first "breakfast" meal alone but soon abandoned the plan. We were allowed a brief nap before Fil's unrelenting orders to "Vamos, vamos!" moved us on to our next engagement.

Fil's brother Joe, a businessman and elected local politician, and Joe's wife Lilia, a banker in the nearby town of Lajes, hosted the film crew. Lilia's contacts at the whaling museums of Lajes and Calheta de Nesquim proved invaluable to achieving Luke's goals. Luke and Manny stayed at the home of Manny's cousin Manuel Nunes, a farmer and farm equipment contractor, and Manuel's wife Leovegilda Dutra, who turned out remarkable meals every day from her two indoor kitchens and one outdoor summer and barbecue kitchen. Their hospitality featured Azorean specialty dishes of pork, beef and *bacalhau*—a salted cod casserole—barbecued seafood, lobster and pasta, along with ample lashings of Portuguese wines and *aguardente*, the locally brewed Portuguese firewater.

The bounty of our first experience of the Azores would have been a sharp contrast to the life options faced by the boy now known as Portuguese Joe Silvey, living on Pico in the early 1800s, in the shadow of an active volcano. Black rocks smothered the soil after each volcanic eruption, making survival on the island a hardscrabble existence for Azoreans, who relied on the land. Mount Pico, a dramatic Mount Fuji–like peak that dominates views from most parts of the island, is an active volcano lying along two fault lines. Vents on the volcano have continued to emit lava periodically ever since the mountain was formed, about 240,000 years ago. The caldera near the top of Mount Pico still pours out warm sulphurous air. On some of the Azorean Islands, casseroles

Mount Pico, the highest point in Portugal, still emits warm sulphurous steam, and was once a raging volcano that made survival difficult for Azoreans. Here it rises in the background above the tidy whitewashed town of Lajes do Pico, a major whaling centre until 1987.
Photo courtesy of Ruben J. C. Furtado

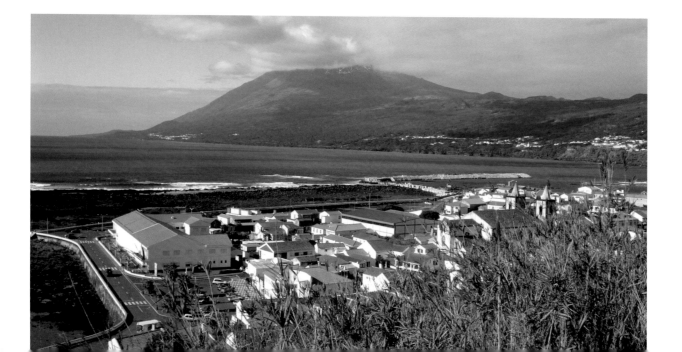

are cooked merely by submerging them in pits super-heated by geothermal activity, and hot springs may carry warnings that the water is close to the boiling point. The elements that make the Azores a fascinating tourism destination to visit today challenged and even defeated early settlers, dependent on agriculture where pockets of soil had to be stolen back from the capricious volcano. By the time Joe was a child, Pico could no longer feed its inhabitants.

The Azores lie in the uninhabited middle of the Atlantic Ocean, almost equidistant from Portugal, Africa and Newfoundland. It has always been an archipelago of extremes, of acres of forbidding black rock interspersed with pockets of brilliant green fields and vineyards, white calla lilies gone wild, birds of paradise, bright nasturtiums and wild sedums. Blue hydrangea hedges border long stretches of island roads. Gardens flourish all year around with bananas, pineapples, figs, oranges and tropical flowers, although a chillier, rainy spring allows the planting of new seasonal crops. In winter, storms rage up the Atlantic Ocean from the Antarctic, with no land mass to stop them, while hot breezes from Morocco waft through the Azores in the summer. Today, there are many attractive whitewashed vacation homes belonging to Azoreans who sought better economic opportunities elsewhere, including Europe, California, Canada and New England.

The "discovery" of the Azores is usually credited to the Portuguese during their "Age of Discoveries" in the early fifteenth century, as the Portuguese explored Africa, India and Brazil, setting up colonial relationships everywhere. A cherished Portuguese saying is that "God is everywhere, but the Portuguese were there first." The Azores were presumed to have no indigenous people or previous inhabitants, an assumption challenged in the last few years by archaeologists Nuno Ribeiro and Anabela Joaquinito, who have uncovered compelling evidence of hypogea (tombs excavated in rock), sanctuaries and pre-Christian temples dating back to the fourth century BC.

Whoever got there first, the location of the Azores made the relatively isolated islands a key stop for any seafaring nation. Deep ocean trenches lie off the Azores, drawing sperm whales—the creatures that shaped the islands' history and way of life—in search of their preferred food, the giant squid that live in the darkest ocean depths. Whaling, using the most ancient of tools—the longboat, harpoon and lance—lasted almost three centuries on the Azores. Among the first peoples to chase and kill sperm whales from tiny boats, the Azoreans also were among the last to stop hunting the giant cetaceans, in 1987.

Today tourism is a key but not yet fully developed part of the Azorean economy. Whales are hunted by motorboat and with cameras, not harpoons, and the startling topography and the vegetation, both of unique endemic plants and acres of planned gardens, draw hikers from all over the world. But above all it was the people and the culture of the islands that Luke appreciated most. One night in Pico, Loevjilda and Manuel invited a folkloric dance group with traditional instruments to perform after the usual feast, complete with flaming drinks. Luke learned to dance the *chamarrita*—a traditional dance involving couples in a large circle, somewhat evocative of square-dancing—while wearing *embarcadas*, the ancient sandals made of a slab of leather tied with rope that have been worn in the Azores for centuries. A large group gathered for

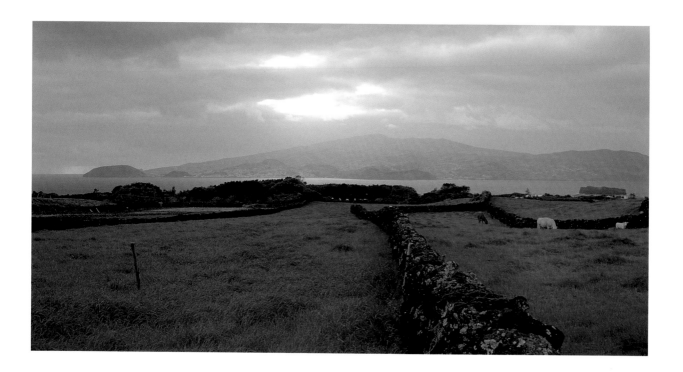

The UNESCO-protected walled vineyards of Pico Island were built on land previously covered in lava. The Azoreans cleared the land and built rock walls that trap heat from the sun and prevent erosion of soil.
Photo courtesy of Jules Molloy

the feast and the dancing, and to wish Luke—as a son of the Azores—every good fortune with the *Shore to Shore* project.

The Azores were not always so welcoming. The first Portuguese settlers who arrived on Pico about 1466 were fleeing wars, starvation, pestilence, the Inquisition and in some cases anti-Semitism. They found a landscape so alien that they used the name "Mistérios" (meaning "mysteries") to describe the barren fields of sharp black lava on parts of the island. It was a century before a volcanic eruption in 1562 showed settlers the origin of the Mistérios and the devastation that could result. New layers of lava turned more fields to rock, but the stubborn Azoreans cleared the land piece by piece, turning the lava moonscape into rock walls to trap the sun and retain soil. Today the island of Pico is a patchwork quilt of these walls, some big enough to shelter only a single grapevine while others encase whole pastures. The scale of human effort is so remarkable that the United Nations has declared the walled vineyards of Pico Island a UNESCO-protected historical treasure, a designation that farmers now grumble may impress tourists but impedes their bulldozer-clearing of the land for cattle.

The islands that in some eras provided settlers with untold bounty also suffered decades of droughts and disease that virtually eradicated every cash crop. Famine and major volcanic eruptions throughout history turned Azoreans into emigrants again and again. No doubt some Azorean young men were thrill-seekers, full of wanderlust, but the failure of the potato crop, grapevines and oranges, amid recurring drought over the centuries, offered many Azorean men little choice but to seek their fortune—or their family's survival—abroad. As Robert L. Santos writes in his history of Azoreans who came to California, "The land tenure system on the islands allowed no opportunity to better oneself, there were many natural disasters to fear, the Portuguese government's

mandatory military conscription for 14-year-olds caused thousands of young men to flee and, finally, the discovery of gold in California lured thousands more from the islands." Some men kept promises to their mothers or wives to return home but many more, including Portuguese Joe Silvey, never saw their island home again.

Born into a traditional, large Azorean family, Joe Silvey (or de Simas) came of age very early, and was sent to sea, most likely on an American whaling ship with his father and brother, at the age of twelve. It was a pivotal time in Pico's history, with Azorean men desperate to escape or find work, and an American whaling fleet desperate for crew members. The American whalers would set sail from New England, bound for the lucrative Gulf Stream whaling fields, particularly those in the deep waters off the Azores, where they could take in fresh water, supplies, and most importantly, a crew that would work for free during an indenture lasting four or five years, sometimes longer.

Joe Silvey was baptized as José de Simas on April 23, 1828, in Calheta de Nesquim, a tiny Pico village. His baptismal certificate, as reproduced by Vancouver lawyer Manuel Azevedo, lists his father as João José de Simas and his mother as Francisca Jacinta, the daughter of Antonio Silveira Quaresma and his wife Maria do Espirito Santo. Joe's parents, went on to have a large family, as was the Azorean Catholic custom. His sisters Maria Jacinta, Francisca Jacinta, Rosa Jacinta and Joaquina Inácia all spent their lives on Pico but Joe's brothers, Manuel, Antonio and Domingo, as well as his father, likely also sought their fortunes at sea. Joe is believed to have first gone whaling at the age of 12, with his father and brother, but the date 1846 is noted at the bottom of his birth certificate, representing possibly the date of his final emigration, at the age of 18, never to return. Joe's Canadian descendants say he always talked longingly of his homeland.

Luke stands in the walled vineyards of his great-great-grandfather's home village, Calheta de Nesquim, on the island of Pico. Behind him is the town's whitewashed church, painted using whale products. The church looks down on a charming seaside village and a steep boat ramp used to launch whaling boats, which were formerly used for hunting, but are now used for races and regattas.

Photo courtesy of Jules Molloy

For Luke, the highlight of his trip to the Azores was his visit to Calheta de Nesquim, his great-great-grandfather's home village. Today Calheta de Nesquim is a charming seaside village centred on a steep slope with a public square and a whitewashed church, built long after Joe Silvey had already gone. The picturesque coat of arms on display everywhere refers to the story of how the village was founded. In the late 1600s, a ship from Brazil loaded with mahogany, most likely heading for the port of Horta on the Azorean island of Faial, foundered in a storm at sea. Everyone perished except for three sailors that a dog was able to bring to shore, going back three times to guide the sailors, including the ship's captain Diego Vaz Dourado, to a natural rock dyke on Pico Island in front of a small sheltered bay. The dog's name was Nesquim, and Calheta means "bay." At least one of the three sailors stayed close to where he had been saved by the dog, giving the village its name and heraldry.

Calheta de Nesquim looks much as it did when it was an active whaling town, integrally connected to the industry that lasted in the Azores for almost three centuries. At the top of a sloping ramp down to the ocean is a *bota*, or whaling shed, that still houses the traditional whaling skiffs, which are now used for races and regattas. The old shed is now a whaling museum, and the skiffs are lovingly kept and maintained. Above the village, the mountainside is divided and terraced by rock walls almost to the summit, an incredible transformation of land when one considers it was almost all done by hand. Whaling, despite its danger, was a relief from agricultural labour. Men who toiled at various jobs in the village considered whaling an essential industry, and it took precedence when whales were sighted. Above the town still stands a tower called the *vigia*, or lookout. During all daylight hours, a man stared out the long narrow window to the ocean, searching with powerful binoculars for the distinctive huge blow of a sperm whale. Sighting a whale was heralded with a rocket or flare and able-bodied men rushed down the fields to the sea, where whaleboats lay at the ready. The longboats known as *canoas* were hauled down the ramp to the ocean and the crews rowed out in the direction of the last whale sighting.

Even as the centuries passed on the island of Pico, traditional whaling methods were never abandoned. After harpooning one of the massive sperm whales, which could weigh as much as fifty tons, whalers would kill it with a lance to the heart . Fifty tons of whale could provide as much meat and bone as a herd of cattle.
Photo courtesy of the New Bedford Whaling Museum

The only concession made by Azoreans to modernity in later years was to use a two-way radio and motorboats to tow skiffs toward the whale, but the crew still launched a harpoon when the boat got close to the beast and finished it off with a lance to the heart. The massive sperm whales, which could weigh up to 45,000 kg (50 tons), could provide as much oil, meat and bone as a herd of cattle—enough to support a small village. Azoreans used virtually all of the beast. Blubber yielded a huge quantity of oil, which was used for lighting, as an enema for treating animals, for caulking boats, as a mix in whitewash and even as an agglutinant in preparing hydraulic mortars. Many an old whitewashed Azorean church, built in the 1700s, was held together with whale oil. The Azorean-caught whales yielded a white, waxy oil that burned cleanly and brightly. The citizens of London, England, bragged it was "the best-lit city in the world" in the 1800s, "its numerous street lamps flickering brightly with candles produced from the carcasses of North Atlantic whales."

But Azorean whaling faced competition from other parts of the world. "By 1780, more than 200 whaling ships from New England could be found berthed in the Azores, wanting to fill out their crews," writes Robert Santos. "Azorean males became the human fodder for many a whaling enterprise. Whaling crews were always in demand by Yankee captains who could be ruthless in the treatment of their crewmen and often made their lives unbearable." Joe Silvey was taken on as a crew member when he was only a boy, and his life aboard a whaler likely was truly grim.

In 1840, about the time that Joe Silvey is believed to have left his home in Calheta de Nesquim to travel to the busy port of Horta, on the nearby island of Faial, looking for

work, no fewer than 169 American whaling ships stopped in at Horta. If Joe thought he was leaving Pico for prosperity, it is likely that he quickly found he was mistaken. Frank J. Gomes, "one of those Azorean teenage males sometimes smuggled aboard whaling ships," told a California researcher decades later than he had "voyaged four years under great hardship… and was given a mere $100 when he came ashore in San Francisco in 1877."

A major conduit for mustering Azorean crews was the office of the first US consul-general in the Azores, John Bass Dabney. Based in Horta, the Dabney & Sons trading house was set up to export wine, spirits and oranges from Portugal, but soon found a more lucrative line of business in outfitting cargo ships and whalers operating between American and Azorean ports.

"It was a perfect storm, an American trader making money by outfitting American whaling ships with sailors from the Azores. They were so desperate to leave, to make their fortune, they were willing to risk everything, their lives, their future, their homeland," said noted Azorean historian Ermolindo Avila, now ninety-eight, in an interview inside the Lajes do Pico Whaling Museum. "The men of the Azores were treated as little more than slaves aboard these ships. It was said that many of them jumped ship but it was the whaling ships' captains and companies that often broke the contract, by not paying when they reached shore. Most of the Azorean men who left on whalers never returned home." Avila's own grandfather left to go whaling at a young age but did return home at the age of thirty-nine, married a young woman and raised a large family.

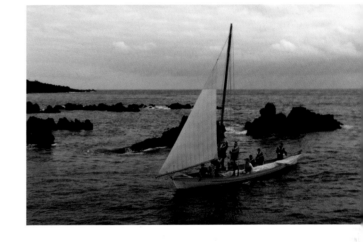

Luke, guided by young men from Pico Island's rowing and sailing teams, took to sea in a whaling skiff launched from his great-great grandfather's home village of Calheta de Nesquim.
Photo by Suzanne Fournier

By 1876, Dabney had begun outfitting his own whaling vessels, and was able to establish the first whaling company in the Azores to send out provisioned vessels, in a partnership with Captain Anselmo da Silveira, who was from the village of Calheta de Nesquim. Soon after, whales were being processed in the Azores, with no need to make the long sea voyage back to America.

Today, Captain da Silveira's stern stone bust stands outside the whitewashed church in Calheta de Nesquim, staring down at the village whaling ramp and beyond, out to sea. On a sunny April day, Luke Marston stood below the captain's statue, on the very ground that his great-great-grandfather might have walked. Posters, in Portuguese, announced that Luke would be speaking at a public meeting that evening in a small auditorium off the village square, just below the church. A truck with a loudspeaker on top drove through the town blaring out inducements to buy freshly caught fish and *lapas*, or limpets, the mollusc with the Chinese hat–style shell that is a key delicacy in the Azores. But first, Fil's sister-in-law Lilia Jorge had arranged with the village mayor for Luke to take a special voyage on an old whaling skiff.

Just below Captain da Silveira's statue, we watched as a long whaling skiff, or *canoa*, was carefully wheeled out of its shed by several young men, mostly in their teens. Luke

was with them, having been invited to join the young men in launching the skiff into the mildly turbulent Atlantic. Once they were all aboard the crew rowed out of the rocky bay, beyond the breakwater, and into the open ocean far from shore. After half an hour, the young men rowed the skiff back in. Then they went out again—after loading up a sail, which immediately caught wind in the brisk spring weather, taking the skiff swiftly back out to sea.

"It was one of the highlights of my trip; it was just amazing to be able to go out on the open ocean in that whaling skiff," Luke recalled later. "The boat was very stable, even in pretty decent waves—in fact it reminded me a lot of our West Coast ocean-going canoes. I was thinking that this is just what my ancestors did, for hundreds of years, on both the Portuguese and the First Nations side! And the young guys from the village had some solid skills, they knew what they were doing. While I was out there in the boat, I was thinking some of these guys are just about the age Joe was when he set out to sea, but he never came back."

As Luke and the Calheta de Nesquim crew headed out to sea again, visible at a distance bouncing up and down in stiff waves, discussion on the dock was brisk among bystanders. Villagers had seen the posters, in Portuguese, advertising Luke's talk that evening, and many were familiar with the story of Portuguese Joe Silvey—from Jean Barman's book, the internet and local talk.

When I told several villagers that the actual surname on Portuguese Joe Silvey's birth certificate was Simas, and that his parents were João José de Simas and Francisca Jacinta Simas, residents began to puzzle over that lineage. A thirteen-year-old boy eagerly volunteered to take Manny Dacosta to a house just behind the church, now a charming guesthouse called Casa Faidoca, saying that the woman who owned the house had long declared herself a known descendant of that family line. And Tatiana de Simas, a young woman who worked in the Calheta de Nesquim whaling museum, said in fact there were only two families, one of them hers, left in Calheta with the Simas lineage.

As Luke returned in the whaling skiff, Tatiana pointed out a local man, who was

Luke stands in a whaling skiff about to be launched from the steep boat ramp in Calheta de Nesquim. Above the ramp is a large boat shed where the skiffs are stored that doubles as a whaling museum, full of photos of island whalers and their vessels.
Photo courtesy of Jules Molloy

backing his Jeep down the ramp to pull the skiff out of the sea, as a member of the same extended family. Manuel de Simas, a genial white-moustached man in a ball cap and rubber boots, towed the skiff up and then came over to talk, with Tatiana translating. With an astonished laugh, Manuel confirmed his heritage, and said that the names of his great-great-grandparents appeared to be the same as those of Joe Silvey's parents. Manuel insisted his sister Angela, who still lived in the old family house and kept photos and records, should be consulted as well. When Luke came up the ramp with his new crewmates, and learned about his possible familial connection to Manuel, the two men gave each other a warm hug.

As the skiff set back out to sea, this time with Luke helping to steer the boat, Manny Dacosta and I were taken by Jeep to almost the top of the steep hillside above Calheta de Nesquim, where Manuel's sister, Angela Machado, gave us a warm welcome. She gave a tour of the old house, a traditional stone Azorean building with a large kitchen on the ground floor and two storeys above, that was immaculately clean, and modernized, but otherwise not a great deal had changed since it was built 150 to 200 years ago. Narrow wooden winding staircases led from floor to floor and the original log roof beams were still visible. Angela took out old photo albums to show photos of her grandmother, Deolinda. "My grandmother used to tell me that she slept here, in this room, with her grandma, Francisca Jacinta," said Angela. She indicated that both she and her brother Manuel believe their great-great-grandmother was the same person as Joe Sil-

vey's mother. Angela gave the names and dates of the intervening generations, between herself and Francisca Jacinta, and there was much discussion of the family lineage, with Manny translating but struggling to keep pace.

Angela, who runs a seaside restaurant on a rocky shore where placid swimming pools form in summer, had cooking to do. She had been asked to prepare a feast for the Canadian visitors that evening. Time and a language barrier did not permit a thorough resolution of names, dates and relations, as we left her home high on the hillside and returned to the town centre. Townspeople were already beginning to gather inside the auditorium as Luke donned his ceremonial vest and unpacked the various pieces of the to-scale cedar maquette of his sculpture.

Luke began his presentation to the villagers by drumming, singing and speaking a few words in his traditional language, Hul'qumi'num: "Welcome, and thank you, my name is Ts'uts'umutl, and I have a warm heart today to talk to you about my work." Shifting to English, he went on to say, "It's a great honour to be here," through

Luke unveils the cedar maquette of the *Shore to Shore* sculpture before a standing-room-only crowd of Pico Island residents. Former whalers, some of Luke's Portuguese relatives, Azorean media and local politicians listened carefully to Luke's description of the *Shore to Shore* sculpture and of the Portuguese-Canadian community. The white-haired moustached man in the front row is Manuel de Simas, who comes from the same lineage as Luke.
Photo courtesy of Jules Molloy

interpreter Fil Jorge, although a number of people in the audience, including Azorean reporters, did speak English. He then began to put together and describe the maquette: "About the time Portuguese Joe came to Canada, my people were using a cod lure like this," he said, in reference to the three legs of the cod lure in the sculpture. He explained that although the cod lure in his sculpture would be 3 metres (10 feet) high, the lures were traditionally much smaller, less than 30 cm (12 inches) in length. A long post was used, from a canoe, to push the cod lure deep into the water, Luke explained. "It starts to spin as it comes up, spinning and spinning and bringing the fish up with it, and at the top there were people waiting with spears to spear the fish as they came up," Luke said, drawing nods and smiles from a crowd quite accustomed to fishing and its tricks. Luke then talked about his family, including his great-grandfather, Antonio Silvey, the son of Portuguese Joe Silvey, who married Alice Aleck from the Penelakut Island band. Luke also explained that his native name, Ts'uts'umutl, comes from Alice Aleck's brother David, his great-uncle. "I knew we were Portuguese, too, and I grew up carving and creating Native art, and in this sculpture I have represented both sides of my family," he said. Luke went on to describe the symbols on the sculpture as he continued to put the small maquette together, giving detailed information about Khalti-naht, the first wife who died of tuberculosis, and Kwatleematt, Joe's second wife and Luke's great-great-grandmother.

"And here's the man of the hour," Luke continued, describing the figure of Joe Silvey: "Joe is standing on seine nets, he's holding short throw nets and he has a spring salmon in one hand and a whaling spear in the other." He then showed how the three fins of the cod lure tell the detailed story of each figure. Luke also described the rest of the sculpture and explained that the base was to be done by an Azorean craftsman, using Portuguese stones.

Audience members were rapt in their attention, and the stories Luke told of Joe catching whales for their oil, fishing for salmon, logging and running a saloon, clearly resonated with them—Joe had the types of livelihoods with which people in the small Azorean village were familiar. Luke was applauded warmly, thanked as a "son of the Azores" and invited to return with his family for a much longer visit. Even little children had sat quietly through his speech, kneeling on their chairs, and came up afterwards to get a closer look.

After Luke's *Shore to Shore* presentation in the town hall of Calheta de Nesquim, villagers approached Luke to ask detailed questions and share information about their own lineage.

Photo courtesy of Jules Molloy

As the crowd filed out into the warm spring evening, a woman rushed up to say she had missed Luke's speech but wanted to meet him. Adelina Maria Silveira said she had confirmed that she and Luke were related. Adelina explained in more detailed email later that her Aunt Natalie in Toronto, a city with a large Azorean expatriate community, had seen a television documentary made by another Azorean expat, Bill Moniz, and read Jean Barman's book on Portuguese Joe Silvey. "We talked a lot about it and

with the knowledge of his old family, and we discussed questions with other old people who were still alive at that time, we came to the conclusion that Joe Silvey, José Silveira, was an ancestor of my grandfather Manuel José da Silveira." Adelina and Luke had time for only a quick handshake and exchange of information, before we were whisked back to the town of Maddalena on the other side of the island.

Two days later, Luke fulfilled another goal of his journey, of tackling the arduous two to three-hour climb up to the top of the Pico volcano. His companion was Manny Dacosta, who had made the climb several times before. After driving partway up the mountain on a switchback road, Manny and Luke succeeded in reaching the top of the peak after two hours of strenuous hiking. Luke was exhilarated by the climb, which ran the gamut of climate conditions on the island, starting at chilly spring temperatures and light rain, through a bank of cloud and finally up a rock scramble to the peak above the clouds and bright sun. The combination of volcanic air wafting out of active vents and bright sun made the peak much hotter than below, despite the altitude. "It was unbelievable, I was just so elated," said Luke. "When we got to the top, I looked at my watch and it was exactly 12:12 p.m., just after noon. I felt like I was on the top of the world. I stood on top of a large rock and shouted, 'Joe!'" Above the cloud bank, views went on forever, for 360 degrees, and Luke could see the Azores stretching out below and the Atlantic Ocean beyond.

Luke had come to the Azores to get a sense of his ancestor, the life on Pico and the family Joe had left behind, and he had done so. He was also excited to be able to tell the people of Pico that his ancestor—their ancestor—was to be honoured in an important urban park on the Pacific Ocean in Vancouver, Canada. Invitations were issued and promises were made by residents of Calheta de Nesquim to attend the unveiling of the tribute to one of the sons of their own village.

After leaving Pico, Luke met with government and civic leaders on the islands of Faial and São Miguel. In Ponta Delgada, the capital of the Azores, Luke met with the president of the Azorean government, Vasco Alves Cordeiro, at the presidential palace. Cordeiro, a busy head of state who in the same two-week period had met with former British prime minister Gordon Brown and the speaker of the US House of Representatives, was attentive and cordial but also frank. Luke addressed the Azorean president in Hul'qumi'num and English, then drummed and sang before assembling the maquette of the *Shore to Shore* sculpture for an attentive Cordeiro. Luke thanked the Azorean government for its help in shipping tons of Azorean stone, and funding the Azorean stonemason to go to Canada to build the base. "The waves here, on the base, represent travelling from shore to shore, from Portugal to Canada," Luke explained. "You could

Luke ascends to the top of Mount Pico, one of his goals during his visit to the island birthplace of his great-great grandfather.

Photo courtesy of Manny Dacosta

look at those designs and think it was Portuguese or look at it and think it was Coast Salish—it's a good layering of the cultures."

Luke later acknowledged that although he did not know the extent of his hosts' knowledge of First Nations history, the reception he had been given was genuine and gracious. "The Azoreans have so much respect for First Nations culture," said Luke. "I know I have Azorean blood in me too, so maybe I'm biased," he joked.

President Cordeiro thanked Luke for his commitment to creating and installing the monument, noting it is difficult "to even imagine what the Azoreans endured way back all those years ago, working not only for their survival but also becoming ambassadors of the Portuguese or Azorean culture." The sculpture in Stanley Park, Cordeiro told Luke, "is the best tribute you can pay to this history and the way Azoreans have walked all over the world, contacting with other cultures and other people, giving a living testimony of this ability to establish ties with other cultures." Luke's pride in his First Nations heritage, as well as his Azorean ancestry, was evident, the president remarked, adding that the sculpture "is the best way to pay homage not only to Portuguese Joe but for all of those who can be represented by his journey."

Luis Silva, an Azorean-Canadian who helped to organize Luke's visit, told Cordeiro that the *Shore to Shore* project is a symbol in Canada of the spirit of reconciliation, and recognition that the First Nations were treated poorly by the colonizers, subjected to "residential schools and many atrocities." Silva emphasized that "we have to start bringing these stories home." Cordeiro agreed: "There are many lessons we can learn from this story, of tolerance and the importance of bridging to another culture… and of treating that culture with respect." Luke added thoughtfully that although he always knew growing up that aboriginal people had been subjected to appalling cruelties, and "that colonization wasn't a good thing for First Nations," he also knew about Portuguese Joe Silvey, "and that this was never a bad story, it was always good. We're turning the page, not dwelling on negative elements, we're going to turn the page and move forward." The meeting at the presidential palace ended with Cordeiro promising that the Azorean government would be represented at the unveiling of the sculpture in Canada.

Luke emphasized later that to him, at its heart the *Shore to Shore* project is about reconciliation. One of the most poignant aspects of his trip, he said, was that despite the grim backdrop of colonialism, he gained an awareness of how similar the lives of Azoreans in the middle of the Atlantic Ocean were to those of First Nations living along the Pacific Ocean. Portuguese Joe Silvey must have felt at home on the West Coast. Coming to Canada, his skills certainly had been welcome. Joe was willing to survive by doing many jobs—logging, fishing with seine nets, even whaling for oil. He brought with him the lessons and travail of his homeland and learned to respect the skills and ways of First Nations. The Pacific coast must have seemed luxurious by contrast, with bounteous fish and seafood, and fertile soils. Once Joe had a Salish wife and many children, he could not leave them and return to the Azores, although he often spoke to his children of his hope that he might one day visit his homeland. The Azorean respect for family, hard work and old customs likely helped Joe to appreciate the values of First Nations, in their commitment to cultural tradition, respect for elders' knowledge and caring for children.

However, Joe could not have possessed a wholly rosy view of life, either in Canada or on Pico Island. He would have been able to contrast the First Nations life in Stanley Park and along the BC coast with the daily rough-and-tumble of life in his Gastown saloon. He also experienced the racism toward mixed-race families that grew along with the sawmills and factories on the BC coast, and made a deliberate decision to remove his family from that discrimination, to a remote Gulf Island. He would have known about the abrupt displacement and eviction from Stanley Park by the new city government in Vancouver, a cruel end to Khaltinaht's people's many gener-

ations of occupation on the fertile peninsula. Joe even helped create a school on Reid Island to protect his children from the cruelties and separation of the nearby residential schools that Kwatleematt's people had experienced.

As he neared the end of his life, living on Reid Island on the Pacific coast, Joe could look back on a successful life in Canada, despite being so far from his homeland. He and Kwatleematt raised ten children to adulthood, and provided them with an upbringing relatively protected from the overt and institutionalized racism faced by First Nations and mixed-race families elsewhere. Joe and Kwatleematt established a strong lineage of people who are today for the most part proud of both their First Nations and Portuguese heritage. In a quote as applicable to his own family as to many other mixed-heritage families on the West Coast, Luke Marston observes: "There is a deep sense of family, and belonging, in both cultures, a belief that children should grow up knowing not just about the modern world but about their ancestors and where they came from, who their elders were, who their great-great-grandparents were. Many First Nations people intermarried with Europeans, although it's not often acknowledged, and those were important relationships that helped to create who we are today."

Above and top: Luke meets Azorean president Vasco Alves Cordeiro in the presidential palace to thank his government for its support of the *Shore to Shore* project. Cordeiro told Luke that the sculpture "is the best way to pay homage not only to Portuguese Joe but to all those that can be represented by his journey." *Photos courtesy of Jules Molloy*

THE SILVEY FAMILY: THE PACIFIC SHORE 5

On a bright spring day in May of 2014, several generations of the Silvey family converged by fishboat, herring skiff, water taxi and seaplane to gather on the beach at their ancestral home of Reid Island. Ravens called, while eagles swooped and dove, plunging from high above the island swiftly down to Trincomali Channel. It was the annual Silvey Mother's Day pilgrimage, led by Eunice Weatherell for the last thirty years, to pay homage to Portuguese Joe Silvey and Kwahama Kwatleematt, who were buried in a beautiful, small cemetery on the north shore of Reid Island, as later some of their children and grandchildren would be.

In many ways this coastline, these shores, these islands, were, and remain, the epicentre of Silvey family life. Silvey and Kwatleematt built a strong family base on Reid Island, and their descendants in turn ranged and settled all over the Gulf Islands, Vancouver Island and the Sechelt Peninsula. Home to Kwatleematt's people for many thousands of years, these rich Pacific shores and islands must have resonated deeply with Joe Silvey, reminding him of his childhood home in the Azores, where family ties ran deep and hard work was essential to secure a living from the land and the sea. Later generations of course migrated to the bigger cities and towns of BC and Canada, but a surprising number of Silvey descendants remained connected to the Pacific coast, many employed in resource-extraction industries.

On the north end of Galiano, numerous Silvey family members worked over the years at what was once a bustling marine supply and fish-buying dock, in Home Bay on the Penelakut Reserve. Other Silveys were active commercial fishermen, catching the abundant herring and salmon in coastal waters. Dogfish, or mud sharks, were caught for their oil. Joe and some of his descendants even tried their hand at whaling off the Pacific coast. One family moved to mid-island on Galiano and began a mink farm known as the Seven Sisters Fur Farm. For many Silvey descendants, however, their emotional home base is still Reid Island, where Portuguese Joe and Kwatleematt moved their family circa 1878–79.

On their way to the Mother's Day reunion, Portuguese Joe Silvey's great-granddaughter Eunice (granddaughter of Joe's first son Domingo) and her husband, Rennie

Opposite: On Mother's Day in 2014, several generations of Joe Silvey and Kwatleematt's descendants gathered on Reid Island. Silvey and Kwatleematt lived on the island and raised their family there. Every year many of their descendants return to take care of the small cemetery where Silvey, Kwatleematt and other family members are buried. *Photo courtesy of Jules Molloy*

Weatherell, travelled on their wooden-hulled fishboat *Jacinto Isle* from Saturna Island to a rendezvous point on the Spanish Hills dock on northern Galiano Island, directly across from Reid. There they met Eunice's nephew Lorne Silvey, and Lorne's nephew Clay Silvey, descendants of Domingo through Eunice's brother, Jack Silvey. For more than three decades, Jack had lived with his wife Jeanne on Devina Drive, named for Jeanne's mother, Devina Baines, the former postmistress for North Galiano. Jack and Jeanne bought the first property on Devina Drive, right outside the reserve boundaries. Old boats still lie outside their house today, some belonging to their son Lorne, who now owns land on the south end of Galiano. Among them sits Jack's old *Sea Wave* fishboat, used for decades, carefully propped up on dry land, its bright blue paint starting to peel. Jack, a skilled fisherman who sewed his own nets and even poured liquid lead to make his own net weights, maintained close ties with relatives on Penelakut Island, formerly Kuper Island, and on Valdes and Vancouver Islands. As he grew older, Jack retired from commercial fishing but kept his hands busy by becoming a prolific weaver of hammocks, which he used to display with a for sale sign outside his house. "My hammocks now live all over the world, I've made about 250 of them, but I must be a lousy salesman, I haven't sold a single one," Jack would joke. "I just give them away."

When the winter dances of the Coast Salish began in longhouses on nearby Penelakut and Valdes Islands, loud gunshots reverberated across Porlier Pass as reserve residents went out in boats to gather food for the feasts. As a senior with limited ability, Jack would drive down to Baines Bay on the reserve in his truck and face his truck to the pass, flicking his headlights at the hunters. "I've got a craving for some nice duck," he'd explain. Jack and Jeanne were among our closest neighbours on North Galiano but were quite private. We had to coax them to come out to the neighbourhood party we held every Labour Day weekend on the Spanish Hills dock, where Jeanne's mother had worked in their store and post office. Then they became regulars, and we reserved a place of honour for Jack and Jeanne, who would bring their own portable chairs down to the dock, set them up in a prominent spot, and greet neighbours in an informal receiving line. Jack especially always had a joke or two to tell. As Jack became more infirm, his grandson Clay and his son Lorne took care of him and Jeanne, until Jack's ill health required him to leave his beloved island. Sadly, Jack died in September 2014.

Everybody waited on the dock in the morning sun that Mother's Day for more relatives who were driving down from the BC Interior. They had caught the Tsawwassen ferry to Sturdies Bay on Galiano, then were driving up to converge at the Spanish Hills dock for the brief voyage across to Reid as a group. Rennie had his binoculars trained on the water, and called out the names of boats of friends and relatives as they arrived across the channel from Salt Spring Island, Gabriola Island and from cities and towns up and down Vancouver Island.

While they waited they reminisced about old times, like when Rennie's father Bing (Cuthbert) Weatherell was lighthouse keeper on North Galiano, and when Eunice's brother Ken Silvey, a skilled boat builder, lived in a house on stilts at the Baines Bay marina. Chris Thompson talked about his career as a hotel manager in the Interior and on Vancouver Island.

Soon the group from the Interior arrived. John Gabara—another great-grandson

Cousins Ken Silvey and Jane Marston, whose grandfathers were sons of Joe Silvey and Kwatleematt, greeted each other warmly and caught up on each other's news at the Silvey family's annual Mother's Day gathering on Reid Island.
Photo by Suzanne Fournier

of Domingo Silvey, through Domingo's first daughter, Clara Silvey Bell, and her eldest daughter, Marie Bell Gabara. John Gabara, now a rock supplier to highways crews in the BC Interior, reminisced about growing up on Galiano and attending the one-room classroom of the north-end school.

Soon everyone except for Rennie, who continued on in the *Jacinto Isle* over to Reid, boarded Dan White's water taxi, which zipped them all from Galiano to Reid. Dan unloaded the passengers from Galiano, his metal ramp coming in handy for older visitors, then saved everybody else who had travelled in larger vessels from Vancouver Island the painstaking process of having to scramble ashore in a few tiny rowboats, by loading people from the bigger boats onto his water taxi and taking them to the beach.

With excitement building about the prospective installation of *Shore to Shore*, the high-profile public art monument honouring their ancestors, it was expected that the turnout of family members would be much greater than usual. Two film crews were also on hand to record the reunion, which was held on the beach at South Bay, very close to where the family members descended off the boats. Portable tables were set up and guests brought food and snacks for the potluck feast. Young men carefully guided elders to seats on a bench scooped out of cedar driftwood, or to a warm spot on a smooth rock, while babies fussed and teenagers jumped from rock to rock along the water.

Any new arrivals were greeted warmly as they made their way onto the beach. Elders who were siblings and cousins, just two generations removed from Portuguese Joe and Kwatleematt, hugged each other. Those who were new to the event explained their genealogical connection to the extended Silvey family. A baby who was an eighth-generation descendant of Joe and Kwatleematt slept in the shade of a driftwood shelter and then was cuddled and carried about by his parents and his grandmother, Melody Silvey, one of Ken Silvey's daughters. Young ones endured teasing about their rapid growth. Soon a lavish spread of crab, fish cakes, ham, turkey, beef and fried chicken, with potato salad and a dozen pasta, green and vegetable salads, was laid out on a portable table and the feasting began.

Jane Kwatleematt Marston, the great-granddaughter of Joe Silvey and Kwahama Kwatleematt, granddaughter of their third son, Antonio Silvey, and the mother of artist Luke Marston, later made her way slowly over the treacherous rocks to the family cemetery on a grassy slope just above the beach. A huge lilac tree laden with fragrant blossoms hung over some of the graves, perfuming the air. Jane took out her drum, her abalone shell, sage, cedar boughs and a carved cedar fan of eagle feathers. Kneeling beside the simple stone graves of Kwatleematt and Joe, Jane fanned sweet sage and cedar smoke over each resting place in turn. Jane was alone with her son Luke, who had accompanied his mother to the cemetery, away from the noise of the picnic. In a quiet

Jane Kwatleematt Marston hugs Luke at the gravesite of her great-grandmother and namesake Kwatleematt. Behind them is a huge lilac tree that perfumes the air every Mother's Day.
Photo courtesy of Jules Molloy

Luke drums while his mother uses a carved cedar fan of eagle feathers to waft sage and cedar smoke over the simple stone graves of Kwatleematt and Joe.
Photo courtesy of Jules Molloy

family moment between mother and son, Luke drummed softly as she spoke. "It's an honour to be at the gravesite of my namesake, Kwatleematt," said Jane, in the stillness of the graveyard while voices wafted up from the picnic below. "I honour Khaltinaht, Kwatleematt and Portuguese Joe and how they brought two cultures together and brought a big family into the world. We are all at this picnic today to attest to that, we are their descendants in the world and we honour them."

Jane paid tribute to Kwatleematt, who raised her children in a small house a short distance away from the cemetery, just across an orchard, vineyard and a garden (now meadow) that is still known as "Granny Lucy's field," referring to Kwatleematt's English name. The Silvey families who homesteaded there lived off the bounty of the land and the ocean. Silvey's acumen with fishing and seafood were vital to the family's survival, but Kwatleematt's contributions—her gardens and food-gathering practices, and her innate knowledge of the First Nations' rich history on the land—were just as significant. Of the elders on Reid that Mother's Day, several said that they never felt more blessed in their lives than when they lived on the island, with little pocket money yet self-sufficient. "Kwatleematt retained the knowledge of her people all her life, in the herbs she grew, how she knew the plants and medicines of our people and how to combine them," said Jane. "She helped many, many people."

"It's a rich life we lead now," said Jane. "When I look at my son, Luke, who has embraced both cultures, and all my children and grandchildren who embrace both cultures, I can see they've come a long way from the colonial past. This is the legacy of Kwatleematt and Joe and it is a good one."

Tears flowed down Jane's face as Luke continued to drum. "I feel this will be my last year here," she said, briefly acknowledging her precarious health. "I hope my children and grandchildren will take the opportunity to come out here every Mother's Day to carry on this tradition, to say, Auntie Eunice, we want to help you now. I lift my hands up to all those who have committed to carry on this tradition."

As Jane finished speaking, a procession of those who had been picnicking below slowly began to enter the cemetery, led by Eunice Weatherell, who was not only the organizer of the annual picnic but the cemetery's caretaker. Eunice is Jane's cousin (her grandfather Domingo and Jane's grandfather Antonio, both sons of Portuguese Joe and Kwatleematt, were brothers), so both Eunice and Jane are great-granddaughters of Portuguese Joe Silvey and Kwatleematt. Eunice, who grew up on Reid Island with her father, John Lawrence Silvey, and her mother, Laura (McFadden) Silvey, in a family of ten children, spent the first twenty years of her life on Reid. For thirty-one years since, Eunice has been coming back to the Reid Island cemetery on Mother's Day, to tidy the graves, plant flowers, cut the grass and honour her ancestors. It is a job that Eunice took over from her mother Laura, who kept up the cemetery for a dozen years after her husband died. It was Laura who kept track of burials and made sure all the cemetery papers were in order and a legal notice was posted at the site. In 1964, Laura wrote to the BC Public Utilities Commission trying to assign her brother Joe to the task. He in turn appointed trustees. Too frail to live by herself on Reid, Laura moved to nearby Galiano Island in the 1970s, although when Eunice asked her late in her life where she had been happiest, Laura replied without hesitation: "Reid Island. We were all together and I knew where everyone was."

By 2009, concerned that the cemetery might be neglected or the land taken over, Eunice went to Victoria to speak to officials at the BC Consumer Protection Agency. They appointed her as executor, along with her nephew Lorne Silvey, and lauded her for looking after an historical cemetery, many of which have been lost. Eunice and her husband Rennie were told they could build a small cabin adjacent to the cemetery, allowing them to spend time near the old family homestead or stay overnight to avoid the long journey back to Saturna.

Leaning on her walking sticks, Eunice made her way over to her family's graves while a number of family members gathered around. Eunice laid flowers on the grave of her sister Sylvia, who drowned on October 11, 1947, and on those of her grandparents, Domingo and Josephine Silvey, and great-grandparents Portuguese Joe and "Granny Lucy," Kwahama Kwatleematt.

Eunice, who had made her way up to the cemetery with considerable difficulty, "carrying my friend Arthur" (arthritis), noted that she had asked her young nephew Drew Silvey to be ready to assume her cemetery duties, with her nephew Lorne Silvey as backup, "but they still have to obey what I say," she warned. "I have that stubborn Silvey blood and that native blood too!" Eunice thanked Rennie for bringing her to the cemetery every year, and then she turned to Luke Marston. "I'd like to thank Luke for all he's done and is doing, daily," in carving the Portuguese Joe and Kwatleematt sculpture, and to raise money for it and get it finally in place. Jane and Eunice both said they were looking forward to the installation. "That will be such an exciting day when we finally see Luke's creation, this amazing tribute, finally installed in Stanley Park," said Jane.

Wearing a black ceremonial shirt decorated with beading and small cedar paddles, Luke stepped forward, acknowledging it was his first time visiting the cemetery where his ancestors are buried. "It's amazing we're all here, after hundreds of years," he said, looking at the large gathering. "We all have the same blood and we all come from

Luke sings and drums as Silvey descendants quietly fill the small graveyard on Reid Island. Standing in the middle is Luke's nephew Lorne Silvey of Galiano Island, and kneeling to his right are Lorne's nephew Drew Silvey and his young son. The woman to Lorne's left is Lorraine Silvey Stacey, a descendant of Luke's great-grandfather Antonio Silvey; behind Lorraine is her son Antonio Saunier. The younger generation of Silveys has agreed to take over some of the cemetery care-taking duties that have been carried out for decades by their elders.

Photo courtesy of Jules Molloy

the same people. Your husbands or wives, in the First Nations world, you're always accepted, no matter where you come from, just like Portuguese Joe was accepted into the First Nations communities."

Luke admitted the path to getting the monumental bronze sculpture installed in Stanley Park had been "a difficult journey. But it's not about me, it's about who we are and where we come from—we're slowly coming together again." Picking up his drum, Luke said he wanted to sing a song that the Cowichan used to sing when they were waiting for people to come home from a battle. It was a sacred song, simple but strong: "Praying for you, I am. That's how it is. These are my prayers."

After the solemn speeches, the crowd of more than fifty gathered for a group photograph. Strawberry shortcake drew everyone back to the picnic site and as the sun sank slowly in the late afternoon, the picnic was all packed up, children, chairs, tables, coolers and dogs, back onto the boats, with goodbyes drifting across the water.

Eunice observed that some years at the cemetery, it was just her and Rennie, with maybe her brother Jack Silvey and his wife Jeanne, Lorne's parents, coming over from North Galiano. But the 2004 publication of Jean Barman's book on Portuguese Joe Silvey, Eunice's 2013 self-published memoir and news of the major monument to Kwatleematt and Portuguese Joe Silvey drew family members to the Mother's Day event in larger numbers.

Shore to Shore in particular has brought the family together more. The extended Silvey clan, some well into their eighties, have met several times in recent years, to get regular progress updates on the sculpture and to raise money for the project. On a rainy day in early 2014, they all gathered in a room at the Occidental Hotel in Nanaimo,

a venerable establishment known as the Oxy, owned by one of the Silvey cousins, Chris Thompson.

Meat raffles, seafood draws and auctions of elaborate Easter gift baskets were some of the activities the family organized to raise money for *Shore to Shore*. Two T-shirts were designed, one with the logo and the other featuring a photo of Silvey and Kwatleematt, and were selling briskly, as were the $200 limited edition black-and-white prints Luke had created of the *Shore to Shore* logo and given out as gifts in Portugal. By June 2014 the family members were still continuing to raise funds. They did not have the resources or deep pockets of the Portuguese-Canadian community, but they made up for that with enthusiasm and heartfelt support for Luke. Regular family meetings were held for updates from Luke and to raise money, mostly on Vancouver Island, with fundraising efforts spearheaded by Chris Thompson and Lois Silvey—both descendants of Domingo—and Lorraine Silvey (who prefers the name Rain Stacey), a descendant of Antonio.

Chris Thompson's mother, Laura, was one of Domingo's daughters, while Lois's father, James Adolphus Silvey, was Domingo's third son. Lorraine's father, Ralph Arnold Silvey, was a World War II veteran and second son of Antonio, who had nine children with his wife Alice Aleck, two of whom died as infants. Antonio's first daughter Edith was the mother of Jane Marston, Luke Marston's mother. For Jane, one of the most significant connections to her family history came when she was given her traditional name, Kwatleematt, by a Sechelt elder. By July 2014, Chris Thompson, Lois Silvey and other Vancouver Island Silvey cousins travelled to the Sechelt Peninsula to meet one of the direct descendants of Kwatleematt. The reunification of the Silvey family, sparked by Jean Barman's book and the family's own desire to reconnect, led to renewed interest in the family's early history.

The Lives of Joe Silvey, Khaltinaht and Kwatleematt: Early Silvey Family History

At the age of fifteen, on September 20, 1872, Kwatleematt was legally married to Joe Silvey, a widower almost three times her age with two small daughters. Kwatleematt was not exceptionally young to be married, for that era, and the ceremony took place, as the priests had insisted, in the Catholic Mission church in Sechelt. She was an educated and resolute young woman who doubtless chose to marry Silvey of her own free will. Kwatleematt's parents, Andrew Kwakoil and Agatha, were most likely present at the wedding of their daughter. Also present was Joe Silvey's eldest daughter Elizabeth, who could not have been more than five years old, but told the Vancouver archivist Major J.S. Matthews in 1943 that she had sailed with her father and tiny sister up to Sechelt in his sloop *Morning Star*. Elizabeth remembered the wedding, and she remembered returning to Howe Sound with her father and his new bride. "Father, he always used to go around fishing, and we stayed at home in the house he built. We did everything them days, including making money. It was the oil they were after." Major Matthews helpfully explains, "Mrs. Walker means that they had to do everything for themselves, did not spend much as there was nothing to spend it on, and were so industrious that they made money from the fish and the oil."

This is the wedding photo of Kwahama Kwatleematt and Joe Silvey, who were legally married on September 20, 1872. Kwatleematt was only fifteen years old at the time—twenty-three years younger than Joe.

Photo courtesy of Jessica Silvey

In her wedding photo, Kwatleematt is dressed in a lovely high-necked dress, her hair parted in the middle and modestly drawn back from her face. She looks straight at the camera, confidently and resolutely. Beside her, their shoulders just touching, is Joe Silvey. He wears a suit jacket, vest and tie, his greying hair closely cropped and his face clean-shaven, but for the handlebar mustache that would become the trademark of many a Silvey male descendant in the future.

With Kwatleematt as a helpmate and caregiver to his two young daughters, Joe Silvey redoubled his efforts to make a living, travelling on his *Morning Star* up and down the Pacific coast. His little family either stayed in the house at Brockton Point or travelled with him. Silvey ranged as far afield as Nanaimo and Newcastle Island on Vancouver Island, to Gabriola Island and to Porlier Pass between Galiano and Valdes Islands. The family also often sailed back up the Georgia Strait to Kwatleematt's home territory on the Sechelt Peninsula.

Joe Silvey was a pioneer in the commercial seine fishery in BC, obtaining the province's first seine licence and teaching Kwatleematt and the aboriginal women at Brockton Point how to make seine nets. With one end of the net anchored to shore and the other out in a boat, the seine net would scoop massive schools of herring, right from the waters around Stanley Park. Some of the catch was salted and sold to schooner operators who would take on as much as 150 barrels of fish at a time, making fishing a profitable living indeed.

Although Joe and Kwatleematt's first two children were born at Brockton Point, the family explored more idyllic, isolated spots up and down the coast, land to which Joe as a new British Columbia citizen (on March 23, 1867) could try to stake a claim. He had earlier tried to claim Mary Ann Point on Galiano Island, so named after his late

first wife's English name, but instead returned to his home base on Brockton Point. He never lived on southern Galiano Island but is known to have plied the waters in and around all the Gulf Islands, as far south as Point Roberts.

Life was becoming less comfortable at Brockton Point for the mixed-race families that abounded, primarily from marriages between indigenous women and settler husbands. As the white population of Vancouver swelled, discrimination toward those families became more harsh and overt. Joe and Kwatleematt had been denied permission by the government to lease the Brockton Point land on which his cabin stood, and where he left his family for long stretches while he was away fishing or logging. As time went on, Joe must have seen the increasingly populous spot as less and less secure.

When BC became a province of Canada in 1871, the federal government took responsibility for aboriginal people and began to try to confine them to reserves. Centuries-old villages around what is now Vancouver were deemed to be habitations that only sprang up after Europeans arrived. "These Indians have squatted on the Govt. Reserve between Coal Harbour and the First Narrows," trumpeted the BC Reserve Commissioner in November 1876. Joe could read the writing on the wall. He sold his Gastown property, where he had run his Hole-in-the-Wall saloon, and his Brockton Point cabin was either sold or given to a fellow Portuguese immigrant, Joe Gonsalves. Silvey was able to pre-empt 65 hectares (160 acres) on verdant Reid Island, a 100-hectare (240-acre) island directly west of northern Galiano Island, and the family moved there in 1881, never returning again as a family to the Vancouver area. Reid was centrally located

By 1879, Joe and Kwatleematt had abandoned their cabin at Brockton Point, now close to a growing city rife with discrimination toward mixed-race couples, to move to idyllic Reid Island. The *Shore to Shore* sculpture now stands at the left of this photo, approximately where the tall stand of Douglas fir and cedar begins.

Photo D-04722 courtesy of the Royal BC Museum, BC Archives

in fine fishing territory, with abundant shellfish beaches and lush green fields where Kwatleematt could establish her garden. Joe found a permanent home for his beloved Azorean grapes, from the grapevine cutting he was said to have carried from the Azores in a potato and undoubtedly planted and replanted wherever he settled.

Kwatleematt would go on to live a long and apparently happy life on Reid Island, becoming the matriarch of the children she and Silvey had together, and their offspring, as well as his two daughters from his first marriage. Descendants describing her from family lore say she was a loving and capable mother and grandmother, who appeared to possess all the skills needed to homestead and to create a rich life for her children, despite few financial resources.

She planted an apple orchard, in a field sloping down to the sea, that still bears fruit today, at least 125 years after it was planted. She made her own bread. And Kwatleematt's productive garden was legendary. The bounty from the sea rounded out the Silvey children's healthy diet. They all became self-reliant and knew how to harvest shellfish from a very young age. "We were told as kids, when the tide was out, the table was set," recalls Joe Silvey's grandson Ken Silvey, now an elder. "You wouldn't go down to the beach, even as a little kid, and not come back with something, clams, mussels, oysters—if you were by the water you'd take out a line and jig for fish. You'd catch heck if you came home empty-handed." Many Silvey family descendants who grew up on the tiny island recall their childhood on Reid as the happiest times of their lives, where they ran free as children but still learned responsibilities. Kwatleematt made a point of passing on indigenous teachings and the Shishá7lh (Sechelt) language to her children, but the whole family also spoke (or at least understood) Portuguese, English and the Chinook trading language.

Barter with people from other passing fishing boats was common and relations with indigenous groups living in the area were cordial. The interdependence of a frontier existence must have seemed vastly more fruitful and friendly to Joe and Kwatleematt than living alongside avaricious newcomers anxious to get ahead in a burgeoning metropolis. Vancouver was finally declared a city in 1887, just six years after the Silveys had moved to Reid Island, but family members say that Joe had seen enough of the place. He deplored the sawmill owners who not only refused to hire indigenous or mixed-race workers but also refused to have them live anywhere near the mills with their families.

On occasion, Joe used his seine nets to catch salmon with the Penelakut First Nation, a tribe that several Silvey descendants would join in the future, through marriage and family ties. When the Penelakut caught a deer or shot ducks, the Silvey family were sure to get their share. Portuguese immigrants who, like Joe, became fishers and farmers on the Pacific Ocean coast, who went on to settle on Gabriola, Salt Spring, Vancouver and other islands, would make a point of stopping by Reid Island, as Joe was considered a leader and a mentor.

But while Joe may have ranged up and down the coast, seeking work in the fishing and logging industries, it was Kwatleematt and her impressive set of skills that kept the family contented and fed on Reid Island. She spent long winters by the cabin fire sewing and mending seine nets, both for her husband's use and to make money. In a study of

Sechelt Nation women and their early contributions to the economy of BC, authors Susan Roy and Ruth Taylor point out that "the wage-labour, subsistence and cultural-production work of Coast Salish women was integral to family and community survival. They produced goods for their extended family and common use and brought in hard cash, enabling both the survival and the persistence of Indigenous communities." Roy and Taylor continue, "Much *shishalh* [Sechelt] oral history describes the *shishalh* women of earlier generations as ambitious, smart, strong, powerful or *skookum*, a Chinook word meaning all of those things." In her day, Kwatleematt must have embodied the definition of skookum.

Kwatleematt was only in her mid-forties when Joe died of a heart attack. In all, she lived on Reid Island for fifty-three years, although family members say that she and her second husband, Joe Watson, also spent part of their time in a small beach shack, near Swartz Bay on Vancouver Island. Granny Lucy, as she was called by many more people than her own grandchildren, became well known as a medicine woman, who knew all the native plants by name and could recommend their effective use for various ailments.

Of Khaltinaht, perhaps less is known because her young life was curtailed so early by tuberculosis, at the time an endemic and incurable, although not always fatal, disease. The young woman was of noble birth, the granddaughter of Skwxwú7mesh Úxwumixw (Squamish Nation) chief Joe Kiapilano and the daughter of Kiapilano's son Kwileetrock. Her mother is believed to have been Musqueam. According to Joe

Joe Silvey asked Chief Kiapilano if he could marry the chief's granddaughter Khaltinaht, a pretty girl with large, soft, deep, dark eyes, and hair down to her middle. Kiapilano agreed, and the traditional marriage, much like the one depicted below, was celebrated with a big potlatch and the couple was sent off in a large canoe laden with blankets. Kiapilano was born at Musqueam and had children there, but left as an adult to live with Squamish people.
Photo courtesy of City of Vancouver Archives

Silvey's eldest daughter Elizabeth, her father told her that her mother Khaltinaht "was a pretty girl with dark eyes, and hair down to her middle, large deep soft eyes." Elizabeth was told by her father that after a canoe ride with Khaltinaht, Joe Silvey asked Chief Kiapilano if he could marry his granddaughter. "Then the old chief said, by signs, that he could; waved his hand and arm with a motion signifying to 'take her.' He motioned with his right arm and waved, quickly, upward and outward." Elizabeth recalled that the two were married "under Indian law. The old Chief Kiapilano took my father and the chief of the Musqueams took my mother and the two chiefs put them together." It was a great ceremonial occasion, a potlatch in which many possessions were given away, Elizabeth recounted. "And then they put my mother and father in a great big canoe with a lot of blankets, made them sit on top of the blankets, and then brought them over to home at Point Roberts."

Xwu'p'a'lich, Barbara Higgins, who prefers her Shishá7lh name to her English name, is a direct descendant of Silvey's second wife Kwatleematt and a recipient of oral history from her grandfather Henry, Silvey's son. She recounted the story of Joe and his first wife somewhat differently, but definitely more vividly. "When Portugee Joe [her pronunciation] came down from Yale, that's where he had gone to cash in on the Gold Rush, Indian people were very upset because the non-natives were digging everywhere, looking for gold, even in our graveyards." Portuguese Joe was wiser than most newcomers, digging his house into the ground like an indigenous pit house. "But the people came through and tried to burn out all the white people, and they burned out Joe's pit house anyway."

According to Xwu'p'a'lich, Joe tried to escape an angry crowd of aboriginal people that was pursuing him. "He had a big Indian canoe and he had five Portuguese guys with him, and they came down the river at night," she said. "They didn't know the rapids that well and the Indian canoes were catching up on him… the headman was sitting in the stern, and he'd hit the side of the canoe with a club that made a big noise, bonk, bonk… and they'd go faster, they didn't have to look or anything, they knew that river. Portugee Joe was scared for his life, he thought he was dead meat." Finally as they came to a river island, Joe and his friends hid their canoe on the shore and out of sight, and the other canoes went right by. They waited for daylight, got back in the canoe and paddled downriver until they came to Musqueam territory at the mouth of the Fraser River, near the ocean. "Portugee Joe's heart just about stopped because there was another big, big crowd of Indians, but Chief Kiapilano called him in," recounted Xwu'p'a'lich. "The chief came to the beach and treated him like friends, he was altogether friendly." Joe left the Musqueam people not only hugely relieved, but also cherishing a memory of a beautiful young woman, introduced to him as the chief's granddaughter. The young Portuguese man's next act of courage was to ask the chief for his granddaughter's hand in marriage and to his surprise, the old chief gave his consent. "In the Indian way, Portugee Joe and Khaltinaht were married," said Xwu'p'a'lich. "Chief Kiapilano took a blanket and put it around Khaltinaht's shoulders and her father put a blanket on Portugee Joe, and they were married. They gave them a huge canoe, filled with blankets, and Khaltinaht sat on top."

Both young women who married Joe Silvey and had children with him had chal-

lenging lives but also had the benefit of a strong early life, steeped in the ways and skills that had allowed the Coast Salish to become one of the most prosperous indigenous nations in North America. The richness of ocean food sources, along with harvesting of food and medicines from the land, allowed the Salish in pre-contact times to enjoy the benefits of a highly stratified and evolved society. There was a high-born (or noble) class, as well as an artisan class with a powerful aesthetic strongly tied to a rigid design protocol, rich in symbolic meaning drawn from legends and oral history. Art and ceremonial dress, even everyday objects of utility, were often highly decorated. There were also workers and even slaves, taken from clashes with warring tribes along the coast.

However, at the time Silvey asked for the hand of Khaltinaht in marriage and again when he married Kwatleematt a few years later, it is likely that those marriages took place only because of the decimation of First Nations populations by waves of epidemics. Chief Kiapilano was likely being pragmatic, in allowing his granddaughter to be married to a stranger and a foreigner, one of those who seemed to be invading in endless and ever-greater numbers. Skwxwú7mesh Úxwumixw (Squamish Nation) hereditary chief Ian Campbell, who has been a strong supporter of the *Shore to Shore* project since its inception, said he was taught in the traditional Salish way that it was completely unacceptable for a high-born woman to marry outside her class, let alone outside her tribe. Such a bride would have been shunned. In the new era of the late 1800s, however, as European population numbers rapidly overtook those of First Nations, particularly in the southern coast of BC, society was profoundly changed, and intermarriage became common. Today barriers still exist for those of mixed heritage, although there is scarcely a First Nations person in British Columbia who can accurately cite a lineage without any non-native ancestors.

The effects of centuries of colonialism on First Nations people is becoming better known to most Canadians: the devastating impact of residential schools, the grinding poverty, the removal of aboriginal children from their parents by mostly well-meaning social workers, the lasting generational impact. Although the Portuguese-Canadian community has enthusiastically embraced the *Shore to Shore* project, donating thousands of dollars toward the realization of such a monument, some First Nations have been considerably more cool to the concept of celebrating cultural integration. Yet, as Luke Marston puts it: "The story of Portuguese Joe is a positive one, it had a good outcome. Joe had a deep respect for the Coast Salish tribes he married into, and he made a strong and lasting commitment to his family. And he couldn't have thrived as he did without the support and the knowledge of the indigenous people. That's why the legacy of Kwatleematt and Joe Silvey, and of Khaltinaht, has benefited not only their immediate descendants but all British Columbians."

BREAKING GROUND IN STANLEY PARK FOR SHORE TO SHORE

6

O n Tuesday June 24, 2014, all of Luke's hopes and expectations for the sculpture installation took a giant leap forward, as the official ground-breaking ceremony for *Shore to Shore* was finally happening. It was a small but significant group—many of the people who wished the project well and had helped bring it to fruition—that gathered at Brockton Point just before 11:00 a.m. "It's been almost four and a half years since we began work on this project, and we're finally here," Luke stated in his opening remarks. Members of the First Nations that Khaltinaht and Kwatleematt came from—the Squamish, Musqueam and Sechelt—were present, as were Maria João Boavida, the Portuguese consul-general in Vancouver, many Silvey and Coast Salish family members, and key backers from the Portuguese community.

The grass around Brockton Point was damp from overnight showers but by late morning, watery sunlight filtered through the big trees and in the end, the forecasted rain held off for the entire ceremony. But it was a cool morning, and just before the ceremony began, Luke sat in his truck trying to warm up his drum, sitting beside Stz'uminus spiritual leader Herman Seymour, who was garbed in a traditional Salish woven blanket. Luke, holding the drum up to his truck's heater, wanted the drum to be flexible enough to give a deep resonance.

Archaeological observers were also present on June 24 at the new site, which had been tentatively chosen on a walkabout of Brockton Point by officials from all three First Nations, but would still have to generate soil samples that showed no traces of historical aboriginal occupation. Sarah Smith from AMEC Consultants, the archaeologist who shut down the previous test site months earlier, after she found ancient slate knives, seal harpoon toggles and other artifacts, pulled up in her truck to supervise but confided that she had few concerns about the new site. "It's all soil that has already been thoroughly disturbed, plus the sculpture will actually be on top of fill that was brought in to create a berm," Sarah said. "I'm not anticipating any archaeological issues today."

Although the first dig had not turned up any human remains, it was known to lie

Opposite top: The ground-breaking ceremony for the *Shore to Shore* sculpture in Stanley Park took place on June 24, 2014. In attendance, from left to right, were a Silvey family friend, Jane Marston wearing her traditional woven Coast Salish robe, Luke, Portuguese-Canadian contractor and project backer Fil Jorge, Luke's cousin Chris Thompson (behind), a Silvey family friend, Vancouver Parks Board commissioner John Coupar, Portuguese-Canadian project supporter Victor Marques and Portuguese consul-general Maria João Boavida.

Opposite bottom: AMEC archeological consultant Sarah Smith made notes at the ground-breaking ceremony, but she expected no cultural conflicts with the already disturbed site on a berm at Brockton Point.
Photos courtesy of Richard Lam

very close to the Brockton Point burial ground, where Coast Salish had interred their ancestors for many generations. Burials also had continued in the post-contact era. The abundance of settler artifacts in the second stratum of soil, followed by aboriginal tools and objects, did not bode well for *Shore to Shore* to be installed on that site. Luke had initially been drawn to that site, in part due to its proximity to where his great-great-grandfather's cabin had been, but the consensus was it would be not be auspicious to place *Shore to Shore* on troubled ground.

For Luke, the switch-up from the site he had originally preferred was somewhat bittersweet. The first site between the park perimeter road and the bike path, on a relatively clear stretch of grass, would have given the sculpture prominence for all park-goers and set it off from the mish-mash of cultural styles in the totem pole area just to the west. The new site, however, was prominent and distinctive as well, sitting atop a berm just north of the park road, where the sculpture's monumental height could not fail to attract attention. It also was set off by a small landscaped rise from the group of Northwest Coast totem poles, Susan Point's Salish house frontal gates and the most recent addition, the Yelton pole.

The important thing about any site, Luke said to the group, is that "we depend on what our ancestors tell us—when we uproot this ground, we want them to know we mean them no harm and we will take care of them. We must treat Mother Earth with gentleness and kindness, with respect." Regardless of what First Nations consultants dictated, Luke had confided earlier that it was essential to him, as a Salish artist, to locate *Shore to Shore* on a site that troubled no one, living or ancestral. Although Luke grew up in contemporary times, the Coast Salish still hold strong beliefs about ancestors and the power of those who have passed. Ancestors must be consulted and honoured, by prayers, food burning and purifying rituals, before any ceremony proceeds. The ancestors' fears must be placated, so they know no harm will be done and no sacred place will be desecrated. The belief is central to Coast Salish culture yet a cornerstone of that culture requires that spiritual beliefs are not to be discussed and dissected publicly, but handed down in a good way through story and example, from elders to children.

As cedar branches were being handed out to extended Silvey family members and spiritual leaders, I couldn't help but reflect that this final spot chosen for *Shore to Shore* seemed more protected and blessed. It is situated back from the water's edge amid a grove of the cedar, a tree so crucial to the Coast Salish for sustaining their way of life for centuries. Cedar has provided a source of clothing, food storage, ceremonial dress, house posts and beams, and even canoes, often skillfully made from the bark without costing the tree its life. The trees in that grove today, although big, are shadows of the giants that lived before them. Among the huge cedars on the Pacific coast, where proven First Nations occupation dates back 9,000 to 11,000 years, powerful spirits still can be felt moving among the tall trees. The cool morning of the ground-breaking, even the slight breeze felt warm and embracing as the group made a circle on the rise and began to sweep the ground, cleansing and blessing, with boughs of cedar. Stz'uminus speaker Herman Seymour began prayers in his own language, with eyes closed, hands outstretched and quivering, to acknowledge the ancestors' spirits that were present.

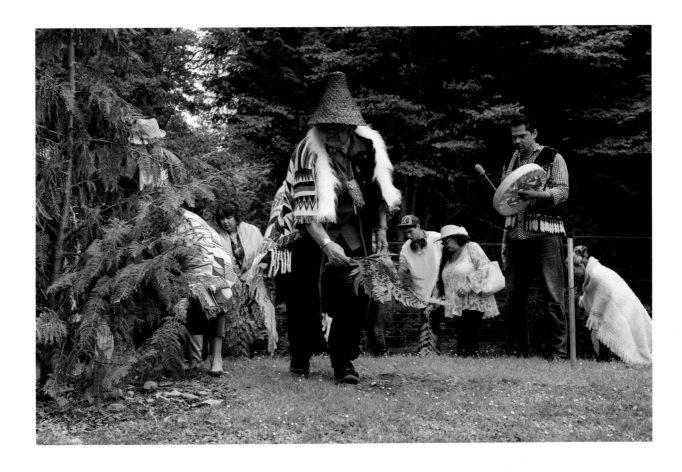

Many of the old human remains in the park were long gone, removed or destroyed by park road crews decades earlier, but it was essential to acknowledge and respect the spirits of ancestors who had passed, and whose graves might have been in that very grove of trees.

Luke drummed as his mother, Jane Kwatleematt Marston, and his wife, Stacy Miller, with their two daughters Marlin and Ryza, took part in the ceremony. The procession slowly moved around the sculpture site in a circle. Other participants included Portuguese consul-general Maria João Boavida, Coast Salish leader and Stó:lō fishing rights activist Kwitsel Tatel (whose English name is Patricia Kelly) and Barbara Higgins, the Shishá7lh (Sechelt) elder Xwu'p'a'lich, who is a direct descendant of Kwatleematt. Lorraine Silvey, a direct descendant of Joe Silvey and Kwatleematt's son Antonio, with her handsome teenaged son Antonio, a fifth-generation Silvey, beside her, also brushed the ground with cedar, her waist-length hair swaying as she bent forward.

Luke spoke his name, Ts'uts'umutl, and a few words in Hul'qumi'num, which he then translated: "I'm very happy in my heart to be here today." He then set out his ancestry, from his great-grandfather Antonio, the son of Joe Silvey and Kwatleematt, explaining that Antonio stayed on Reid Island all his life, and his second, happy marriage was to Alice Aleck, known as Swealt, a Penelakut woman from Penelakut Island, then known as Kuper Island. Today, Luke's eldest sister, Denise Augustine, an instructor

While Luke drums, Sechelt elder Xwu'p'a'lich, a direct descendant of Joe Silvey and Kwatleematt, blesses the ground where the *Shore to Shore* sculpture will be located. Xwu'p'a'lich lives on the very spot on the Sechelt Peninsula where Silvey and Kwatleematt once lived together.

Photo courtesy of Richard Lam

of First Nations studies and strong supporter of the sculpture project, carries the name Swealt. Luke also acknowledged the *Shore to Shore* family of supporters, which had continue to grow up until that day. "We're finally here, and we couldn't have gotten here without help from our Portuguese brothers and sisters, from my brothers and sisters, without all the physical and financial help of so many people," Luke said. Luke's cousin Chris Thompson spoke next, thanking the Parks Board, the Portuguese community, First Nations, the Silveys and supporters for backing the $750,000 bronze installation. "And we still need a few more dollars," said Thompson, directing the audience's to a table where the *Shore to Shore* prints and commemorative granite bricks could be purchased.

Luke and his mother Jane Kwatleematt Marston with the maquette at the ground-breaking ceremony. Jane is admiring Luke's fine carving detail on the woven cedar hat of her namesake and ancestor Kwatleematt.
Photo courtesy of Richard Lam

Portuguese consul-general Maria João Boavida then stepped forward. "In 1867, the year that Canada was born, a Portuguese man was living here in Stanley Park, one of the most famous icons in the country, one of the most beautiful places in Vancouver," Boavida remarked, looking at the Vancouver skyline and the Brockton Point beach from the small berm on which *Shore to Shore* would be located. "Like so many men from the Azores, Joe Silvey left his country looking for a better life," she said. "In the late 1800s, there were probably many European settlers with similar tales—something must have been quite remarkable about this man indeed. My conviction is that what made him different was his deep respect for the land and for the people who were already living here when he arrived. He chose to embrace the richness of First Nations culture and traditions; he chose collaboration instead of confrontation; he chose integration instead of segregation; he chose to share knowledge and adapt it to his life here. His Coast Salish family became the cornerstone of all his decisions but he never forgot his Portuguese heritage." Portuguese Joe Silvey, she suggested, was a "symbol of tolerance, and of multiculturalism before the word was even invented." The consul-general said with emotion that although there are 35,000 Portuguese living in BC, this will be the first monument to honour their history and heritage. It also will be the first, she said, to honour the "richness of a dual heritage that was kept alive from generation to generation" for more than a century. It will represent the union of two cultures, one from the Atlantic, one from the Pacific. "And for *Shore to Shore*, the circle is complete, as the monument comes to live here in Stanley Park," Boavida finished, to applause.

Patricia Kelly, well known by her Stó:lō name Kwitsel Tatel and as the activist who fought a landmark aboriginal fishing rights case all the way to the Supreme Court of Canada—and won—acknowledged her Coast Salish "sister" Debra Sparrow. The connection cited by Kelly only served to underscore the interconnectedness of the Coast Salish, who she acknowledged are "fifty-four separate tribes strong" but closely linked through ties of family and marriage. Kelly said she had witnessed the archaeological testing of the earlier site that turned up the ancient artifacts best left undisturbed. "Now I'm telling you to bring all good wishes and goodwill to this sculpture as it begins its life

on this land, which is unceded Coast Salish territory, called a park today, but land that we never surrendered," said Kelly, who then threw her head back and sang the song she termed the "Coast Salish Anthem."

Debra made it clear that she spoke for the Musqueam First Nation, and on behalf of her brother, the Musqueam elected chief, Wayne Sparrow. A direct descendant of the Musqueam people who lived for several thousand years in the land now called Stanley Park, Sparrow recalled being told by her beloved grandfather Ed Sparrow, who lived to be almost 100 years old, the story of her great-grandmother Matilda Pete's cruel eviction from her home, in the ancient village of Xwayxway. "The police banged on her door and told her she had half an hour to gather her things. She started frantically stuffing things into paper bags and then as they led her away she turned and saw them setting fire to her beloved house," said Debra. "I remember my grandpa sitting here in my house, telling that story to an anthropologist, with tears running down his face."

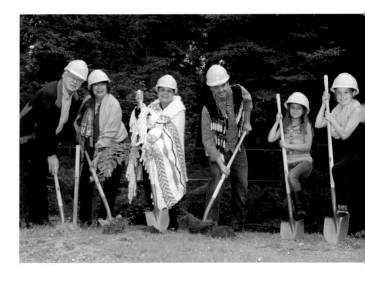

To Debra Sparrow, it is clear that Khaltinaht was a Musqueam woman, and that Stanley Park is neither a park nor federal land. "It is Musqueam land, to us it is home, that's what my grandfather called it," she asserts. As for Khaltinaht, she was the granddaughter of a Musqueam woman, Homulchesun, who was married to Joe Kiapilano, who was also born at Musqueam. "Kiapilano had more than one wife at Musqueam and then the people told him that was no longer acceptable, so he went to live on the north shore, near the Capilano River, and eventually Joe took more than one Squamish wife," Debra said. Khaltinaht is believed to be the daughter of Kiapilano's son Kwilitrock and a woman named Sukwaht, whose brother Sam Kwiakult lived at Xwayxway, a collection of longhouses now on the north side of Stanley Park, facing the north shore.

The extended Silvey and Marston family members pick up shovels to break ground at Stanley Park. From left to right: Chris Thompson, Lois Silvey, Jane Kwatleematt Marston, Luke Marston and his daughters Ryza, eight, and Marlin, ten.
Photo courtesy of Richard Lam

When Kiapilano later made peace with the Musqueam, although he never returned there to live, he was given a blanket, with a design that he then displayed on his housefront poles. Luke chose that design for Khaltinaht's fin of the fish lure. "My grandfather saw in the *Salish Weaving* book a photo of Kiapilano 'of Squamish' wearing that design, but my grandfather said, no that is ours," said Debra who added with a shrug that although to her, Kiapilano clearly was Musqueam, "the Squamish claim Kiapilano because he died there and he had children with Squamish wives after his children were born at Musqueam." She relies on her grandfather "who was respected as an historian, because he lived 100 years and was taught by grandparents who also lived that long, so he had direct knowledge of three to four hundred years of history. He talked of Portuguese Joe Silvey and going to the park to visit his relatives." It was at Musqueam that Silvey first saw Khaltinaht, and it was there that the old chief Kiapilano also gave Joe permission to marry his granddaughter. Khaltinaht's eldest daughter

Elizabeth, who remembered old Kiapilano visiting the family at Brockton Point, also confirmed that it was the Musqueam people who came to get her mother's body for burial when Khaltinaht died, to return her to the place of her birth.

"And today, we are all related.

"Our roots are planted firmly in this very soil on which we stand today, on both sides," said Sparrow. "We all have the same blood running through our veins," she said, referring not only to the First Nations who are tied to the park's history, but also to those of Portuguese and other heritages. Sparrow added that indigenous people will be relying on aid from every Canadian who chooses to join them in opposing various pipelines slated to transit through First Nations territory not covered by treaty. "When we are fighting against projects like the pipeline, we have to be on the same side. Warriors are standing beside each and every one of you." Debra then covered Luke in the blanket she brought for him, which was lined with white fur, and woven in her signature intricate designs. Like Luke, Debra has pored over slides of and books on Coast Salish art, adapting symbols and stories to her own artwork.

In a later interview, Sparrow said her family history is closely tied to the peninsula now called Stanley Park. "I remember my grandfather, Ed Sparrow, saying to me, if you don't know who you are and where you come from, you're nothing." Debra said her grandfather, who lived to be almost a century old and had crystal-clear recollections of his people's history, would ask her to take him to Stanley Park. "He would tell me where the villages once were, where the people gathered their food and medicines, about the beaches where they gathered seafood and all the fishing sites. It was as clear to him as yesterday. Well into his nineties he would reminisce and tell us important stories." Edward Sparrow was born in 1898, just as the last of the (xʷm 0kʷ ẏ m) and Skwxwu'7mesh (Musqueam and Squamish) people, along with mixed-race families and new settlers, were being evicted from Stanley Park. Xwu'p'a'lich, born in 1933, was able to learn all about her family history from her grandfather, enjoying his influence for more than thirty years of her life.

As Debra spoke, standing beneath the cedars, long black hair trailing down her back, the gap in time between Khaltinaht's life, just 150 years earlier, and the present seemed to blur a bit. The stories of Khaltinaht's traditional marriage to Joe Silvey say the beautiful young woman was sent off to her new life in ceremonial fashion, with canoes laden with goods, sitting atop the traditionally woven Salish blankets. Today those blankets woven of mountain goat hair are gone, but the Coast Salish art revival means their textiles have gained a new and vibrant life. Salish weavings now grace non-native and aboriginal homes alike, fulfilling their traditional purposes of utility, decoration and ceremonial use, and even serve as indications of a certain wealth, as they did in the potlatch days.

Debra Sparrow can no longer access the wool of the small white dog-like animal—

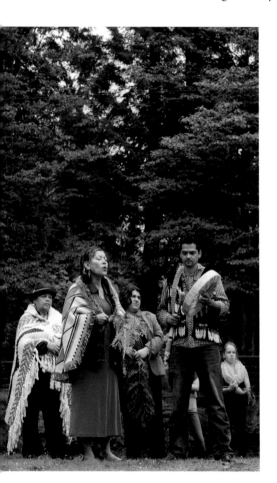

Kwitsel Tatel acknowledges the close family, cultural and political ties between the Stó:lō, Musqueam, Tsleil-Waututh and Squamish and sings the Coast Salish "national anthem" as Luke drums.
Photo courtesy of Richard Lam

now extinct—that was blended with mountain-goat hair, to make Salish weavings water-resistant, a mix that was still used in Khaltinaht's day. "She was a weaver, I am a weaver; she was of the Mali people, and I am Mali, which is our name for people who lived on the Musqueam flats near the Fraser River, and she was of our family," said Sparrow, adding that a shock of recognition went through her when she first saw Luke's sculpture with the lifesized figure of Khaltinaht. "She could be me."

Debra, who attended the first blessing of the ground for *Shore to Shore*, said as she researched Khaltinaht's background, she felt even more connected to her. "I feel like Khaltinaht told me, 'pay attention, pay attention, to who I am.' Now I've got this direct link to her, it's my responsibility to honour her and make sure she's being looked after right. She's not just a sculpture of what was, she is a living being who lived right here." As visitors flock to see *Shore to Shore*, in Stanley Park, Debra Sparrow predicts the effect will be "amazing. People are going to be as taken aback as when the first Egyptians came out of the tomb, to see Khaltinaht standing there among the cedar trees at the point on the ocean where her people lived and she lived, with her husband Portuguese Joe and her two daughters. She will come alive, make people aware, in a very dynamic way, of her life and her history. I told Luke that is why his sculpture had such a mesmerizing effect on me, and I know it will on others."

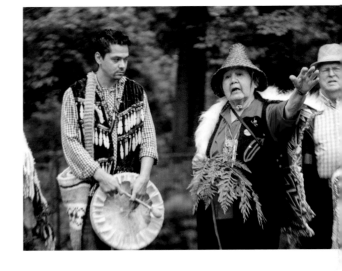

In the Coast Salish tradition, blankets always are bestowed at occasions of ceremonial significance, and there was yet another blanket for Luke that day, this time from the family of his own great-great-grandmother. Just as Debra was there to represent Khaltinaht and her Musqueam heritage, Barbara Higgins, the Shishá7lh (Sechelt) elder Xwu'p'a'lich, stood up to represent her great-grandmother Kwatleematt. The grandfather of Xwu'p'a'lich was Andrew Henry, the youngest son of Joe Silvey and Kwatleematt. Henry, as he preferred to be called, was born in 1890, more than twenty-three years, or a full generation, later than Silvey's eldest child, Elizabeth.

It was about 1920, several years after his father Joe Silvey's death, when Henry followed his older brother Joe to Egmont on the Sechelt Peninsula, also the home territory of their mother Kwatleematt. "The impetus was Henry's great discontent over Domingo's handling of Reid Island, their father's legacy," explained historian Jean Barman. Henry and his wife Amelia, the sister of his brother Manuel's wife, had six children together and were married almost sixty years before she died in 1966. Family stories say he died just two weeks later, of a broken heart. Xwu'p'a'lich's father was one of Henry's sons, and was known as Bill Silvey, although his first given name was Andrew, like his dad's, and her mother was Sarah Paul, of a distinguished Sechelt Nation lineage.

A dignified woman wearing a red robe and a traditional woven cedar hat, Xwu'p'a'lich stepped forward to say that she was there to represent her great-grandmother Kwatleematt. Xwu'p'a'lich met Luke Marston only on the day of the ground-breaking, but

Luke listens intently while Xwu'p'a'lich tells the dramatic story of "Portugee Joe's" escape from hostile First Nations people and his flight by canoe down the Fraser River to Musqueam, where he was welcomed by the great Chief Joe Kiapilano. Kiapilano eventually gave Joe permission to marry his beloved granddaughter, Khaltinaht.
Photo courtesy of Richard Lam

she had much to tell him. At age eighty-one, she is old enough to have known her grandfather Henry. Historians can follow documents to re-create the life of Silvey and his descendants, but to Xwu'p'a'lich, the oral history she heard from her parents and grandfather is far more compelling.

Xwu'p'a'lich still lives on the very land, near Egmont on the Sechelt Peninsula, where Joe Silvey and Kwatleematt briefly lived after they were married in 1872, with the two little girls from Joe's first marriage. "I remember all the stories about Kwatleematt and Portugee Joe that I heard from my parents, and from my grandfather. He heard it all from his dad." Although Kwatleematt was educated by the Oblates and could read and write, Joe could not. Many of Silvey family tales live on most strongly in oral history, without distinguishing whether the teller or the subject was Coast Salish or Portuguese.

At the ground-breaking ceremony, Xwu'p'a'lich began with a prayer. "Our people respect the land and water and sky," she said. "We give our thanks to the Creator for putting us on the land to follow our traditional ways as best we can, to follow what our people did for years and years.

"Kwatleematt was my great-grandmother," she continued. "I have lots of memories about what I was told about when they lived at Brockton Point. So many people in BC don't know about their history," she told the listeners. "It's your history, it's quite a rich history, and we need to know it. To have pride in our country, we need to be one people. We need to be one nationality," Xwu'p'a'lich emphasized.

She turned to face Luke, at her side. "I am very proud of this young man," she said, honouring him for "working so hard" to create a tribute not just to Portuguese Joe Silvey but to Kwatleematt, and to Khaltinaht, and for giving back to British Columbians a key part of their own history. "It's a very good thing that I still live on the property that Portugee Joe Silvey used to fish from," she said. "When they first started to do the names of places it was Silvey Bay, then it was Secret Bay and Co-op Bay. I want to change it back to Kwatleematt Bay," she concluded, to applause.

Reflecting on the ceremony later, Luke emphasized that to him, at its heart the *Shore to Shore* project is about reconciliation, and choosing to bury old unproductive bitterness and instead take pride in shared heritage. For Luke, the Azorean respect for family, hard work and traditions resonated strongly with the values of First Nations, their commitment to cultural strength, respect for elders' knowledge and caring for children.

"It's our responsibility to carry on the legacy of our ancestors," says Luke. "It has been a really long journey to get the sculpture installed in Stanley Park, not just for me, but for my family, for the whole extended Silvey family. They have been really interested in the project from the very start. It's been an intense process for the First Nations in whose traditional territory the sculpture is located; and for the Portuguese community that rallied together to support this monument. And now, as *Shore to Shore* has the chance to be seen by millions of people a year in Stanley Park, the spirit of reconciliation will grow and be strengthened."

Acknowledgements

Every book has a journey. I hold up my hands in thanks to Jane Kwatleematt Marston, who started the journey of this book, in so many ways. Jane visited our Galiano home in late 2013, with her daughter-in-law and good friend of ours Terry Bottomley. A few weeks later, Jane called with a request, the night before she faced serious major surgery. It may have been an order. Jane can be direct and forceful concerning the interests of her beloved extended family. "I want you to do the book about Luke, and Shore to Shore," said Jane, referring to the sculpture to be installed in Stanley Park, which had occupied much of her son Luke Marston's time for more than four years. Jane was clear that the book should focus on Luke and his journey as an artist, as well as the family history and the sculpture. And of course, Jane had helped initiate the Shore to Shore project, with her keen interest in the story of her great-grandfather Portuguese Joe Silvey and her great-grandmother Kwatleematt. A trailblazer in the Coast Salish art revival and a remarkable artist herself, Jane mentored many young Coast Salish artists, most notably her children Luke, John and Angela Marston.

I would like to profusely thank Jean Barman, an advisor to the Portuguese Joe Silvey project from its earliest inception, for the solid research that created the foundation for my book, and for her warm and friendly advice to me in pursuing this project. I would like to think I followed her advice not to get bogged down in the minutiae of historical detail and geneaological research and to tell the story of Luke Marston and the creation of Shore to Shore.

I also very much appreciated and relied on the research of Eunice Weatherell, a Silvey descendant whose family recollections and photos in her book, Walking in the Footprints of Portuguese Joe Silvey, put a lively human face on the story of her family growing up on Reid Island. Eunice also was a gracious host and organizer of the annual Silvey family Mother's Day gathering on Reid Island, where she has for decades tended the graves of her great-grandparents Joe Silvey and Kwatleematt. I thank her and other Silvey family members for welcoming my husband Art Moses and me, and for sharing their stories with us and the other chroniclers there from film and television. I spoke to many Silvey family members, including Ken Silvey, Lorraine Silvey Stacey, Lois Silvey, Chris Thompson and Drew Silvey, who invited me to several "cousins' gatherings" and introduced me to their relatives from all over BC, including some fascinating Silvey elders well into their 90s. Lorne Silvey, our Galiano neighbour, shared his extensive knowledge of family history and connections. I am also grateful to Manuel Azevedo and Rocky Sampson for sharing some of their research.

Melanie Zavediuk, director of the Inuit Gallery of Vancouver, was invaluable in providing interviews, documentation and photos of Luke Marston's work. Gary Wyatt of the Spirit Wrestler Gallery helped to provide context and background on Coast Salish art and Luke as an artist and Douglas Reynolds of the Douglas Reynolds Gallery was helpful with comments and photos, as was Elaine Monds of Victoria's Alcheringa Gallery. My warm thanks also to Rebecca Blanchard of Seattle's Stonington Gallery, whom I interviewed and who kindly sent me her seminal 2005 book Contemporary Coast Salish Art, from an important show that included both John and Luke Marston.

North Galiano has been an important home base for our family for 25 years and I have always been fascinated by this island's early history, its rich Coast Salish heritage and the Portuguese who we always knew had lived on our shores, as Lorne Silvey used to tell us, for at least eight generations, intermingled with First Nations, Japanese saltery-owners, fishers and settlers of many nations.

I am grateful to the Marston family, whom we came to know through our good friends and Galiano neighbours Mike Marston and Terry Bottomley, for including us in some of their warm family gatherings. And this book could not of course exist without the extraordinary artistry, patience and generosity of Luke Marston, whose perseverance throughout this project I truly admire. I appreciate the support and interest of Luke's wife Stacy Miller and their lovely girls Marlin and Ryza. Debra Sparrow of the Musqueam Nation, Squamish councillor and hereditary chief Ian Campbell, Kwitsel Tatel (Patricia Kelly), Xwu'p'a'lich (Barbara Higgins): I hold my hands up to you in grateful thanks for your wise words and insights.

Editor Pam Robertson did an excellent job and the good people at Harbour Publishing, including managing editor Anna Comfort O'Keeffe, editorial assistant Shed Simas and designer Roger Handling, have been thorough and helpful throughout the production of a challenging manuscript and the processing of many photographs amid a short—and changing—time-frame, due in large part to the scope and dynamics of the Shore to Shore project.

Thank you to Michael Durkos and Tycho Mommsen-Smith, whose exquisite carpentry created for me a studio and sanctuary where I can just cross the yard but shut out the world to write undisturbed.

I would like to thank Fil Jorge for his ongoing support for the project and his expansive generosity as a host and tour organizer for our trip to the Azores, as well as Fil's family members Manuela and her daughter Theresa, who hosted many wonderful meals. Fil's brother Joseph and wife Lilia were skilled facilitators for the visit of Luke and our entourage and Fil's brother Garcia assisted with translation. Manny daCosta kept us informed and entertained in the Azores, while his cousin Manuel and wife Loevjilda and their family created many memorable days and evenings of fabulous Azorean food, wine and traditional music and dance. Filmmaker Peter Campbell and cameraman Jules Molloy were great travel companions and assisted this book with their valuable insights and sharing of information and photographs. I look forward to the premiere of Peter's film, especially in the Azores! And Luis Silva, who took over as tour organizer from Fil in San Miguel, did an excellent job.

I would like to acknowledge the invaluable support of my family. I feel truly fortunate that my husband Art, daughter Naomi and son Zev all possess excellent writing and editing skills, in their busy lives in communications, in editing and law, and in academia. With my broken right arm in a cast or two months, their help was especially crucial. Warmest thanks and hugs to Art, Zev, Naomi and her wife Elan.

Suzanne Fournier

Index of Works and Exhibitions

Index of Names